PEOPLE · IN · FOCUS

PEOPLE · IN · FOCUS

HOW TO PHOTOGRAPH ANYONE, ANYWHERE

BRYAN PETERSON

AMPHOTO
AN IMPRINT OF WATSON-GUPTILL PUBLICATIONS/NEW YORK

Bryan Peterson is a professional photographer who specializes in the corporate, industrial, and editorial markets. Among his clients are NBC, DuPont, and American Express. His work has appeared in numerous magazines, including *Audubon, Popular Photography,* and National Geographic's *GLOBO.* Peterson is a contributing editor to *Outdoor Photographer* and a columnist for two other photography magazines, Germany's *Foto* and Holland's *Focus.* He has received awards from the New York Art Directors' Club, the *Print Design Annual,* and the *Communication Arts Photography Annual.* Peterson is also the author of two best-selling Amphoto books, *Learning to See Creatively* and *Understanding Exposure.*

Half-Title Page: West Friesland, Holland
Title Page: Portland, Oregon
Page 5: Monument Valley, Arizona
Page 6: Bryan Peterson's studio, Portland, Oregon

Editorial Concept by Robin Simmen
Edited by Liz Harvey
Designed by Areta Buk
Graphic Production by Ellen Greene

Copyright © 1993 by Bryan Peterson
First published 1993 in New York by AMPHOTO,
an imprint of Watson-Guptill Publications,
a division of BPI Communications, L.P.
1515 Broadway, New York, NY 10036

Library of Congress Cataloging-in-Publication Data
Peterson, Bryan
 People in focus: how to photograph anyone, anywhere / by Bryan
Peterson.
 p. cm.
 Includes index.
 ISBN 0-8174-5388-1
 1. Portrait photography. I. Title.
TR575.P47 1993 93-1900
778.9'2—dc20 CIP

Manufactured in Hong Kong

2 3 4 5 6 7 8 9 / 00 99 98 97 96 95

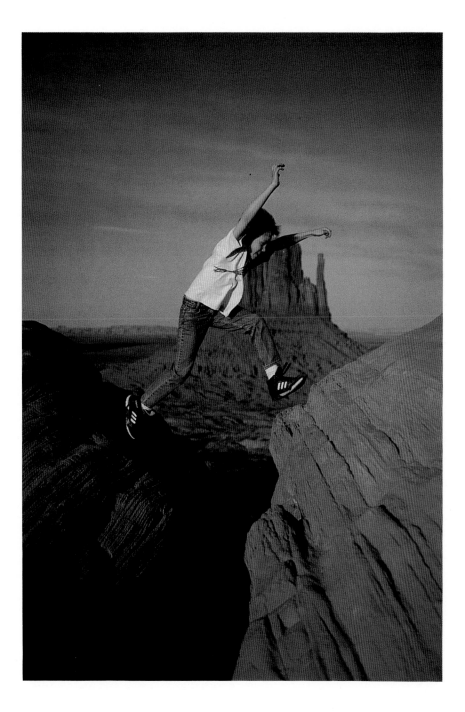

CONTENTS

INTRODUCTION

People are the most photographed subjects in the world because pictures of them tug at your heart and are, in a way, images of yourself. A full-framed "portrait" of a 3-year-old boy's sad-eyed, tear-streaked face touches most people. The specific reasons for his tears might be unknown, but everyone can feel his pain. Conversely, three elderly people sitting on a front porch laughing hysterically may generate a number of interpretations of the image's subject matter, but one thing is certain: everyone can understand and appreciate the meaning of laughter. In addition, most people can give thanks to their mother, father, or some other relative who had a camera and the ability to press the shutter-release button, forever preserving small but revealing vignettes in their personal histories.

Unlike photographs of snowcapped mountains, autumn trees, and colorful sunsets, photographs of yourself trigger much deeper emotions. Many people are reminded of their youth, and memories of a long-ago age elicit both positive and negative feelings. Your children laugh as they look at photographs of you and days gone by, with beehive hairdos, Afros, white bobby socks, or bell-bottom trousers. You tell your children that "you had to be there" to understand why you looked the way you did, and you point out that in just 10 or 15 years they, too, will look back with nostalgia and perhaps some embarrassment at the pictures you took of them just last week.

At other times, photographs may cause you to pause and satisfy your need for quiet time and personal reflection. You sigh as you look at photographs of you and loved ones from an earlier era and remain convinced that life seemed so much easier back then. Since the advent of the camera, this seems to be the lament of every generation. You're moved to tears of sadness as well as joy as you relive the now very precious 19 years, 4 months, and 3 days you had with your son or daughter, whose spirit and pride you captured on film while he or she was home, for the last time, before heading off to war.

How you photograph your loved ones, friends, and strangers can also reveal something about you. Do you find that your favorite pictures of people show them in a vast landscape that causes your subjects to appear small and diminished? Perhaps compositions of this type reflect your own inner struggle with feeling overwhelmed by life or just how lonely life can be. Alternatively, these images might strike a positive note because they reflect your love of solitude. Do you find yourself shooting mostly faces? Such compositions might reflect the great compassion you're blessed with as well as your ability to freely interact with people.

The reasons why you do what you do are numerous and in part define who you are, but photography—unlike any other medium—can say volumes about you and the subjects you shoot in a single stroke.

My photographic career didn't begin with people as my main interest. Waterfalls and forests, flowers and bees, lighthouses and seagulls, and sunrises and sunsets drew my attention. This continued for more than 10 years until one day I found myself composing yet another image of a snowcapped peak reflecting in a still lake in the foreground. This moment proved to be a turning point. I began to reflect on the absence of passion that I once felt toward photography. What was missing in my private life was also absent from 95 percent of my compositions: people.

For the next five years, I found myself making a slow but deliberate transition; I spent less and less time shooting people-less compositions. Lethargy gave way to passion once again as I realized that the most vast and varied photographic subject was people. They spoke a language I didn't always understand, but by their revealing themselves to me, I learned more and more about myself. During the first few years of this transition, I struggled with "good" people photography. I had slide pages upon slide pages of nieces and nephews, co-workers, neighbors, and even strangers on the street. Yet these shots weren't at all compelling; they were merely "records" or mug shots if you will.

On more than one occasion, I resolved to abandon my interest in people photography. My landscape and closeup photography was being well received by magazine, greeting-card, and calendar publishers. And, of course, there was a dramatic difference between nature subjects and people: mountains didn't move, flowers didn't stiffen up, and butterflies didn't ask for payment. But try as I might, I couldn't silence the steady voice inside me that kept pushing me to return to people as a subject. The voice became even louder when I saw particularly striking subjects, such as a lone ice-cream vendor in a city square, surrounded by hundreds of pigeons; a woman dressed in red walking parallel to a blue-painted building, with her white poodle leading the way; or a white-bearded man of 80-plus years, sitting on a park bench and chuckling while reading an Archie comic book. But even during these obviously great picture-taking opportunities, I seldom was courageous enough to raise my camera to my eye and take the picture. Because I've always been outgoing, I was continually at odds when a giant wave of shyness swept over me as I started to approach the person or persons who caught my visual attention.

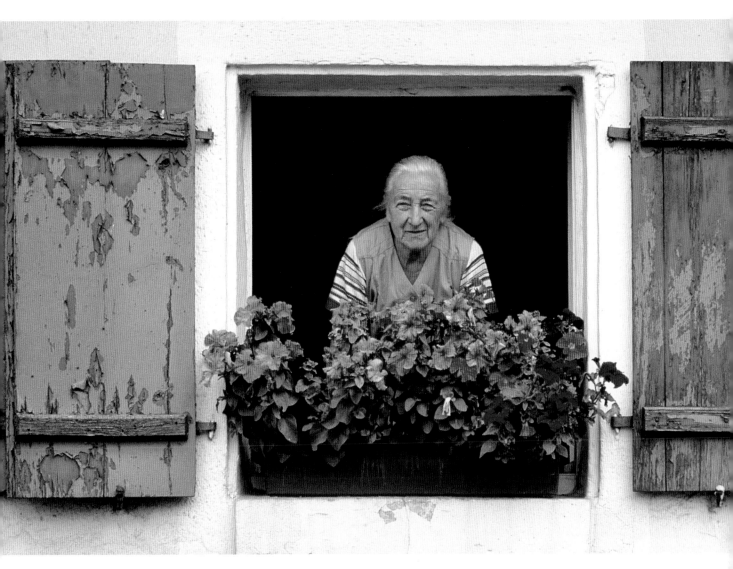

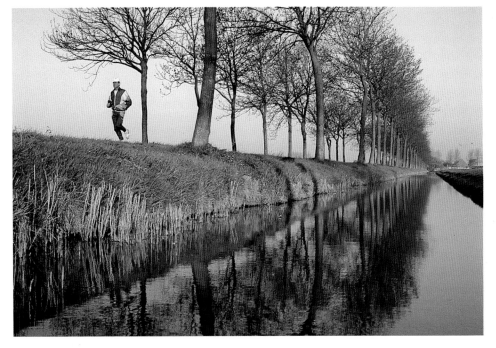

I met this elderly woman in a little village in northern Bavaria while she tended her flowers (above). As Hilda looked out over her brightly colored petunias, I took advantage of the kitchen window and the green shutters to shoot a frame-within-a-frame composition. ● While working in Holland, I came upon this lone jogger bathed in beautiful light (left). I wanted extensive depth of field in this shot in order to include the reflections of as many trees as possible.

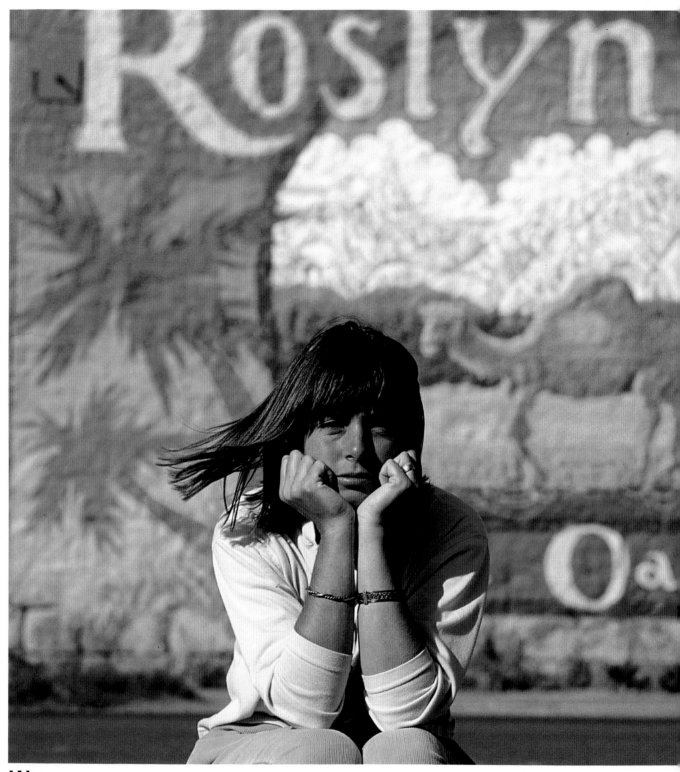

While shooting an assignment in Roslyn, Washington, for *Audubon* magazine about the logging-industry war between loggers and environmentalists, I met Susan at a strategy meeting. After we discussed the need for a balanced approach to this controversy, I asked her to pose for me. For this revealing portrait, I had Susan sit on a bench in front of a large mural painted on the outside wall of the Roslyn Cafe.

I finally concluded that I was afraid of rejection and intimacy! Unlike landscapes, people can talk back and do have something to say. Sometimes potential subjects would say exactly what I didn't want to hear and refuse to be photographed. But when I heard a "yes" response to my request, my anxiety over being rejected was quickly replaced by the fear of intimacy. Unlike a closeup of a flower that needs no coaxing, people pictures demanded that I get involved with my subjects if I hoped for any degree of spontaneity. Otherwise, when I raised my camera to my eye, my subjects often became self-conscious. It was as if I were a physician with a huge hypodermic needle, and I was about to give them the biggest shot of their life. It was now becoming clear to me that in order to create truly compelling images of people, I would have to go far beyond the simple process of pressing the shutter-release button.

As the weeks and months unfolded, I began to further analyze my feelings, as well as the meanings behind my usually excited responses to people and the settings I viewed them in. It wasn't the surroundings or the colors or the light that caught my attention, but rather the person or persons in the scene. Remove the main subject, and the "sentence" would lose its impact. The people were the exclamation point. Slowly, my fear of rejection gave birth to a confident anticipation. While approaching my subjects, I often pointed out their level of importance in the scene. I might say something like, "I don't know if you are aware of it, but right now you are at the heart of a truly wonderful picture. Would you mind, while you continue doing what you're doing, if I shot several pictures of the moment I'm referring to? I'd be happy to return later when my film is processed and share this moment with you." I am the first to admit that this approach didn't always work. Experience has taught me that some situations require more diplomacy, and others require less. I also discovered the importance of showing a genuine interest when photographing people, no matter what the situation. I was clearly able to achieve a greater degree of cooperation and spontaneity when my tone and intent were sincere.

No one will argue that every successful landscape shot or closeup relies in large measure on its ability to evoke both mood and emotion and that quite often luck played a major role. But I've learned that luck is seldom a factor when you try to shoot good images of people. Every successful photographer possesses a combination of creative and technical skills, as well as the ability to anticipate the decisive moment. But I maintain that beyond ƒ-stops, shutter speeds, warm light, the right lens, the right film, and the right subject lies the most important element: the ability to relate to and understand what motivates the people you wish to photograph. A short course in public relations can often add miles to your roadway of successful image making.

You also sometimes need to be able to pose, direct, and ask your subject to dress or look a certain way. These tasks might seem relatively easy to accomplish with family or friends but can prove challenging when you need the complete cooperation of someone you met only five minutes ago. Throughout this book, I address many different situations, locations, and cultures with people, of course, as the central theme. I also discuss the psychology of people—not just that of your subjects but your own as well—in great depth here.

When I photograph people, it is never my intention to embarrass them or to call attention to a particular flaw or defect in their physical appearance. Unfortunately, the temptation to exploit or embarrass a subject is at times so great that some photographers succumb to it. Rather than gain their subject's trust, they create an enemy of the camera. I am also not a big fan of shooting from the hip or using a wide-angle lens to distort a subject's face. Perhaps these are "necessary" photographs, but they aren't the theme of this book.

Lucky is the photographer who has a sound understanding of human psychology and the patterns of human relationships. If you're going to be able to motivate anybody to be a subject, you better be prepared to answer the biggest question right away: "What's in it for me?" This is a fundamental "law" of human psychology that governs most of what people do, yet photographers who are looking for willing subjects seldom consider it. Too often, photographers are motivated solely by what is in it for them. Think about this for a moment. When you see a subject who moves you or you get an idea that requires a willing subject, what is really going on in your mind? Do you see a photo opportunity that might help you win a blue ribbon at the county fair, make you some money, or provide the missing link in your portfolio that has prevented you from getting that desired assignment? Do you see a photo opportunity that might increase the funding for AIDS research or call attention to the plight of the homeless? You can argue that the first three reasons are selfish and that the other two are noble. But if you make your intention clear to your willing subject at the outset and offer one of the first three reasons as the impetus for making the photograph, how can this be considered selfish? Conversely, if you immediately make your intention clear to a dying AIDS patient or a homeless person and the individual protests emphatically to your taking a picture, how is this noble?

Like it or not, if your subjects don't feel that there is anything in it for them, they'll protest. And please don't make the assumption that your subject wants to be paid an enormous fee. There are only two pictures in this book for which I actually paid the subject, and in both cases the models were professionals. I've found that most people are willing to be subjects if they feel your tone and intention are sincere—and if they'll get a few 5 × 7 prints in return. They know that it can be expensive to hire a professional photographer to do what you're willing to do for free. I've actually had subjects in foreign countries turn me down because they were under the impression that they would have to pay me if I took their picture.

Remember, you're presenting yourself as a highly experienced photographer, and people hear this in the way you talk. To successfully sell yourself, you also have to look the part. This idea about dressing for success started in the early 1980s and was, for the most part, targeted toward the white-collar world. If you looked as if you were successful (even though you weren't), you would somehow become successful. Tailored suits and dresses in appropriate colors and tones, sharp haircuts, and subtle perfumes and colognes combined to create the image of a successful person. Over the years, many people have attested to the fact that the idea works. It all boils down to the image you want to project. So if you look the part, chances are that you'll be believed.

In this industry, only a few photographers are afforded the luxury of dressing anyway they please. Because of their accomplishments, they are free to look downright shabby or to look as if they stepped right out of the pages of *GQ* or *Vogue* magazine. Have you ever had someone tell you that you don't look like a photographer after you've identified yourself as one? I'm not sure what the stereotypical photographer looks like, but Hollywood wants the public to believe that all photographers use Nikons, carry Domke bags, and wear blue jeans with a sweater and a leather bomber jacket.

As far as I'm concerned, dress is a private matter. Nevertheless, you shouldn't overlook its importance. How you look has a definite impact on how you're perceived. For example, if you show up at a modeling agency seeking some young models for test shots, dress the part. Unless you are an established photographer, your scruffy jeans, baggy sweatshirt, and worn-out sneakers will draw attention away from the seriousness of your intent.

Suppose that you've just received permission to spend several weekends shooting the goings-on in a city hospital's emergency room. You arrive hopeful, expecting to capture the flurry and intensity of activity among the doctors, nurses, and other staff members as one emergency follows another. But as you shoot, you quickly realize that the very people you want to photograph crouch as they pass in front of you and your raised camera. You want to be nothing more than a fly on the wall, yet everyone seems to notice you. Soon, you realize that it isn't the whir of your motor drive that focuses attention on you, but the bright red and orange Hawaiian shirt that you feel so attached to. Save the loud shirt for the party you're going to in two weeks, and put on your white jeans and a white T-shirt; better still, throw on one of those loose and very comfortable scrub outfits.

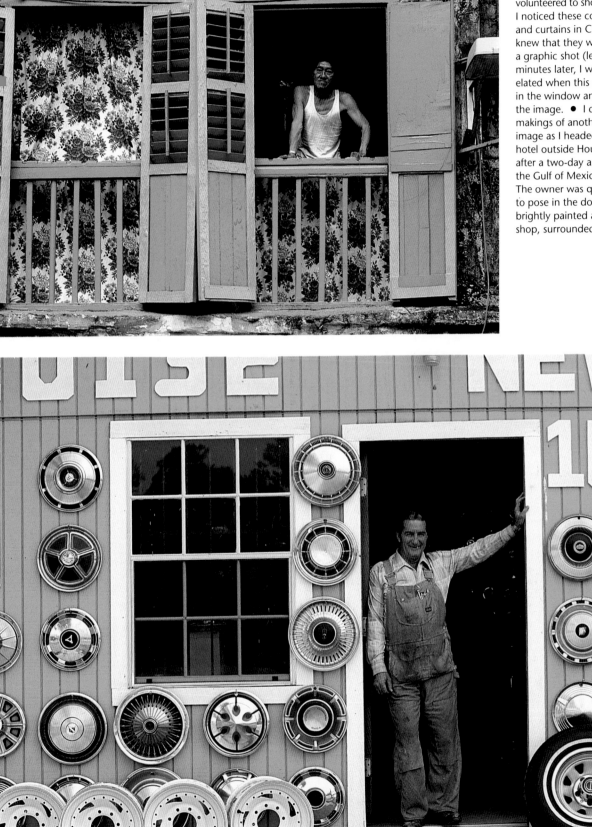

During my first trip to Singapore, Ivan, a young man interested in photography, volunteered to show me around. I noticed these colorful shutters and curtains in Chinatown and knew that they would make a graphic shot (left). A few minutes later, I was even more elated when this man appeared in the window and completed the image. ● I discovered the makings of another graphic image as I headed back to my hotel outside Houston, Texas, after a two-day assignment in the Gulf of Mexico (below). The owner was quite willing to pose in the doorway of this brightly painted auto-supply shop, surrounded by hubcaps.

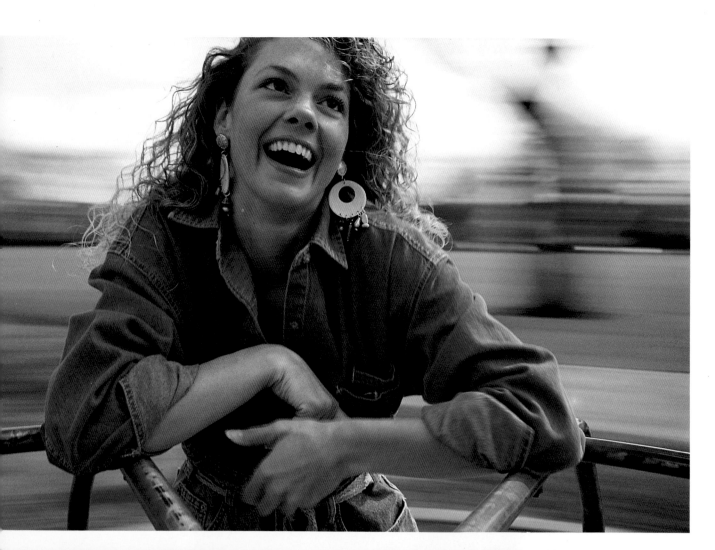

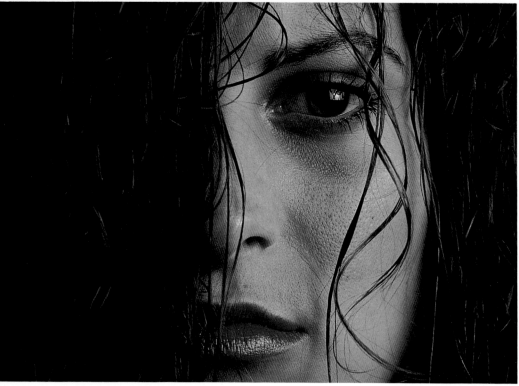

Wanting to take a picture that conveyed Carol's energy and intense passion for life, I asked her to pose on a moving merry-go-round (above). I sat directly across from her and used a slow shutter speed in order to blur the background and produce a sense of motion.

● Although most people would never dream of having their picture taken right after washing their hair, this image shows that you can shoot a compelling portrait in such situations (left). For this dramatic composition, taken in my studio, I decided to show only one of my subject's eyes and moved in very close for a tight shot.

● I was driving along the back roads in Bavaria when I came upon this funny scene (right). Stuck behind this farmer leading his cows back to the barn, I photographed them through the car windshield.

Whether you're shooting in a hospital emergency room or at an outdoor marketplace, the less attention you call to yourself, the easier it will be for you to record some wonderful candids. Remember, you want to blend into the environment, not become the main attraction.

Keep in mind, too, that no matter where you shoot, you are there first and foremost for yourself. You aren't on some noble mission or pursuing some selfish desire. You are there for one primary reason: you want to find and photograph a subject that feeds the fires of your creative endeavors, whether or not it advances your career, enables you to win the blue ribbon, or builds your self-esteem. And in the process, photographers are fortunate enough to be in a position not only to make new friends, but also to learn a great deal more about other people they meet—people who are walking down the street, playing in the park, running along the beach, working in the steel mills, and managing a health-care facility. These are encounters to be embraced and explored. Finally, you must learn and practice the art of empathy. Empathy is the fertile ground where the seeds of trust are sown.

I firmly believe that photographing people is the most challenging and rewarding of all the photographic opportunities that are available. No other subject is more vast and varied. People as subjects can range from babies to great-grandparents; can have youthful or weathered skin; and can be blue-eyed and blond, brown-eyed and black, short or tall, and male or female. When you combine these physical characteristics with the seemingly infinite choice of surroundings, such as urban or rural and forest or desert, the possibilities are truly enormous. And even though *People in Focus* is chiefly about photographing people in natural light, I've included a small number of shots taken in my studio under artificial light. If you embrace both the psychological and technological ideas presented in this book, it will not only make you aware of this visual feast but also help you develop even more compassion for other people. Because people are the subject, it is paramount that you embrace perhaps the greatest rule governing people photography: You rarely, if ever, get a second chance to make a good first impression.

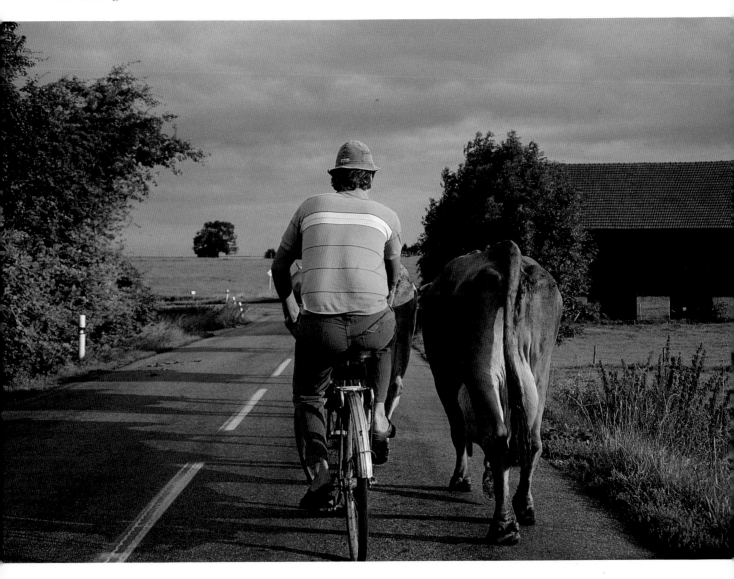

OBSERVING PEOPLE

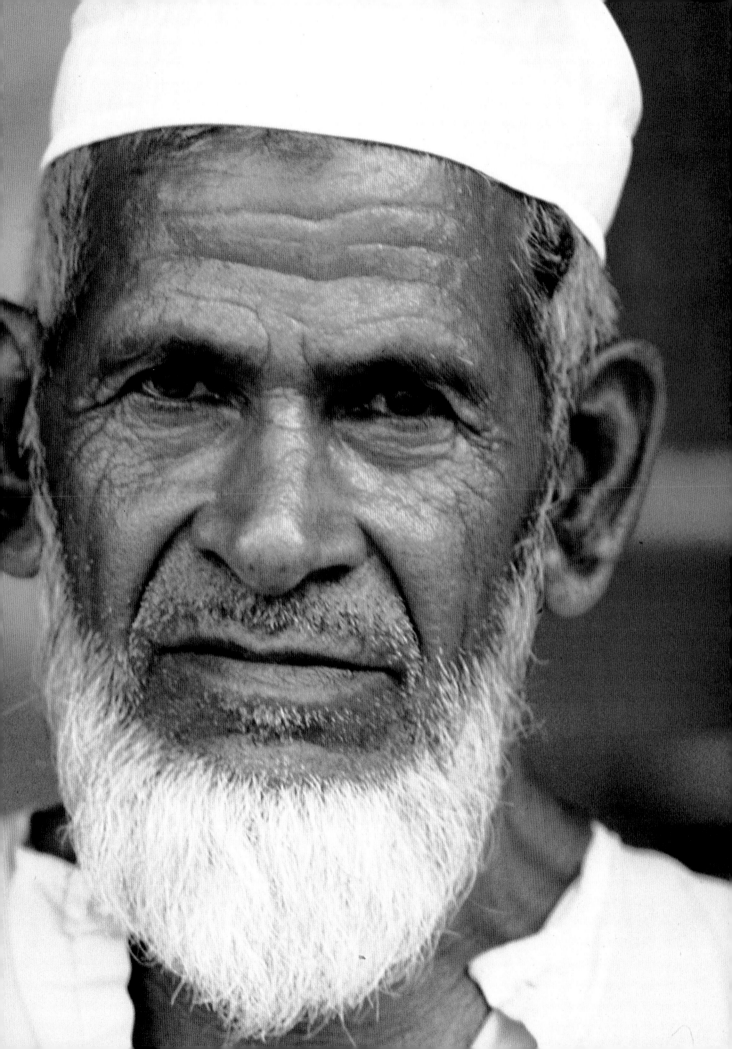

Imagine the following scenarios. At Fisherman's Wharf in San Francisco, several college-aged women sit on a bench carefully observing the many young men walking by, trying to guess which ones will amount to something. In Oklahoma City, Oklahoma, a middle-aged couple watches three small children playing on the merry-go-round at a local park, convinced by the absence of adult supervision and the well-worn clothing that the children must come from a broken home. And in a cafe, a young couple notices an elderly man sitting alone three tables away and hopes that they aren't left alone when they grow old.

People watching—everyone does it. Whether you do it consciously or subconsciously, you make sweeping generalizations about the people you watch. For example, you might say, "He looks like a football player," about a 250-pound muscular teenager with a thick neck; "She looks like a drug addict," about a woman with long, stringy, unwashed hair, dirty jeans, and no shoes; and "He looks like a computer nerd," about a man wearing polyester slacks and thick-rimmed glasses and has five ink pens in the front pocket of his white, short-sleeve shirt with a button-down collar.

Broad descriptions about the people you watch are greatly influenced by a number of factors, not the least of which is how you were brought up. Beyond this, the three most important criteria that partially determine your reactions to the people around you are: 1) their physical appearance: overweight, underweight, potbelly, washboard stomach, muscular arms, slender arms, blue eyes, brown eyes, no makeup, lots of eyeliner, bright lipstick, cleanshaven, bearded, a weathered face, a smooth complexion, long hair, short hair, curly hair, blonde, redhead, or brunette; 2) their clothes: designer fashions, hand-me-downs, summer dress, winter coat, work clothes, formal wear, casual clothes, running wear, or bathing suit; and 3) their environment: at work, at play, in the city, in the country, in the mountains, in the desert, at the ocean, at the lake, at the pool, in the United States, or in a foreign land.

When you come upon people you want to photograph, you have to think about the best way to capture them on film. For example, would you photograph the successful-looking, college-aged men mentioned earlier while they walk, or would you have them stand still in order to include some of the skyscrapers in the background? Would you photograph just the dirty faces and unkempt hair of the children from the broken home, or would you focus solely on the 7-year-old boy's worn-out sneaker and the dirty toe sticking out of it? Would you photograph the elderly man with his coffee cup raised to his mouth as his tired eyes peer directly into the camera, or would you photograph him looking off to the left or right? Perhaps a composition showing only his large, weathered hands grasping the cup would say what you feel.

As you observe people, whether they are relatives, friends, or strangers, listen to your feelings. Pay attention to what you're drawn to: her walk, his mischievous grin, her long hair, his blue eyes, her silly hat, his torn jeans, his wrinkled skin, her sports car, or his workplace. Figure out what causes you to feel anxious, secure, compassionate, sad, afraid, happy, angry, or playful, and why you're reacting that way. The way you feel always determines your response to the people around you.

The way you deal with your feelings determines which people you photograph and how you photograph them. You might be less likely to approach a subject who makes you feel nervous or frightened ("He looks mean, and he is big, too!") than a subject who makes you feel warm and welcome ("He looks like my uncle, and he smiled when I looked at him."). Another photographer, however, might find the "mean" subject appealing ("I feel compassion for this lonely man."), while the smiling subject might arouse the other photographer's suspicion ("I know that 'smile,' and I don't trust it!"). Everyone is unique, and it is this difference that makes photographing people so varied, challenging, and rewarding.

One of my more enjoyable recent assignments was a two-week shoot covering eight states for a national health-care company. The campaign goals were to call attention to the principals who ran the regional offices and to focus on the rural communities the company served. In order to find a typical customer for the shoot, the design firm's art director, a representative from the health-care company, and I drove along back roads near Covington, Georgia. Soon, we found the ideal family (bottom). ● Since we were in the South, no one was surprised by the family's warm greeting. When I observed the young boy enthusiastically eating a thick slice of watermelon, I began to wonder if he was capable of eating an entire watermelon if not several on his own (top). Everyone laughed about his appetite, including the boy, when I mentioned this and told me that my hunch was correct.
● By setting my 80–200mm zoom lens at its longest focal length, I was able to isolate the young boy from his mother and two sisters because of the resulting narrow angle of view. This focal length also allowed me to fill the frame without crossing the boy's psychological boundary. Using an aperture of $f/11$, I adjusted the shutter speed for the light falling on the watermelon until 1/125 sec. indicated a correct exposure.

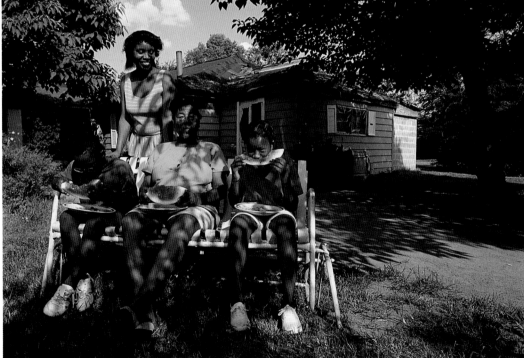

Nothing is able to add to or detract from subjects' appearances more quickly than the environment that surrounds them. A portrait of a young man wearing a blue denim shirt sitting on a log at the beach can suggest that he is a solitary, introspective individual; however, if you photographed that man in the same denim shirt sitting on a bed in a jail cell, you might think that he is a hardened criminal or a sympathetic figure whose life took a turn down the wrong road. A tightly composed shot of a 6-year-old girl's smiling face tells you only that she is in good spirits; however, if you include her environment, you'll have a deeper understanding of her ear-to-ear grin because you'll be able to see the blue ribbon in her hand as well as the Olympic-size pool she just competed in. And the bloodstained apron and the seriousness of a 55-year-old man's expression might scare you, but your fear will dissipate when the environment reveals that he is a butcher at the local grocery store.

When you photograph people at work or at play, the importance of the "right" environment can't be overstated. For example, if your 5-year-old daughter has a gift for playing the piano, it makes sense to include her and the piano in the image. If your boyfriend is a skin diver, include the beach, sand, and palm trees in the image. And if your grandmother makes the best apple pie, then a picture of her with a pie in the kitchen is perfect. Generally speaking, if the environment is going to be part of the composition, it should call attention to or at least relate to a person's profession or character. (Of course, when you begin photographing someone in a particular environment, such as around the home, you should be polite. When I am in this situation, I first knock on the door and explain my desire to the homeowner. I don't think that it is a good idea to just start snapping pictures of someone at home without making my presence known.)

You'll also have opportunities to photograph people in environments that serve as sharp contrasts to them. This is, perhaps, truer of fashion photographers than of any other group. They photograph models in often cold and uninviting environments, surrounded by mounds of black coal, in junkyards, and even inside huge bank vaults. This departure from the typical image of models dining al fresco sitting at an outside cafe in Paris or buying flowers at an outside market serves not only to surprise viewers but also to focus attention on the models and their clothing. And that, after all, is what fashion designers want you to see.

Imagine for a moment the stark contrast of a nude sitting on the steps of the Lincoln Memorial; a bank president sitting in an old, torn-up recliner inside a burned-out building in an urban ghetto; or someone dressed in winter ski wear walking along the beach in Hawaii. Let your imagination run wild thinking up odd environmental juxtapositions, and you'll soon find yourself with a shoot list that will keep you busy for months.

When photographing people in a specific environment, you have to give some thought to scale, too. Nothing else duplicates the human form. Thus, when shooting pictures with people in them, keep in mind that viewers' eyes are drawn to the size and scope of other elements in the scene. When I was doing research on one of Oregon's largest state parks during the late 1970s, I came upon some black-and-white photographs of logging activity taking place in the area. One shot reminded me of just how important people in a picture can be, if only because they provide a size relationship to the subjects around them. In one shot, five loggers stand shoulder to shoulder with their saws and axes in front of a very large and wide Douglas fir tree; despite the image area the men take up, the tree still protrudes from both sides of them. Without the loggers, I wouldn't have appreciated the tree's enormous size.

I discovered another shot that demonstrates the importance of scale while turning the pages of *National Geographic* magazine. Photographer Craig Aurness's picture of the Mojave Desert beautifully captures the wind-sculpted dunes, but without the lone runner that appears at some distance from the camera, the size, scope, and grandeur of the composition wouldn't have been nearly as impressive. The addition of a person in the scene not only provides scale, but also suggests both struggle and victory in a vast, forbidding landscape. My reaction to this image would have been completely different if the composition showed a coyote crossing the dunes rather than a human being.

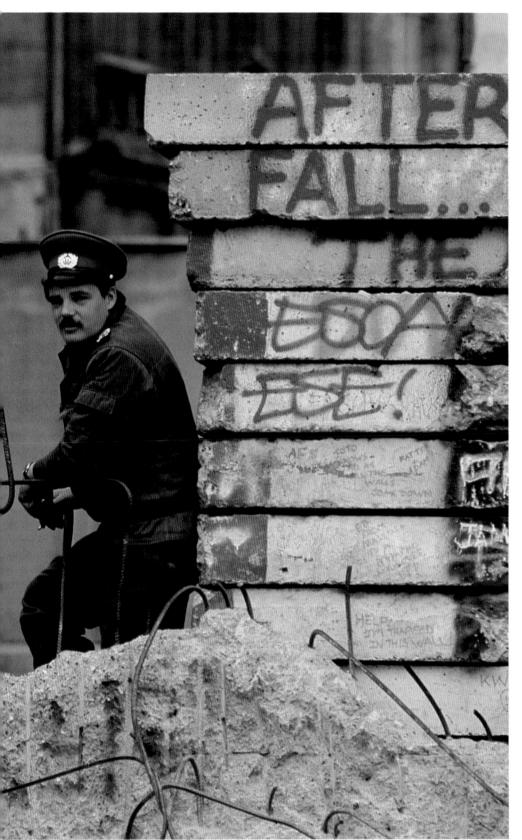

I returned to Germany six months after the fall of the Berlin Wall. As I walked along the remnants of the wall near Checkpoint Charlie one afternoon, I noticed an East German border guard continuing to patrol the area.

● Responding to the obvious historical significance of the scene, I raised my 80–200mm lens to my eye and composed this portrait. I don't have any idea who spray painted the words, "after, fall and the," but in combination with the destroyed concrete, they serve as a fitting background because they call attention to the guard and a very important event.

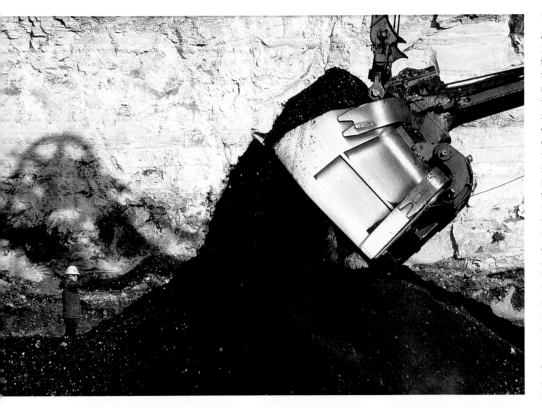

When I was hired to shoot an annual report in Rock Springs, Wyoming, I didn't look forward to working in –55°F temperatures. As the mine-safety manager and I drove around the area, we came upon a large shovel scooping up mounds of fresh coal. ● I knew that I could get a great shot if I were to place someone near the shovel. Although the manager looked at me as if I were crazy, I was eventually able to convince him to pose for me despite the frigid cold. ● I followed the manager over to the pile of coal and mounted my camera and 80–200mm lens on a tripod. After I zoomed the lens to 100mm and set the aperture at ƒ/8, I adjusted the shutter speed until 1/125 sec. indicated a proper exposure for the light reflecting off my subject's jacket. Finally, I ran as fast as my legs would go to a spot that would allow me to include part of the shovel and the coal in the image.

English Country Ale

While on assignment photographing London pubs for Northwest Airlines, I finished up an interior shoot of one of the more famous bars near Tower Bridge and collected my equipment. As I proceeded down the street toward the next location, I noticed a young man sitting in the pub drinking a beer. The mottled glass was typical of many London pubs, and as luck would have it, the words on the outside of the window frame called attention to the very country I was shooting in. ● I immediately put down my camera bag, mounted my 28–80mm zoom lens on my camera, and then secured both to my tripod. From a distance of only 5 feet, I chose a focal length of 50mm and framed this abstract scene so that it included both the man and the words below him. With the aperture set at ƒ/8, I then adjusted the shutter speed until 1/15 sec. indicated a correct exposure.

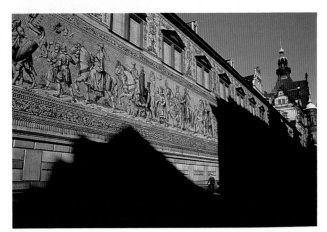

Friends often told me that I had to see Dresden, Germany, just as soon as my schedule allowed. When I finally had the chance to go, I wasn't disappointed. I fell in love with this beautiful, romantic city and stayed two days longer than I'd planned. Rising early each day of my visit, I was out shooting long before most other people reached to turn off their alarm clocks. ● An hour after sunrise one morning, I found myself rounding a bend in the road that revealed this immense painted mural showcasing an era gone by. The strong sidelight cast a large shadow on the wall, creating a sense of depth. I raised my 20mm wide-angle lens a bit, set the aperture at ƒ/11, and pointed my camera toward the sky and the wall. After determining 1/250 sec. to be the correct shutter speed, I recomposed the image in order to include the falling shadow. ● After shooting a few frames, I caught sight of a young boy wearing a red sweatshirt and riding a bicycle; he was headed right for a small gap in the shadow. I quickly fired off two frames when he hit that exact spot. I was lucky to be in the right place at the right time.

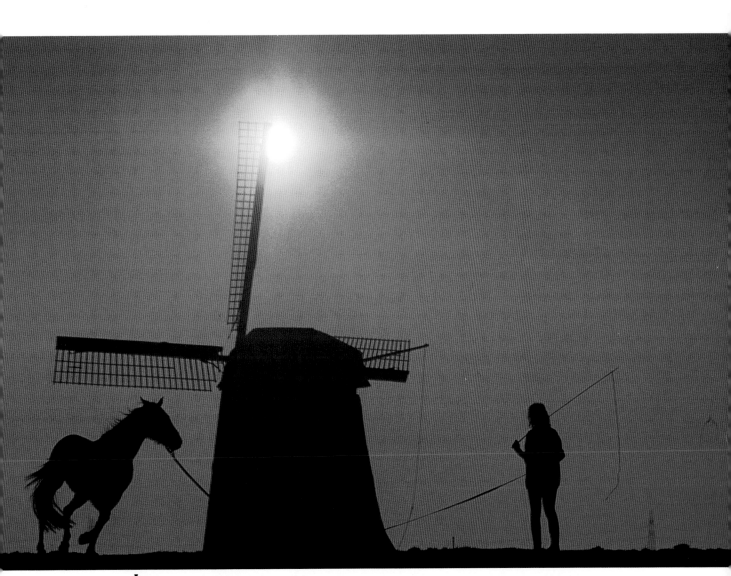

As I drove around West Friesland, Holland, I chased the sunset, hoping to find something to place in front of it. As luck would have it, I came upon this woman, whom I later found out is a famous horse trainer. I quickly pulled my car over to the side of the road and grabbed my camera and 80–200mm lens off the front seat. Next, I mounted my camera on my tripod and placed a Cokin sunset filter in front of the lens. I decide to use this filter because it was still a bit early for natural sunset colors to develop in the sky. With my lens set at 200mm, I chose an aperture of ƒ/8, and while I aimed my camera skyward to the right of the sun, I adjusted the shutter speed until 1/500 sec. indicated a correct exposure. ● Since the woman was running the horse in a circle, I deliberately waited until the horse was on the left side of the picture before shooting. This balanced the composition. The moment you look at this image, you realize that you're looking at a picture of a woman and her horse in Holland— not Mexico, not America, not Japan, but Holland. Obviously, environmental symbols have a strong effect on what photographs can convey.

THE CLOTHING

When you walk into a doctor's office and a person in a white uniform greets you, there is little or no question that the individual is a nurse. If, however, that same nurse were wearing faded jeans and a sweatshirt, you might question the person's abilities. Many people consider clothing to be an important barometer, indicating whether you are, for example, rich or poor, liberal or conservative, playful or serious, and meek or powerful. Simply put, clothing or the absence of it can define and redefine your character and personality. How many police officers look authoritative out of uniform? How many ministers cease to look like members of the clergy when they take off their collars?

For most people, clothing is a primary form of identification and provides an immediate answer to the question they both ask and are asked most often: "What do you do?" A tight head-and-shoulders portrait of a firefighter in uniform or a Native American chief in full headdress leaves no doubt as to their occupations. Including the fire station or reservation in your composition is an option, but the photograph's success doesn't depend on this added element simply because the clothing defines the subject.

In many cases, clothing immediately identifies people from other cultures or countries. For example, when a young boy walks down New York City's Fifth Avenue wearing his lederhosen, his costume is readily identified as that of Bavaria, Germany. As such, many people would remark, "He must be German." Similarly, a bald, 35-year-old man wearing sandals and a bright orange robe is immediately thought to be a Buddhist monk as he crosses Broadway. In both cases, if the compositions were to show the subjects from the neck down only, most people would make the same quick determinations of their country and/or culture. Such is the effect of clothing.

Finally, how many of you have worked side by side with several co-workers for months and not paid much attention to them until the company picnic? When you finally take notice of the people you work with on a daily basis, you discover that the usually conservative attire of the white-collar world and the uniforms of the blue-collar world give way to perhaps more revealing and colorful clothing. Keep this in mind when you shoot; clothes can play a major role in successful people photography.

As I drove along one of the literally hundreds of back roads in Holland, I came across some parents and their children picking a few tulips. The flowers, of course, serve as a great visual aid, but the children's clothes immediately tell you that this photograph was made in a foreign land. I wasted no time in getting my 800mm lens out of the trunk and attaching it to my camera. Next, I securely mounted both on my tripod. Zeroing in on the children, I set an aperture of $f/8$ and adjusted the shutter speed until 1/125 sec. indicated a correct exposure. ● Because the subjects were a great distance from the lens, I wasn't able to give them any directions, such as "Move to your left a bit. No, too far. Go back. Good." I also didn't have time to walk into the field and introduce myself because it was becoming obvious that the family was about to leave. Minutes after I made this shot, the parents and children headed for their car. I packed up fast and managed to get their names, address, and signed model releases. Although not having the opportunity to direct was a bit frustrating, I still managed to get seven strong images from the four rolls of film I quickly shot.

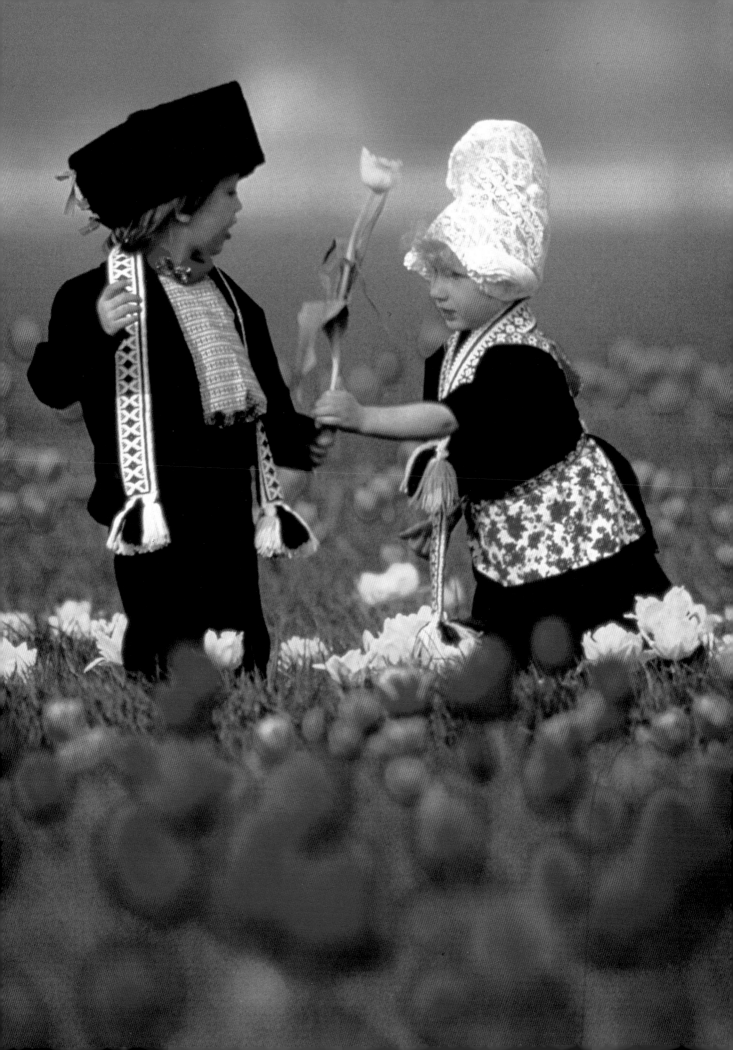

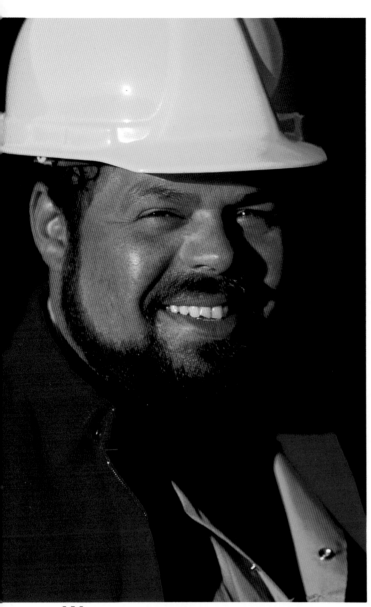

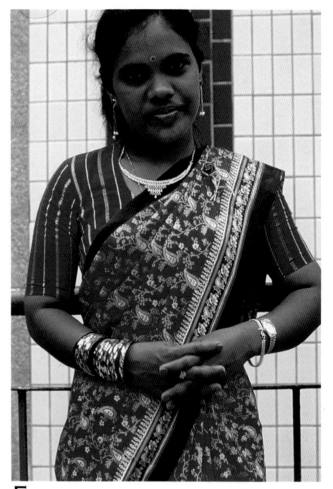

What does this man do for a living? It might not be apparent that he works at a coal-storage facility in Duluth, Minnesota, but it is obvious that he is employed in the blue-collar industry. Or is it? Maybe I'm putting together a photo essay about coal storage, and he is simply a friend of mine who was kind enough to dress the part. Such is the power of the kind of attire people usually associate with the blue-collar industry. ● This man actually does work at the facility. When a design firm sent me there to shoot an annual report,

I was asked to photograph the goings on as well as informal portraits of a few key people who work there, including this individual. ● With my camera mounted securely on a tripod, I set the aperture on my 80–200mm lens at ƒ/8 and decided to place the subject against a background of open shade. I based the exposure on the strong sidelight falling on the worker's face, so I was assured that the area of open shade behind him would record as black on the film because it would be severely underexposed.

Even a cursory glance at this shot of a young woman tells you that she is either from a foreign country or is dressed in a costume from a foreign land (above). I made these shots on an assignment in Singapore, one of my favorite places to visit in Asia because of its cultural diversity. After a bit of diplomacy, the woman gave me permission to photograph her. Before I shot the closeup, I told her that my real interest was shooting only a small part

of her dress with her hands folded in front of it (right). I didn't want to be sneaky, letting her think that I was including more of her in the frame and, of course, trying to explain why I was pointing my camera at her midsection, not her face. ● With my 80–200mm lens set at its longest focal length, I set an aperture of ƒ/8 and adjusted the shutter speed until 1/125 sec. indicated a correct exposure for this tighter composition.

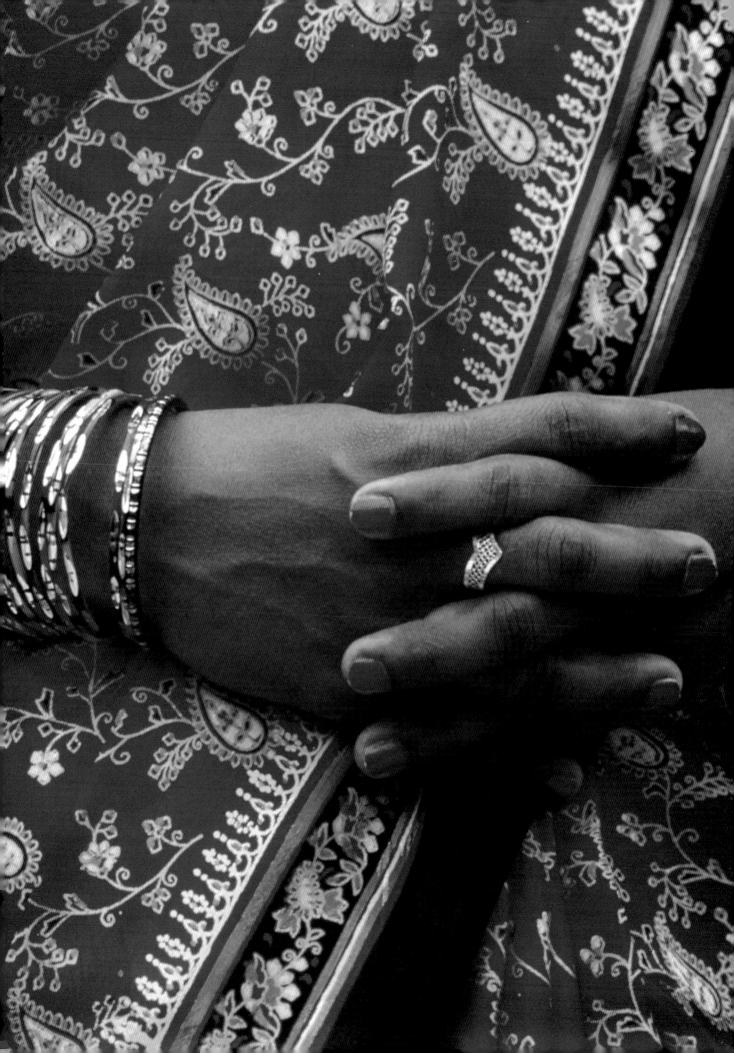

THE FACE

If you were able to see two people engaged in conversation only from the neck down but weren't able to hear them, would you have any idea what they were discussing? You might see some movement in both their hands and legs as the conversation takes place, but you would be limited to guesswork if asked to discern what they were talking about. If, however, you were able to see the many expressions on the people's faces, you would quickly be able to tell whether the discussion was volatile, somber, or fun-filled, even if you still weren't able to hear anything.

Experienced landscape photographers know that if the light or weather isn't quite right at a given moment, they must wait until it is before shooting. They might have to wait minutes, hours, or sometimes even days. In effect, the photographers must wait for the "right" expression to fall upon the landscape, an expression that conveys the mood and emotion they wish to capture on film. Like light and the weather, the face is ever changing. Consider for a moment the interaction between a vegetable vendor and a customer as they haggle over the price of carrots. Within several minutes, expressions of anger, sadness, frustration, disappointment, doubt, indifference, and joy might have revealed themselves on the faces of both people.

Unlike photographing people in the environment, however, shooting their faces—creating portraits if you will—makes many photographers uncomfortable because this type of shooting situation confronts their inability to be intimate. These are, after all, very close encounters with other human beings. Of course, some photographers are drawn to portraits because they enjoy close contact. Experienced portrait-studio photographers know the value of good conversation, through which they can prompt a variety of expressions from, for example, shock to surprise, disappointment to embarrassment, and happiness to joy. Making your subject's face come alive can be a challenge. Startling questions, piercing statements, funny stories, and a photographer who listens all combine to make for great face shots.

The face provides the primary way to determine people's characters. It suggests the subjects' struggles as well as triumphs, and it indicates whether they have a hard or easy life. It is home to the eyes, which are the windows of the soul and reveal whether a person is compassionate, angry, wise, dumb, elated, or depressed. Furthermore, the face not only conveys a multitude of expressions but for many people it also is something to be adorned and "painted." In Western cultures, people decorate their faces in numerous ways; they wear nose rings, lipstick, eyeliner, eyeglasses, and sunglasses, and have mustaches and beards. In India, women mark their foreheads with different colored dots to indicate whether they are single, married, or widowed. Tribes in New Guinea place large discs in their lower lips, and tribes in Africa scar the faces of 12-year-old boys with a hot stick as a rite of passage into manhood. Whether the adornment takes the form of eyeliner, mustaches, or scars, how the face is decorated says a great deal about the person as well as the prevailing customs and culture.

While on assignment in former East Germany, I came upon this woman one morning. She was hard at work, cutting the weeds in a small pasture with her sickle. After parking my car on the side of the road, I walked across the narrow country lane and into her pasture. She immediately stopped working and gave me a look, which I am all too familiar with, that says, "What does he want?" ● Since I speak German, I had no trouble beginning a conversation with her. I explained that I was an American and had obviously traveled a great distance to discuss German unification with people like her. After 15 minutes of small talk about how long she'd lived on the farm and how many days a year she worked clearing the pasture, I asked if she would help me with a magazine story I was doing. ● I also told her that she possessed the German spirit of hard work and independence and that I would be truly grateful if she would simply stand and lean on her sickle while I took several snapshots. The woman seemed genuinely surprised and delighted, as well as a bit embarrassed. When she showed some concern about being photographed in her "dirty clothes," I reminded her that the final image was to be an honest portrayal of who she was and how she lived. She understood and agreed to pose. ● I got my equipment from the car and mounted my camera and 300mm lens on my tripod. With the aperture set at $f/5.6$, I needed a shutter speed of 1/250 sec. for a proper exposure (top). After shooting four frames in rapid succession, I turned my attention to the woman's face. I couldn't help but notice her varied expressions during our earlier conversation, and now I hoped that I would be able to record them on film. ● Starting with a fresh roll of ISO 50, 36-exposure slide film, I switched to my 300mm lens and moved closer to the woman for tighter shots of her face (bottom). The exposure, $f/5.6$ for 1/250 sec., remained the same. As I shot, I deliberately steered the conversation to topics that I hoped would elicit a variety of facial expressions.

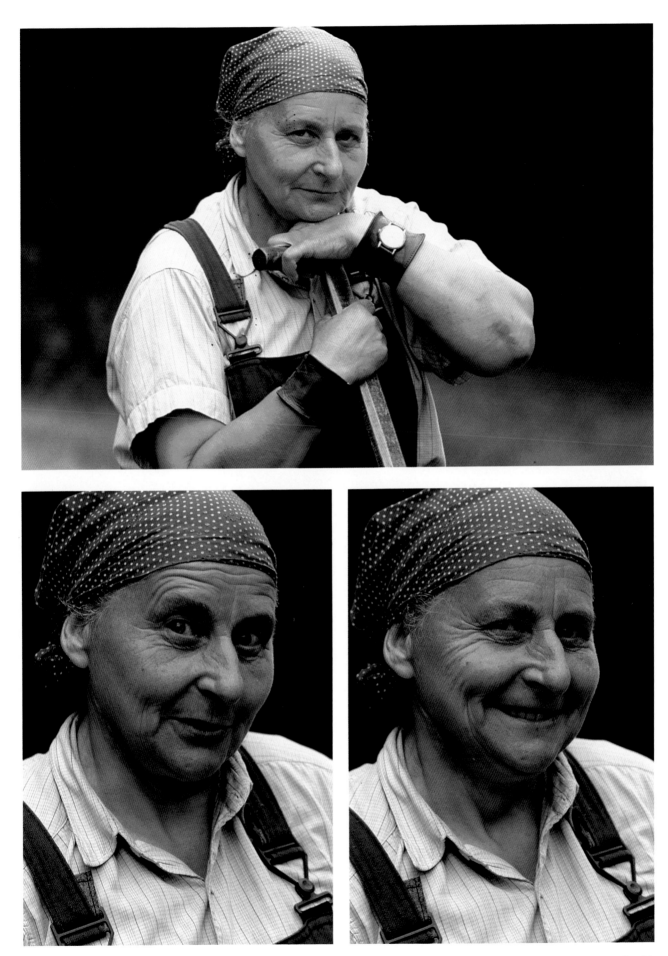

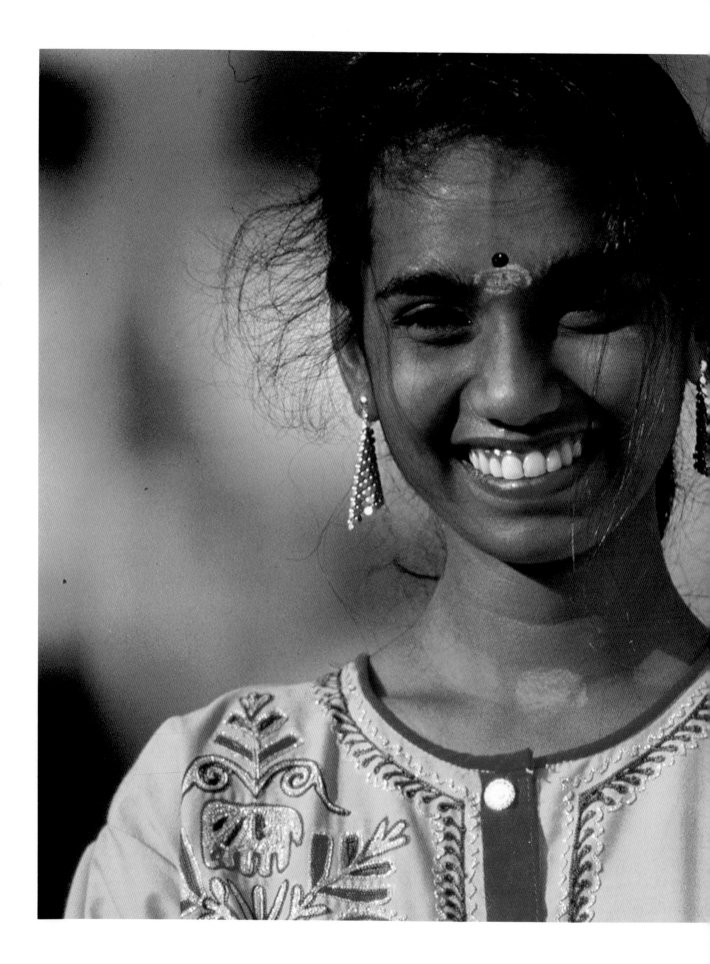

All over the world, facial decorations say a great deal not only about the person but also about the individual's culture and customs. For example, in India women commonly mark their foreheads with a dot whose color indicates their marital status. ● While on assignment, I noticed this woman using a pay phone. Her friendly glance prompted me to approach her when she hung up. I explained that I was shooting a magazine story for a major airline and would be grateful if she would permit me to photograph her wonderful smile and beautiful face. Evidently flattered, the woman gladly gave me more than 20 minutes of her time, during which I asked her to move to various spots until I exhausted all of my ideas. ● With my camera and 300mm lens mounted on my monopod, I set the aperture at $f/5.6$. A shutter speed of 1/500 sec. indicated a correct exposure.

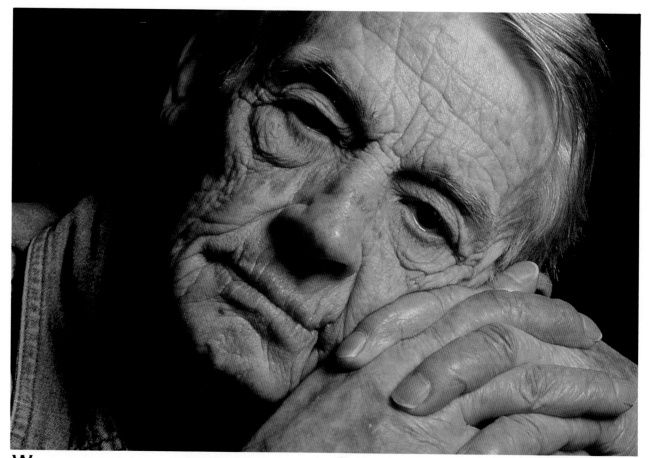

When I arrived at the dentist's office early one morning, I found myself sharing the waiting room with George Rourke, an elderly gentleman who had one of the most tired, weathered, yet wisdom-filled faces I'd ever seen. I didn't hesitate talking to him. A short time later, I made an appointment with him for that same afternoon. ● When George walked into my studio, I couldn't help but notice that he looked even more tired than he did earlier in the day. During the next half hour, he explained that for the past several years he'd been taking care of his wife, who had suffered a rather severe stroke. By his own admission, this was wearing him out. I am always excited to shoot "honest" portraits, and since George thought that this was fair, I decided to photograph him looking tired. ● Using a single strobe head placed inside a soft box to George's right, I was able to call attention to his weariness. With my camera and 80–200mm lens mounted securely on a tripod, I set my aperture at f/11 as indicated by my flash meter. Next, I rechecked that the shutter speed was set to the sync speed of 1/250 sec. and shot this composition at the 200mm focal length of my zoom lens.

One spring several years ago, I was in Holland shooting a corporate brochure for a large Dutch flower grower. Following six days of what turned out to be a grueling assignment, the head of the marketing department suddenly informed me that my services were needed at one of the company's plants in Burjumbura, Burundi. Thus, I had to catch a flight to Africa in less than an hour. The 14-hour plane ride gave me plenty of time to envision all the wildlife I hoped to see, as well as to think about being exposed to a culture that I never knew existed. ● On the third day of this five-day assignment in Burjumbura, I worked in the shipping department, which was outside and resembled a large patio. Overhead cloth protected everyone from the hot midday sun of this equatorial country and kept them cool. While shooting, I noticed a hauntingly beautiful woman whose name was Ijidet. She spoke only French and Swahili, so I was fortunate that other employees were able to communicate my wishes to her. I deliberately chose to photograph her against a dark background in order to call attention to what I felt was her most startling feature, her piercing eyes. ● With my camera and 105mm lens mounted securely on a tripod, I set the aperture at f/5.6. Next, I aimed my camera at the flowers in Ijidet's hands and adjusted the shutter speed until 1/250 sec. indicated a correct exposure. I then recomposed the scene to include her face but was able to shoot only two exposures. Unfortunately, I hadn't bothered to check my film count and didn't realize that so few exposures were left on that roll. Although it took just five minutes to secure another roll and reload my camera, Ijidet wouldn't pose for me again, fearing that I would take her soul. Respecting her religious beliefs and very grateful that I'd gotten off two shots, I moved on to another department.

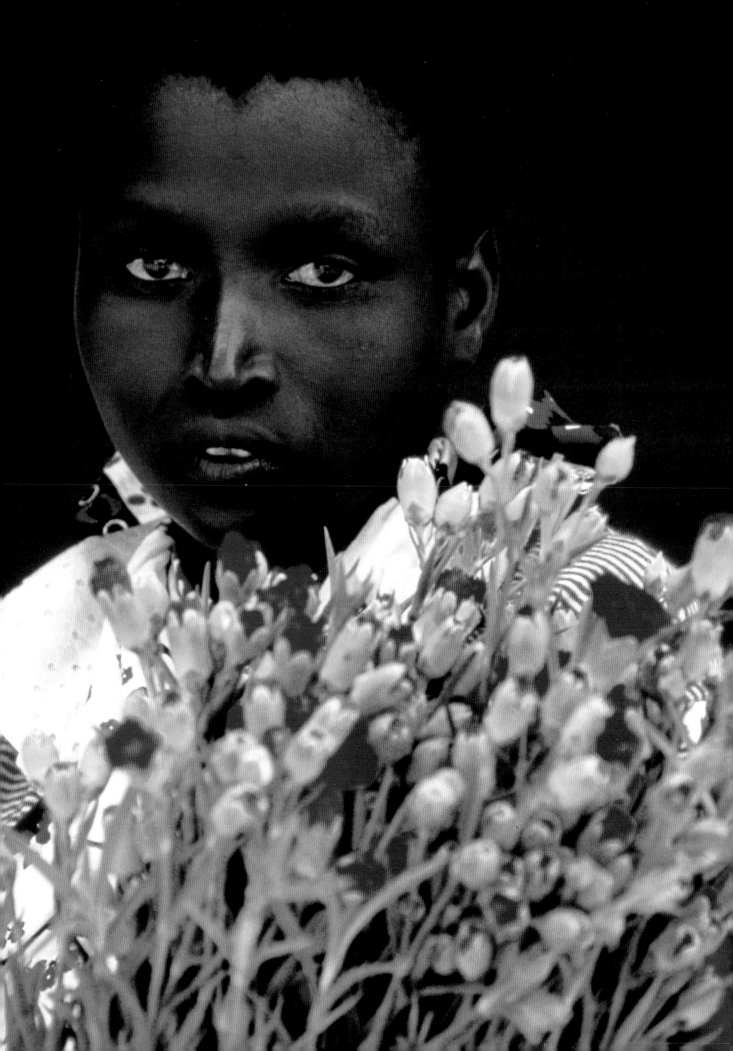

THE HANDS

History records the role of hands in Oriental medicine as a means of diagnosis. Gypsies continue to predict people's futures by reading their palms. And for centuries, the world's religions have elevated the importance of hands by the simple act of folding one's hands in prayer. The role of the hands in everyday life is evident: hands carry, pull, comfort, heal, feed, pray, applaud, drive a car, pick flowers, point guns, and cast fishing poles. Hands can be covered with dirt, grease, cuts, scars, gloves, and jewelry. They can be rough or smooth, and large or small.

Most people are familiar with the saying, "less is more." In terms of the human body, this might be most true when applied to the hands. When a photographic composition is limited to the hands, it opens up the viewers' imagination to an unlimited store of potential faces and occupations that "belong" to these particular hands. The hands are a timeless and tireless subject. Focus your attention on the hands of a potter turning a lump of clay into a vase, a gardener planting seedlings, a minister baptizing an infant, a baker kneading dough, a police officer directing traffic, a grandmother knitting a sweater, or a field worker picking apples. The list of potential hand compositions is virtually endless.

I ordinarily use both available light and vivid colors to creat compelling imagery, and this is particularly true when I photograph hands. For example, if I were photographing the police officer, I would choose a point of view that produced either frontlighting or sidelighting, as well as colorful background. With my 300mm lens set at a wide-open aperture, such as $f/2.8$, I would move in close enough so that only the hand and a bit of shirt cuff will show against an out-of-focus, complementary-color background.

Similarly, if I were photographing the grandmother, I would choose a location where warm sidelight passed through a window and onto the woman's skilled hands. Shooting with my 100mm lens, I would move in close in order to fill the frame with only her hands. As a result, the final image would show in detail the wrinkles and age spots that reveal so much of her character.

A final note: I have yet to meet subject unwilling to have their hands photographed. I believe that this lack of resistance is largely due to the subjects' realization that their faces aren't part of the composition. When I ask people to let me shoot their hands, I often hear, "Go ahead, as long as my face isn't in the picture."

My son and I were enjoying a day at a local park with a friend and her daughter. When I noticed my son taking the girl's hand, I called them over to the picnic table and shot their hands against a background of green grass on a hillside. With my camera and 300mm lens mounted on a tripod, I set the aperture at $f/5.6$ and adjusted the shutter speed until 1/250 sec. indicated a correct exposure. ● I deliberately selected a green background because green suggests a fresh start and new beginnings. Think of how most people respond to green buds on trees and plants during the early days of March. As the saying goes, spring is just around the corner.

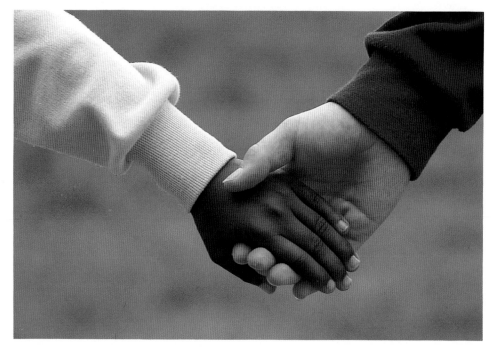

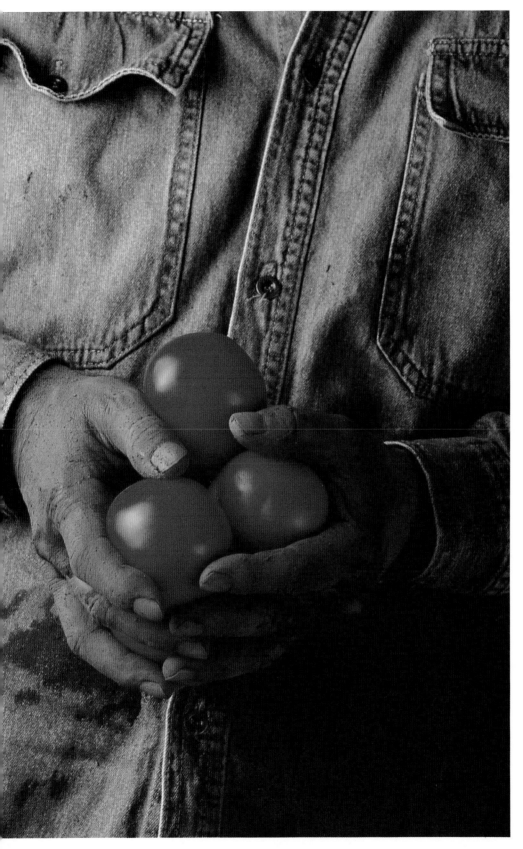

Oregon's Willamette Valley is host to a bounty of agricultural products: cherries, peaches, blueberries, strawberries, apples, walnuts, and numerous vegetables. A few years ago, I was hired to do a cover shot for a brochure that would include a detailed map to many of the roadside stands dotting the area's back roads. ● I chose to stage the photograph in the shade using a variety of fruits and vegetables. Although this image wasn't used for the cover of the brochure, it remains one of my favorites. ● One of my assistants, Dean, graciously agreed to be the model for the shoot. I chose this particular work shirt for its color. After caking the model's shirt and hands with dirt, I carefully placed three tomatoes in them. After positioning a 2 × 3-foot softbox to the model's right in order to create sidelighting for the tomatoes, I took a flash meter reading. Next, I set the aperture as indicated at f/11 and adjusted the shutter speed to the sync speed of 1/250 sec. I then proceeded to shoot variations of this image.

During my first visit to London, I was about to photograph one of the Royal Guards when a security guard asked me to vacate the area in front of Buckingham Palace. My 600mm lens revealed that I was "obviously a professional photographer," and I didn't have the necessary permit. Several days later, I was working near Trafalgar Square when I came upon another Royal Guard standing watch at a building. Before I began shooting, I checked with a bobby to make sure that it would be all right for me to take the guard's picture; I was relieved to hear that this wasn't a problem. ● With my camera and 80–200mm lens mounted securely on a tripod, I composed to show this young man's helmet, face, and sword in profile (right). With my aperture set at $f/8$ and my camera pointed down to include mostly his red jacket, I adjusted the shutter speed until 1/60 sec. indicated a correct exposure. I then recomposed the scene, returning to my original arrangement of the helmet, face, and sword and made several shots. ● When I turned my attention to the guard's hands, I was equally convinced that they, too, would provide another compelling image (below). I switched to my 300mm lens, mounted my camera and lens on a tripod, and moved in a bit closer. For this detail shot, the exposure was $f/4$ for 1/250 sec.

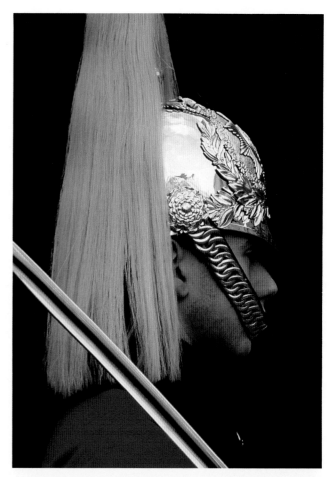

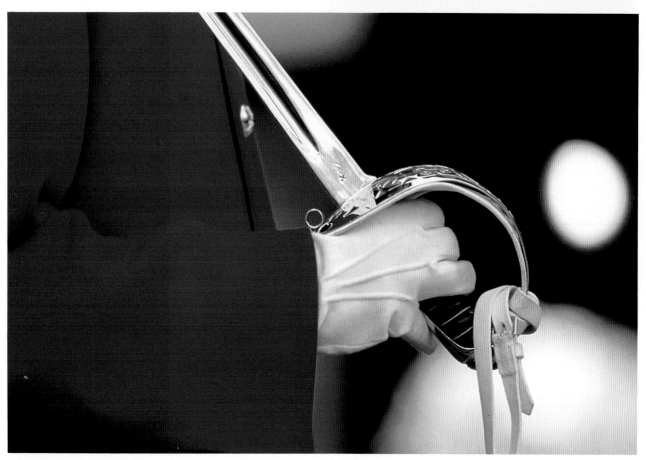

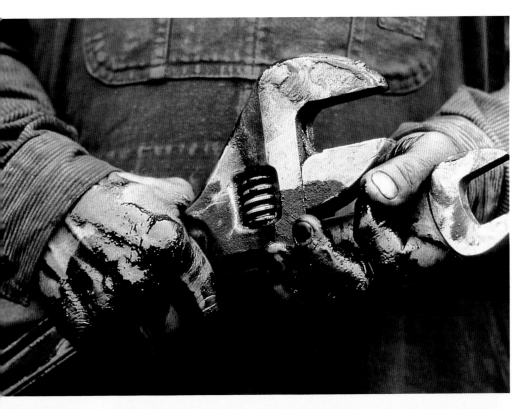

On the third day of a four-day assignment at a steel mill, a maintenance worker began waving his hands excitedly about a photo opportunity that he wanted to share with me. He was tearing down one of the large pieces of machinery and thought that I would want to get some shots of its many parts. Distracted by the worker's greasy hands, I suggested shooting his hands before taking a look at the machine. • I mounted my camera on a tripod, set my 80–200mm zoom lens at its maximum focal length, and chose an aperture of ƒ/8. I then adjusted the shutter speed until 1/125 sec. indicated a correct exposure. It might not be apparent that this individual is a maintenance man at a steel mill, but it is obvious that he isn't a heart surgeon.

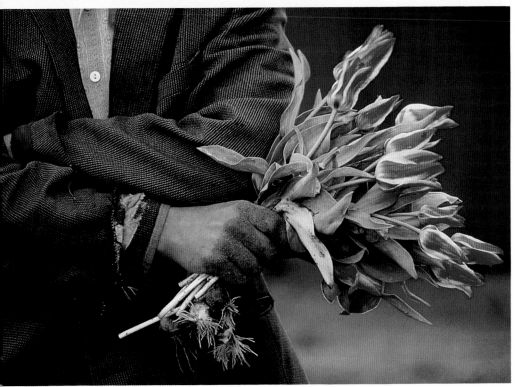

Stooped over with their heads down, a grandfather and grandson patiently walked between row after row of red-and-white tulips. On occasion their keen eyes would prompt them to stop and pull a colorful tulip, bulb and all, out of the sandy soil. When they arrived at the end of each row, the boy was carrying a colorful bouquet. • As the boy finished one row, he was prepared to toss the bouquet onto the waiting burn pile. He explained that the bulbs he and his grandfather had pulled out were diseased. Nevertheless, their colors were so vibrant that I asked him to pose with the flowers before throwing them away. With my camera and 80–200mm lens on a tripod, I zoomed to a focal length of 120mm. I chose an aperture of ƒ/5.6 to limit depth of field and adjusted the shutter speed until 1/125 sec. indicated a correct exposure. The bright diffused light drew more attention to the colors of this beautiful but diseased bouquet of tulips.

APPROACHING YOUR SUBJECTS

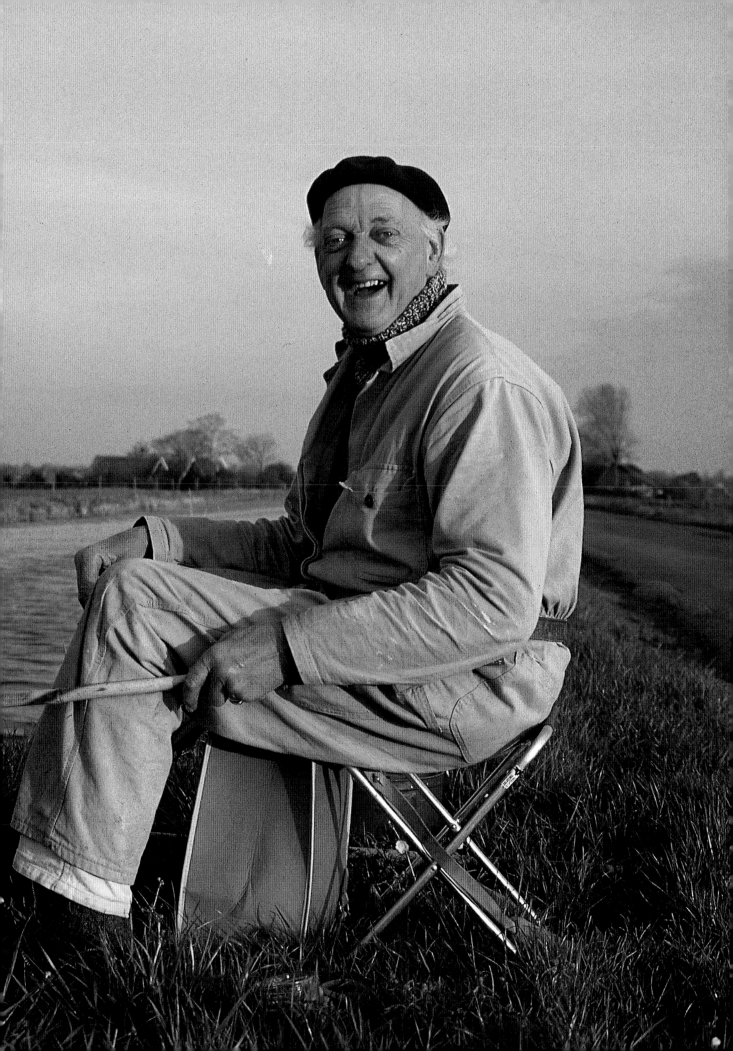

Have you ever sat in an airplane that is headed for a distant place or found yourself seated in a restaurant in a foreign city only to discover that the person sitting next to you or talking loudly nearby is somehow connected to you either personally or professionally? With a bit of surprise in your voice, you might even remark, "What a small world!"

This happened to me while on assignment for a European client. I was in a plane on my way to Hong Kong to shoot the lifestyle of the people who live aboard the junques, which are the unmistakable brown sailing vessels that clutter the harbor. Several hours into the flight, I began making small talk with the gentleman seated across from me. I learned that he was from Hong Kong, had a passion for photography, and had befriended a number of these people while making many business-related trips to the harbor.

I immediately thought of the trust this man had obviously established with these people, and I realized that he clearly had an invaluable edge over me. Because he agreed to show me around without any hesitation, I ate with and slept alongside my subjects, as well as shared in their work—all because I had the good fortune of sitting across from a man who was linked to my subjects' interests as well as mine. In terms of gaining the subjects' trust, the man was able to do far more for me in far less less time than I would have been able to accomplish alone. He was a public-relations genius.

There probably is no better way to meet new people than through a referral. In the workplace, this is called networking. People photographers should practice networking if they hope to succeed. The old saying, "It's not what you know but who you know that counts," certainly applies to people photography. You might be surprised at the number of willing subjects your physician, minister, hairstylist, gas-station attendant, and day-care-center worker can provide. But remember, your sincerity and tone have a big impact on exactly how much these valuable contacts will do for you.

The fear of rejection might be the only reason why many photographers aren't courageous enough to raise the camera to their eye when a great opportunity to photograph people arises. Photographers sometimes anticipate negative responses, with just cause. Throughout the world, the people you wish to photograph—friends as well as strangers—have something to say about your taking their picture, whether they express their opinion verbally or with a rude hand gesture. Even the strongest photographers feel a pang of rejection when someone refuses to be in a picture.

Thus, the way you approach potential subjects is critical. For example, if you have two possible subjects, one who seems to be quite busy and the other who seems to be free to pose, which individual do you think is more likely to respond positively to being photographed? This question might appear to be elementary, but it needs to be asked. Too often I've witnessed photographers approach subjects who don't have time to pose at that particular moment. Not surprisingly, the photographers' requests are turned down.

Several years ago on the fourth day of an assignment in Malaysia, I came upon a very colorful fruit-and-vegetable stand operated by an elderly Chinese man. Up to this point, I'd met absolutely no resistance from anyone I chose to photograph. This man became a memorable exception. I'd become so accustomed to feeling at home in this foreign land that I no longer asked anyone's permission; I simply shot first and asked questions later. His response to my pointing my camera shocked me out of my "comfort zone"; he quickly picked up an orange and pelted me on the head. Needless to say, I wasted no time moving on. As I turned the corner in the busy marketplace, I was still able to hear him ranting and raving in Chinese. I could have easily let this incident shatter my confidence, but within 10 minutes I found myself photographing another vendor who gladly let me take her picture.

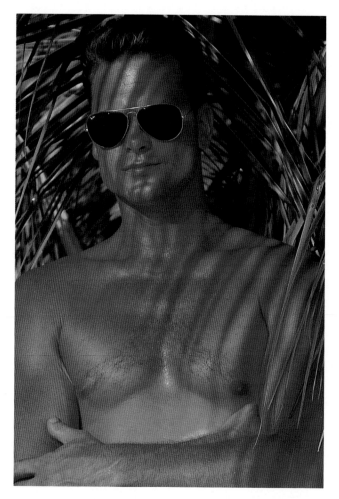

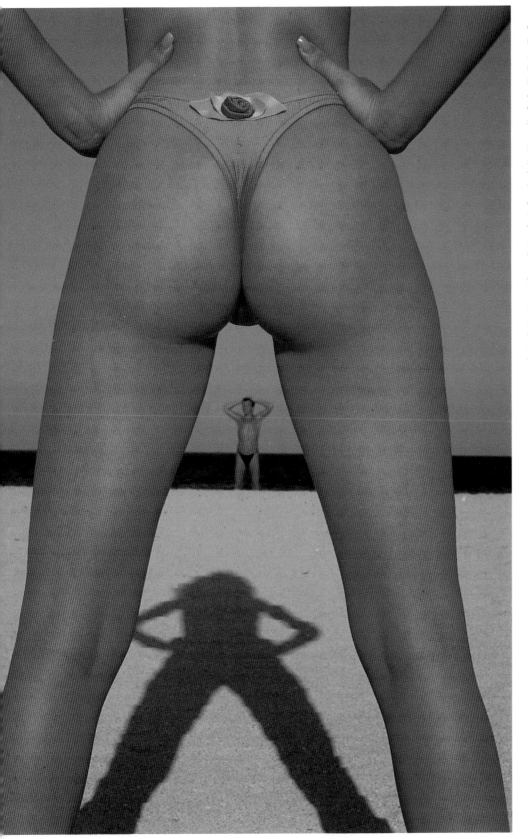

While I was living in Germany, *GLOBO,* a travel magazine co-sponsored by *National Geographic Traveler* magazine, hired me to do several shoots. On one such assignment, I was asked to capture the sexy, fun-in-the-sun spirit of Miami Beach.

● Upon my arrival, I made several inquiries about the hot spots, and everyone told me the name of a local restaurant that always drew quite a crowd. After several hours I had quite a list of willing subjects: four waitresses and their boyfriends, and two customers. Over the course of the next three days, I shot more than 40 rolls of film, capturing these subjects swimming, playing volleyball, roller skating, weightlifting, and dining at the area's many outdoor cafes. ● For one shot, a young man visiting from Fort Lauderdale stood under the partial shade of a palm tree (far left). With my 80–200mm lens set at 100mm, I chose an aperture of *f*/5.6 and simply adjusted the shutter speed until 1/250 sec. indicated a correct exposure for the late-afternoon sunlight.

● When Laura, one of the waitresses, arrived, I came up with the idea of using her legs and the resulting shadow as a frame for the man in the distance (left). I deliberately selected my 35mm wide-angle lens and an aperture of *f*/5.6 in order to limit the focus to her legs and the shadow. I wanted to render the man in the background as an out-of-focus shape to add an element of fantasy to the composition. That was, after all, the theme of the magazine article. I then adjusted the shutter speed until 1/125 sec. indicated a correct exposure for the strong, low-angled frontlight reflecting off Laura's legs.

Undoubtedly people don't want to be photographed for many reasons, but experience has taught me that there are just two main ones. The first reason most people say "no" is that they want to look their best. More often than not, they feel that you couldn't possibly take a good picture of them "at this time," "at this place," "wearing these clothes," and without being able "to freshen up first." Ironically, the reasons people give you for not wanting to be photographed are the very reasons you're attracted to them in the first place. The time (the light is perfect), the place (the environment calls attention to their personality or character), their clothes (the attire "fits" or contrasts starkly with the environment), and their natural appearance (their dirty face or messy hair adds to the visual impact) go a long way toward making them appealing subjects.

My attraction to certain people, however, seldom stems primarily from the surroundings, the colors in the scene, or the light; it comes from the people themselves. They are the exclamation point. If you remove the person or persons from the scene, the image has no content.

People also say "no" because they don't believe a photographer's intent. When you photograph people, nothing plays a more pivotal role in your success than having subjects think that you are sincere; they give little thought to your camera skills. This applies to just about everyone you meet in every part of the world. Trust, like hunger, is a universal need. To help you gain your subjects' trust, simply ask them early in the conversation to tell you about themselves. Most people love to do this, especially when they feel that the person listening is truly interested.

You should also tell potential subjects why you want to photograph them. I can't overstate the importance of answering this question honestly. Don't walk up to a flower vendor and say that you're doing a story for *National Geographic* magazine when you aren't. Don't walk up to a woman on a golf course and say that you are a freelance photographer for *Travel & Leisure* magazine when you aren't. Tell the truth. Explain to the flower vendor that you aspire to shoot an assignment for *National Geographic* someday and that he could be instrumental in your reaching this goal. All he has to do is let you hang around his stand for several hours. Similarly, you can confess to the golfer that you really hope to do freelance work for *Travel & Leisure*, but that you need to show examples of your creativity before the editors will even talk with you.

After you discuss what you can gain from photographing people, they often ask what is in it for them. Offer to give them four or five color prints that they can hang at work or at home. For example, I visit the flower markets on Singlestraat whenever I am in Amsterdam. The sellers' colorful blooms and hectic pace, as well as the customers' expressions as they reach down to touch and smell the flowers, combine for great shots.

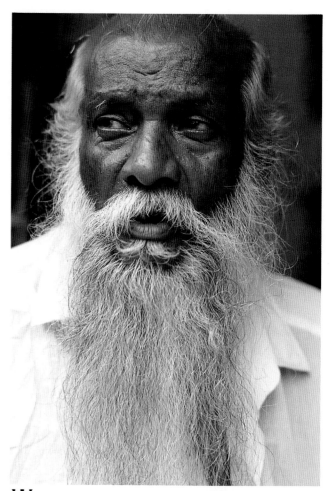

Walking down Singapore's Arab Street with cameras in hand, I saw many "salespeople" hawking brightly colored fabrics, plush handmade rugs, countless leather goods, and handmade baskets. At one shop I discovered the ideal salesperson. He possessed the classic features that most people photographers long to record on film, a weathered face and a long, white beard. When I asked the man for permission to take his picture, he replied, "I thought you'd never ask." Obviously, he was both used to the request and recognized that he did indeed possess some rather unique characteristics. ● Framing him with my 80–200mm zoom lens while he sat on a small stool outside his shop, I sensed that something was missing (above). The right background often adds the necessary impact, but this location didn't provide an additional visual element. As luck would have it, however, another shopkeeper came over with a red hat and suggested that my subject wear it. I immediately agreed and explained to him that it was pivotal to the photograph's success. After I shot a Polaroid so that he could decide if in fact the hat made a difference, he understood its importance. With the hat in place, I fired off several frames. ● With the aperture set at ƒ/8 and the lens set at 135mm, I adjusted the shutter speed until 1/125 sec. indicated a correct exposure (right).

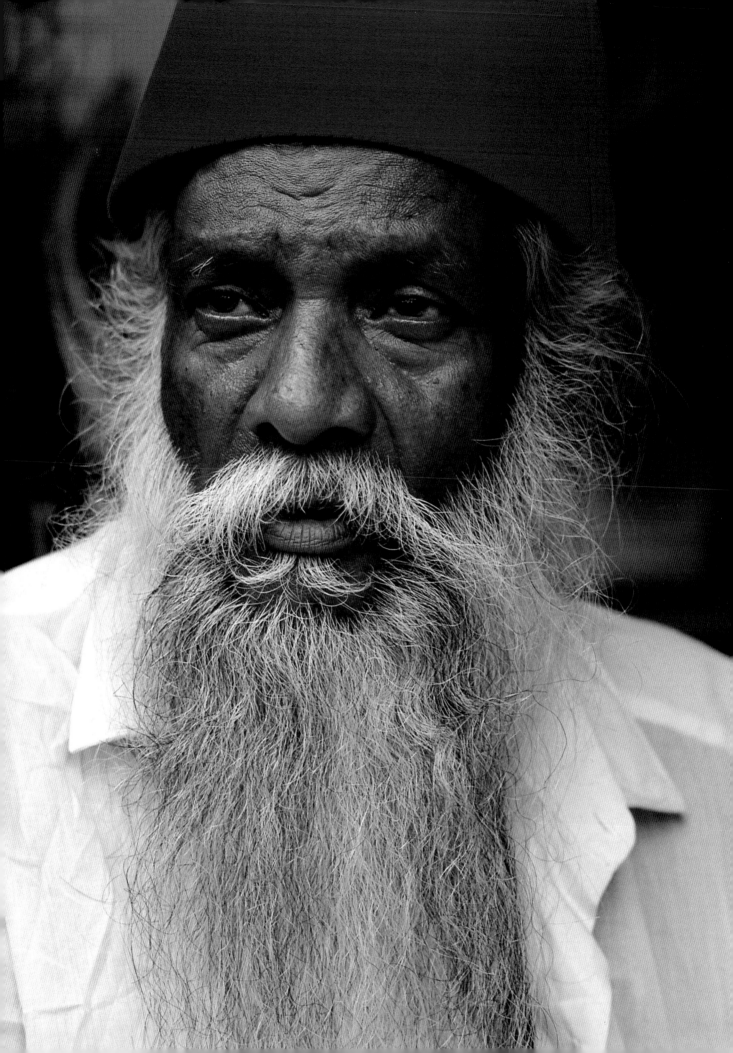

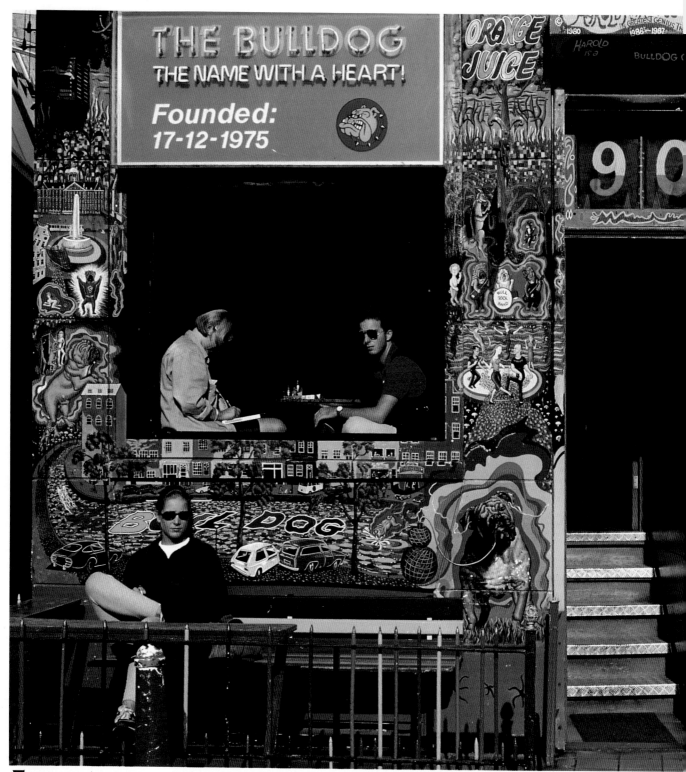

For this assignment for *GLOBO*, a German travel magazine, I was asked to do a story about Amsterdam, including the city's famous, or infamous, red-light district. Because I was a bit apprehensive about working in this area, I decided that the best course of action was to work only during daylight hours and with two very able-bodied assistants: one to watch my front and the other to watch my back. ● When I came upon the well-known Bulldog Restaurant, I realized that it would serve as a great location because of its wild painted exterior. Whether I could get the "right" subjects to pose for me, however, was another matter. Because Amsterdam has a very liberal policy about recreational drug use, I wasn't concerned about finding willing subjects as much as I was about finding subjects who weren't under the influence. After I moved through the crowd inside, I came upon three subjects who had arrived only moments earlier and hadn't "ordered off the menu yet." Two of the people sat inside at a table by the window, and one sat outside the restaurant on a bench. ● With my camera and 50mm lens mounted on my tripod, I chose an aperture of *f*/8 because depth of field was of no real concern. To properly expose for the early-morning frontlighting reflecting off the building, I needed a shutter speed of 1/250 sec.

On one trip, I introduced myself to an elderly vendor with a weathered face. After posing some questions about his flower business, I asked if I could shoot from his stand for several hours and promised not to interfere. He gladly gave me permission and, as I've come to expect, requested several color prints. Before leaving seven hours later, I took his business card, as well as the names and addresses of eight other people who actively participated in some of the compositions. All of the subjects expected—and later received—a few 5 × 7 prints. (Over the years I've met my share of unwilling subjects. But before I'd move on, I'd engage the subject in a conversation to discover why they had such disdain for photographers. Almost always the problem involved an unpleasant experience with another photographer who was arrogant or never sent the promised prints.)

Whenever you approach people, whether your spouse, friends, relatives, or strangers, the level of their cooperation and spontaneity is directly proportional to the sincerity and tone of your intent. This is basic to the whole subject of human relations, yet photographers often overlook it. In their quest for the blue ribbon at the local camera-club contest or even for the Pulitzer Prize, some photographers forget that their subjects have feelings and treat these individuals like robots or puppets. Although the photographers might get an award-winning shot, they prompt a general dislike of photographers in the process.

Always keep in mind that the chief reason for taking a picture isn't to embarrass your subjects or to call attention to a particular flaw or defect in their physical makeup, but to flatter them or to focus attention on their plight. Deliberately shooting unflattering pictures of people can cost you dearly. In the future, these individuals might refuse to let you photograph them no matter what because, in their mind, you made them look bad.

Taking a shot of anyone who protests also creates an enemy of the camera and builds an even greater barrier for the next photographer. Shooting surreptitiously is seldom the right approach either. You aren't treating your subjects fairly, and getting them to sign model releases will be virtually impossible. Although some photographers argue that being sneaky is the only way to get great candids, I strongly disagree. I've shot some of my best candids because I made my presence known to the subject. The real joy in photographing people comes when subjects pose willingly and when all parties involved agree that the final image is an accurate portrayal, whether it is negative or positive.

Finally, I want to stress just how important patience can be. As mentioned earlier, people talk back, and this give and take often results in delays that cost you the shot you want. But this is still no reason for you to rush the next person you come across. Shooting compelling images of people relies so much on your patience that this quality often determines which photographers succeed and which ones don't.

CHOOSING THE RIGHT PEOPLE

A chief advantage that location photographers have over portrait-studio photographers is the opportunity to photograph people in a seemingly infinite variety of environments all over the world. This freedom to choose not only which people to photograph but also when and where translates into greater creativity. (After all, there are only so many backgrounds you can use in a studio.) Perhaps more important, location photographers encounter subjects on their own turf, where, understandably, people are more likely to feel at ease. But all this freedom doesn't guarantee success. In truth, the most compelling subjects often prove to be the most resistant.

Furthermore, experienced location photographers know all too well upon arriving for a photo assignment that one, two, or maybe even all of the people they were hired to photograph don't "fit"; the models don't have the right look for a particular profession. This is when the ability to play casting director comes in handy. You might need to find three subjects who, for example, look convincingly like a judge, a concerned parent, and a psychotherapist. If finding the right people for the shoot is impossible, often the only solution is to shoot a tight, well-composed, and well-lit head-and-shoulders portrait of the subject and allow the corresponding caption to establish the person's job title.

One of the primary considerations of photographing anybody is to make the picture believable. Whether you are on vacation or on a photo assignment or you're shooting stock, your goal should be to return with some hard evidence that you actually photographed the people of Ireland, Singapore, Germany, or Hawaii. For example, a picture of a Caucasian woman selling pineapple at a roadside stand on Maui isn't realistic. But the shot you took of a local Hawaiian man with a tanned face and weathered features, selling bananas and pineapples just a little bit farther down the road, is credible.

Several years ago I was on an assignment for Northwest Airlines, covering quintessential Parisian sights, including bakeries and bakery owners. It took more than seven hours and visits to five bakeries before I found the right subject: a white-haired, 74-year-old man with bright pink cheeks. This was the Paris I wanted to capture. The Vietnamese baker, the Chinese baker, the two young "punk rock" bakers, and the old, gruff female baker just didn't fit my idea of a French baker.

Before you assume I'm prejudiced, let me assure you that I am—but not the way you might be thinking. If I were in Paris to do a story on the enterprising Vietnamese or on enterprising punk rockers, I would have gladly photographed those bakers. My assignment was to "feed" the fantasy that most Americans have about Paris. Thus, the Vietnamese baker wouldn't have fed that illusion any more than the two young adults who looked as if they knew nothing about breadmaking.

Sometimes, however, you may discover that the right person for a picture might actually be the wrong person for the idea or emotion that you're trying to convey. A couple of years ago, a New York advertising agency hired me to spend seven days in Frankfurt, Germany, shooting an American Express campaign. With the recent unification of East and West Germany and the relaxation of the banking and credit-card laws, the company was anxious to launch a campaign that would generate even more members. I was told to use no models, only "real" people with "believable" faces and upscale clothing.

Over the course of the shoot, the art director, my two assistants, and I did some serious people-watching. By the end of each day, we'd found an adequate number of willing subjects whom we successfully paired with an appropriate location. These included museums, outdoor cafes, beer gardens, antique shops, and parks. For example, the art director and I chased after a family of six that was about to board a train at the Frankfurt station. We thought that the parents and children, who were dressed in their Sunday best, would be perfect for the park picture. Luckily, another train was leaving in 45 minutes, so the family was willing to pose.

A few hours later, the art director and I spotted a young, upscale couple walking past the fountain in front of the Opera House. Although they were headed to a nearby pub to meet some friends, they agreed to sit on the bench circling the fountain. A very short time later, I had my shot, and they left with the memory of having their "15 minutes of fame." This assignment proved to be a valuable lesson for me because it served to reconfirm the importance of choosing the right person for the job.

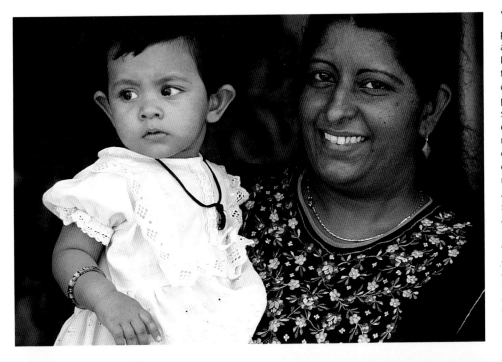

While this woman's business partner was helping a customer at their outdoor-clothing shop, I asked if she would mind my taking a picture of her and her daughter. When she agreed to pose, I had them move outside so that both mother and daughter would be under the much brighter light of the overcast sky. ● With my camera and 80–200mm lens mounted on my monopod, I zoomed the lens to 100mm and set the aperture at ƒ/8. Then I adjusted the shutter speed until 1/125 sec. indicated a correct exposure. Although the woman and her daughter stood against a background of clothing, the exposure time wasn't long enough for it to record on film. This accounts for the somewhat black background.

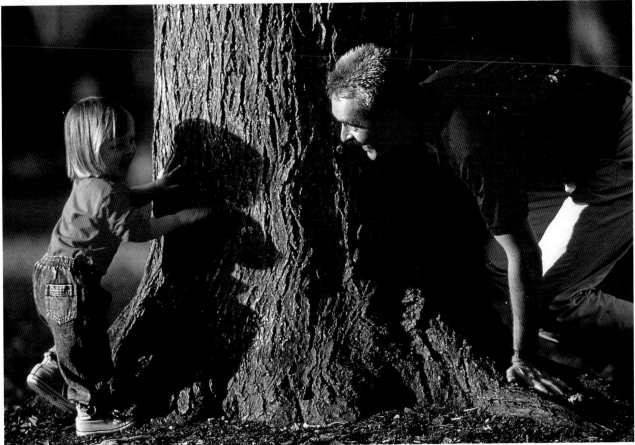

For several minutes, I watched this father playing hide and seek with his daughter. I approached the father and asked if I could take some photographs. He thought that this would be great. So they continued playing, and I started shooting. Several rolls later, I approached the man again and asked him to sign a model release. ● I chose my 300mm lens for this shot so that I wouldn't cross their psychological boundary or intrude upon this intimate moment. Although the aperture I chose, ƒ/5.6, limited the area of sharpness, I was assured that the resulting shutter speed of 1/250 sec. would freeze the hurried action of their play. The low-angled autumn sun provides warmth, and the sidelighting adds a sense of depth.

POSED OR CANDID?

Photographers all over the world frequently debate whether posed or candid portraits are more pleasing. I think that both types of portraits can be appealing when the photographer's primary goal is to depict the subject as accurately as possible. Everyone has been asked to pose for the camera at one time or another, if for no other reason than the annual school portrait. For most people, these shooting sessions are very impersonal experiences, and no one will disagree that these photographs are, in fact, posed portraits. By definition, posing simply means that the subjects move, stand, sit, and/or tilt their head a certain way, most of the time looking into the lens, all at the photographer's request.

"True" candids, on the other hand, are usually described as pictures of people who are free to move at will and express themselves while being photographed. When shooting candids, the photographer doesn't direct the subjects; in fact, they are wholly unaware of the photographer discreetly following and recording their movements. This approach differs greatly from that of the portrait photographer, whose presence is clearly felt.

This definition doesn't sit well with me because I remain convinced that "true" candids can also result when subjects are aware of the camera. Some purists will argue with me on this point, claiming that once you make your presence known, subjects stiffen and you forfeit any opportunity for spontaneity. I agree that some people do freeze up when you point a camera at them, but I believe that most people settle down after a few minutes and go back to whatever they were doing. You can then move about freely and take all the candids you want.

I shot many of the pictures in this book while the subjects were fully aware of my presence, yet I contend that many of them qualify as candids. If only because photography is first and foremost a business for me, I don't have the luxury of shooting "true" candids. I always try to have subjects sign model releases before I photograph them. If I don't have the necessary model releases, I can't lease or sell the rights to a picture for publication, and I probably wouldn't be protected even if my work were limited to gallery exhibitions. Thus, I have no choice but to announce my presence.

In addition to securing model releases when you shoot candids, you need to preset the exposure and, if possible, the focus. This is especially important when you're working the streets. As my earlier experiences painfully prove, I lost many great shots because I was busy fumbling with the aperture or shutter-speed dial while trying to focus and compose. Needless to say, when the subjects "caught" me, they often became self-conscious; some even turned away during these few precious seconds.

Besides teaching me to make my presence known before I started shooting, this problem taught me the value of presetting the exposure. For example, if a subject is bathed in late-afternoon sunlight, I point my camera toward a similar object in the warm light and determine exposure. Losing good shots also prompted me, whenever feasible, to turn the lens' focusing ring so that its distance mark approximated the camera-to-subject distance. (Of course, with the many advances being made in autofocus technology photographers seldom shoot in manual mode, which eliminates the need to preset the focus.)

Posed portraits enable you to plan your shots to a much greater extent than candids do. When experienced photographers deliberately pose a subject, they often use props. The sole reason to include any prop in a portrait is to call attention to the subject's interests, talents, or profession. A prop can be prominent, such as a pet boa constrictor draped around a subject's neck, or it can be part of the background. For example, you might decide to have the proud owner of a restored '65 Ford Mustang stand in front of the car.

Never underestimate the importance of props when you shoot. After all, they can help you reveal something about a subject. Suppose that you notice a smartly dressed, middle-aged man or woman sitting at a table piled high with law books. Would you see a lawyer if the books weren't there? Similarly, imagine that you see a woman wearing jeans, a flannel shirt, and cowboy boots surrounded by a dozen 8-week-old black Labrador puppies. Would you see a breeder of champion dogs if the puppies were removed from the scene?

Beyond this, some props, such as a musical instrument, garden tools, artwork, books, fruits, vegetables, a glass, and a teddy bear, can also solve the problem of what to do with the subjects' hands. And subjects are more likely to feel relaxed when holding familiar objects. Obviously, you should choose appropriate props. For example, don't put a shovel in your subject's hand unless it relates to her, simply to give her something to do with her hands. Similarly, it makes no sense to have your subject hold a clarinet unless it is an extension of him.

Finally, when shooting portraits that benefit from the addition of the prop, keep the background as uncluttered as possible. A "clean" background forces the viewers to pay attention to the subject and the prop. To achieve a simple background, try photographing the subject against a wall or creating a background of out-of-focus tones. The exception to this is, of course, when the prop is the background or is an essential part of the background, such as in the shot of the classic-car owner.

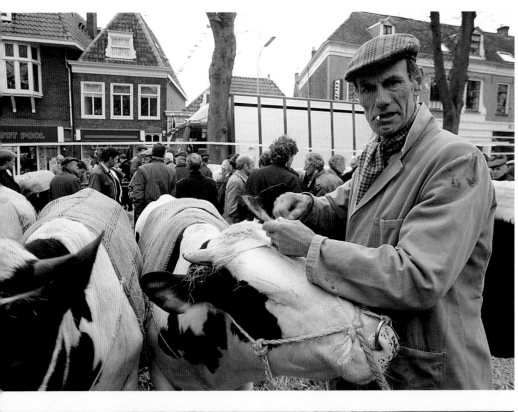

I was awakened one morning in my hotel room in a small town in Belgium by the sounds of cows outside my window. In spite of being quite exhausted when I arrived the night before, I was positive that I hadn't rented a room in a farmhouse. When I got out of bed and looked out my window, I discovered that the ordinarily busy street had been turned into an open cow market. I quickly got dressed and went outside, gear in hand. I didn't have to go far to find subjects because cows were tied to makeshift stalls right in front of the hotel as well as for several blocks down the road.

● Almost as soon as I began shooting candids with my wide-angle lens, I noticed that one farmer was quite annoyed by my presence and made his feelings known (top). I could have been intimidated, but I wasn't. In fact, I decided to switch to my 300mm lens and follow him around. With a smile spreading across my face, I kept focusing on his every move. ● In time, the farmer warmed up and smiled in return. For this candid, I set the aperture at ƒ/5.6 to ensure that the background would remain an out-of-focus tone (bottom). The bright but softly diffused light of the overcast day made determining the right shutter speed easy; everything was equally illuminated. Here, a shutter speed of 1/125 sec. indicated a correct exposure.

While my son and I were traveling along Germany's Romantische Strasse (Romantic Road), he spotted these two women talking in a community vegetable garden just outside the walled medieval town of Dinkelsbuhl. I immediately pulled over, reached for my 80–200mm lens, jumped out of the car, braced my arms across the roof, and shot an entire roll of film of these two women engaged in a lively conversation. • With the lens zoomed to 100mm, I was able to include the walled city as a supporting background element (right). I set an aperture of ƒ/16 to render both the women and background sharp on film. The scene's uniform illumination simplified the process of determining the right shutter speed; the bright overcast sky called for a shutter speed of 1/60 sec. for a correct exposure. • Purists will consider this shot to be a true candid. The women weren't aware of my presence yet, so they expressed themselves freely. • After shooting the roll of film, I strode into the garden and introduced myself. The three of us spoke for a few minutes, and then I asked them to pose for the camera. I left my 80–200mm lens set at 100mm and chose to again include a bit of the town behind them to provide a sense of place (below). Next, I set the aperture at ƒ/5.6 to limit the area of sharpness to the women and adjusted the shutter speed until 1/500 sec. indicated a correct exposure. Obviously, there is a distinct difference between posed and candid shots, but both can be appealing and effective.

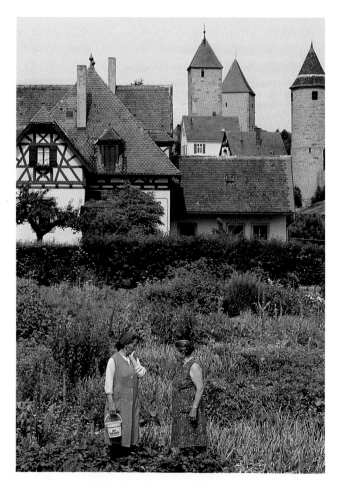

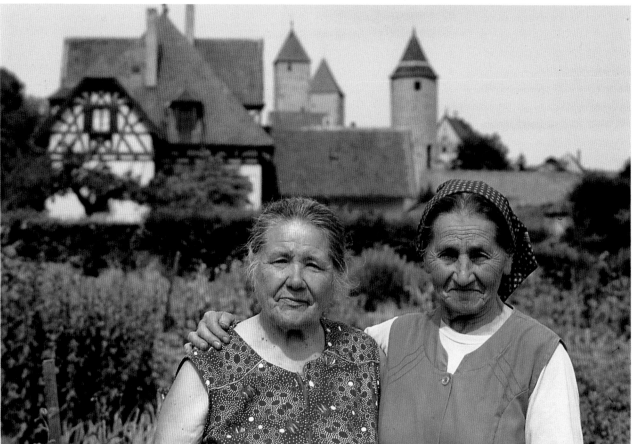

I spent four long days and nights in Germany's North Friesland area, trying in vain to record one of the more famous candy-cane-stripe lighthouses along the coastline. The weather had been anything but favorable; heavy fog prevailed on all but the final morning of my stay. That day, however, I met one of the few inhabitants of this flat, forbidding area. He had many stories to tell, and since I hadn't seen or talked with anyone for three days, I was hungry to listen. ● More often than not, I have to pose, direct, or ask my subject to dress or look a certain way while I'm shooting on location. This man was already dressed to my liking, so all I needed to do was ask him to pose in front of his house. His clothing and his clenched fist, as well as the absence of leaves on the trees, give some indication that although the early-morning frontlighting is bright, the temperature must be quite cold. ● After mounting my camera and 80–200mm zoom lens on a tripod, I chose the shortest focal length. This enabled me to render both the man and his house in focus. I then adjusted the shutter speed until 1/60 sec. indicated a correct exposure.

BREAKING THROUGH THE SHYNESS BARRIER

One of the greatest challenges photographers face is learning to break through the shyness barrier. After talking to my subjects for several minutes, I often ask them a provocative question: "How do you define or see yourself?" Obviously, this question can't be answered with a simple "yes" or "no"; it invites and requires the subjects' participation.

Their responses lead me to ask my subjects another question: "If you could look anyway you want, wear whatever you want, and do anything you want while being photographed, what would I see in the final image?" The purpose of this question is to draw the subjects into the decision-making process about their image. Once you establish a sense of intimacy and gain their trust, most people will tell you some fairly intimate details about their lives. At some point in the conversation, you'll probably learn about a physical flaw that they hate to see on film. For example, people who are concerned about aging don't want to see their wrinkled faces in pictures. Sometimes, however, a flaw was largely the reason why you wanted to photograph a subject in the first place. You might want to capture a weathered face on film because it suggests wisdom to you.

In addition to winning my subjects' trust, one tool that has come in very handy over the years is my Polaroid SX-70. Some of the most resistant subjects agreed to pose after I shot a Polaroid of them because they were able to see immediately what I had in mind. The Polaroid convinced them that they can look good in front of the camera; this concrete evidence and my reassurances were exactly what they needed. At the same time, I stressed how important they were to the image's success. Before long, the potential subjects were cooperative, and I was firing at will. Afterward, I gave several Polaroids to my subjects and promised to send them two or three 5 × 7 color prints.

If you don't have or choose not to carry a Polaroid camera, you might consider shooting a 12-exposure roll of snapshots of your subjects. Explain that you'll come back a few hours later with the prints, and have the film developed at a one-hour lab. When you return, you can clearly convey your intent to your subjects.

This approach works well for me. While driving on country roads in eastern Pennsylvania six years ago, I was taking in the sights: the spectacular fall colors, and the numerous large farmhouses and barns with attached grain silos dotting the rolling countryside. Along the way, I noticed an elderly gentleman sitting on his front porch reading the paper. Realizing immediately that he was the exclamation point in this typical rural landscape, I hoped that he would permit me to photograph him.

I pulled into his driveway, but as I walked toward the front porch, I realized that I'd forgotten my camera. I started to panic since the camera would make my intention readily apparent as well as believable. No sooner did I start to go back to my car to get it than the farmer said, "Let me guess. You're lost, right?" "No," I quickly replied. "Actually, I was just enjoying the day driving around when you caught my attention. You look like someone who could tell a good story or two. And I bet you can tell me things about this area that I could never find in a book."

Three hours, five Polaroids, and four rolls of 36-exposure slide film later, I drove away feeling incredibly nourished, both personally and professionally. Until that day, I'd always made it clear that I was a photographer. I wore a camera around my shoulder, and at times I even carried my gadget bag. But as I drove away from the house, something occurred to me. Without my gear, I didn't give the farmer a chance to cast me in the role of a photographer, whose camera often elicits fear and anxiety. This could have created a barrier between us.

This one experience also prompted me to arrive at most if not all locations "unarmed." I simply survey the surroundings and engage the people in conversation before I get or use my equipment. And although this approach cost me a few compelling shots, more often than not it set me up for the harvest of images that followed. As a photographer, you might want to consider going to some shoots "unarmed" at first.

A final note about breaking through the shyness barrier. Some experienced photographers feel that they should be alone when they photograph other people, without the aid of an assistant. I, along with still other photographers, feel the exact opposite. An assistant can engage the subjects in conversation; keep an eye on their hair, makeup, or clothing; and fix any glaring problems, such as open zippers, unbuttoned blouses, or even a small piece of spinach caught between two teeth. An assistant completely enables the photographer to concentrate on one thing and one thing only: creating great images.

I've shot numerous times both ways, but I prefer to have an assistant with me. And just because you aren't a working professional doesn't mean that you can't enjoy the luxury of having an assistant by your side. Consider asking your partner or a friend help you when you shoot. If this individual likes engaging conversations and meeting new people, put the person to work for you. I believe that you'll see a very noticeable increase in the number of people pictures you shoot, as well as an improvement in them—whether they are pictures of strangers in foreign lands, co-workers, or your own children.

All photographers encounter subjects who immediately stiffen up when they raise the camera to their eye. This little girl fell into that category. Although my assistant, Monique, and I had spent the last 15 minutes engaging the girl and her mother in conversation, my subject succumbed to a bad case of "instantaneous frostbite" as soon as I attempted to photograph her (left). No matter how hard Monique, the girl's mother, and I tried, she seemed unable to relax when I began to shoot. ● I then decided to mount my camera and 50mm lens on a tripod. After setting both the exposure and focus, I sat down beside my equipment, leaving my finger on the shutter-release button. This unconventional shooting position seemed to do the trick. Minute by minute, the girl became less fearful and she was soon interacting with me without being aware that I was taking pictures (below). ● I often find myself using this approach, with both children and adults. It relieves just enough of the subjects' tension so that they can relax and feel comfortable while I shoot. If you've never seen or imagined what you look like when you are behind your camera shooting, ask a friend to take a picture of you from your subjects' point of view. You'll probably discover that you can look a bit impersonal when you stand or sit behind your camera.

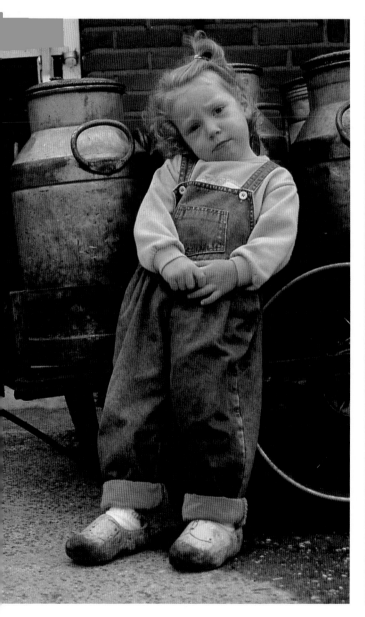

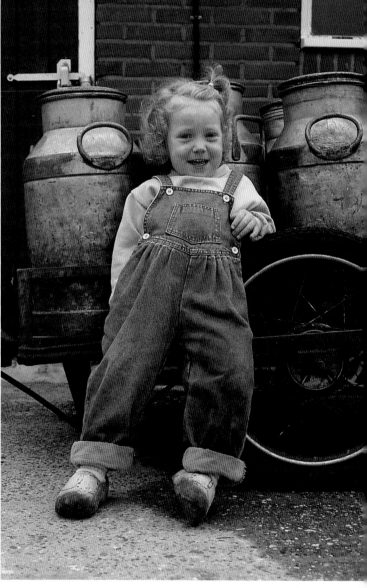

PHOTOGRAPHING PEOPLE IN FOREIGN LANDS

Whether you travel across several continents or just across the county line, the opportunity to meet new and exciting people to photograph is what fuels many photographers. On frequently traveled roads, you'll find many willing subjects who are accustomed to being approached and photographed. This holds true for both the farmer selling pumpkins at a roadside stand in Vermont and the basket vendor hawking wares on Singapore's Arab Street.

In addition, you'll be glad to know that the activity generally taking place on well-traveled roads permits you to go about your business without really being noticed. I learned long ago that when you're shooting on busy streets, it is best to stay within a small area, even up to several hours in some cases. Repeatedly walking up and down a crowded street serves only to call attention to your presence, which is the last thing you want to do. If you stay in one spot for a while, the people nearby will start to ignore you, and you'll be ready to shoot when fresh faces appear. And whether the camera is up to your eye or you're taking a brief break and you have the camera slung over your shoulder, keep a smile on your face at all times. You'll be surprised at the number of people who will come up to you and volunteer to be subjects. Even the most timid people are drawn to individuals who appear to be having a good time.

The downside to shooting on busy streets is that they are seldom the place to be if you want to shoot informal portraits. If you ask the farmer or basket vendor to pose or look a certain way, you'll probably hear that the timing of your request couldn't be any worse. I'm not saying that this is an impossible task, but you should consider another option: the road less traveled.

If you don't feel confident enough to handle shooting on busy streets or prefer to shoot under more controlled conditions, taking the road less traveled is an alternative. Subjects might not be as plentiful, but the opportunity for a more intimate encounter is certainly greater. For example, depending on the season, most country roads display cardboard signs advertising fresh-picked tomatoes, corn, apples, or pumpkins. When you come upon a lone fruit stand, get out of your car unarmed (without your camera), buy some hot cider, and pull up a chair if you know the language well. If you don't, converse in the native tongue as much as you can or try to communicate through hand signals.

Since most of these stands get only one new customer every half hour or so, the operators are usually hungry for conversation. Get to know these people. As you eventually steer the conversation to your interest in photography, you'll soon find two of the most willing subjects you'll ever encounter. They'll gladly stand or sit wherever you ask them to, proud to show off the fruits of their labor.

Before embarking on your journey, make it a point to speak with people at the local tourist office or with the hotel concierge. These individuals can save you a great deal of time and effort by directing you to these back roads. They can also offer you insights into any local customs or greetings that will help you gain your subjects' trust. Even if you don't speak the language, your subjects will often be more cooperative if you understand the customs and formalities.

Of course, it helps to always have a map of the country you're visiting with you throughout your trip. And when traveling in most foreign cities, small or large, I make a point of locating and carrying a map of the city as well. With your map of the area, you are ready for the person you've asked to point you in the right direction.

Because today's airplanes can whisk you to other continents in fewer than seven hours, many people are realizing their dreams of traveling to some distant lands. But getting there might actually prove to be the easiest part of the trip for some people. The problems begin after they arrive at their destination. When you travel abroad, you should always carry your passport with you at all times. I learned this the hard way. After shooting an annual report for a Dutch client in Burjumbura, Burundi, I decided to explore the low-lying hills in the sparse jungle on my day off, hoping to photograph what little wildlife still survived there (see pages 60–61). Walking in a field of tall grass, I pointed my 600mm lens at a shiny object in the distance. Immediately, I was surrounded by Burundian military personnel in camouflage. The shiny object was a 105mm howitzer, and I was shooting in an area where military exercises were being performed. Since I didn't speak Swahili or French and my passport was safe in my hotel-dresser drawer, I couldn't convince the soldiers that I was an American citizen with the proper visa. I was finally released 36 hours later after my client paid a fine of several hundred dollars.

When I walked along the beach at Rostock in former East Germany, I knew within minutes that I would be able to capture a much more exciting image if I could shoot from an elevated position. I went to a nearby hotel and, following several minutes of conversation with the hotel manager, I was given permission to shoot the beach from the balcony of a vacant room on the top floor. ● Once I was on the balcony, I mounted my camera and 80–200mm lens on my tripod and proceeded to shoot three rolls of film, varying the compositions of the patterns on the beach below me. With my aperture set to f/8, I adjusted the shutter speed until 1/250 sec. indicated a correct exposure.

This experience taught me not only to carry my passport with me all the time, but also to learn a little bit of the language of the country I planned to visit. Other than at very large international hotels, English isn't understood the world over. Now I bring along 4 × 6 cards on which I've jotted down the statements and questions that I need most on the road; these are written on separate cards in French, Italian, Spanish, Mandarin Chinese, Cantonese, Japanese, Malaysian, and Russian. The first statement on each of these cards is "I'm sorry, but I know how to speak only English, German, and a little Dutch."

The cards also contain translations of the following common questions:

- Where is your bathroom?
- Where can I find a taxi?
- Where is the train station?
- Do you have any rooms?
- Where is the nearest gas station?
- How much will it cost?
- Where is a telephone?
- Where is an American Express office?
- I am staying at the_____(hotel) located at_____(address). The phone number is _____.
- I am sick and need a doctor.

As you plan and prepare for your trip, also keep in mind that you should never leave the United States without first registering all of your camera equipment with the local Customs office or with Customs at the airport. Ask for the "Certificate of Registration for Personal Effects Taken Abroad." You simply list each of your items and the corresponding serial number on the form. Customs officials then check the serial numbers you wrote down against the equipment you just registered. Assuming that everything matches, they stamp the form with their seal after you've dated and signed it. Until you add another piece of equipment, you'll never need to fill out the form again (unless, of course, you lose it). Don't limit your personal effects to camera equipment, either. If you carry a laptop computer with you, list it and any other expensive items that you travel with.

This Customs form deserves the same respect and care you give your passport. It can save you hours of aggravation. If you lose or have anything stolen abroad or at home, the information on this form enables you to quickly provide the local police with serial numbers.

Clearing Customs brings up a point about film. Whether you buy film or have it processed abroad, the costs you incur aren't subject to the standard 10-percent duty tax. Ask the Customs officials to look up the number HTS/4911.91.15.00 in their *What Is and What Isn't Subject to Duty* handbook. Once they read this section, you'll be free to go.

Finally, while I am on film, I want to share my views about the "dreaded" airport X-ray machines. I've logged

more than 650,000 miles all over the world, and I've never had film ruined by an X-ray machine. Sometimes I put my film in my carry-on luggage, and sometimes I pack it in my checked baggage. I shoot ISO 50 film 95 percent of the time, and according to airport officials, this film is safe from harm. I believe them. Four years ago, 37 rolls of ISO 50 film made their way through seven different airports and X-ray machines without the slightest hint of damage. On the other hand, when I'm carrying rolls of ISO 400 or ISO 1000 film, I place them inside a clear plastic bag and have it out for hand inspection before I go through security. Although many of these machines have a sign posted on them that reads "film safe," they can damage high-speed films, such as ISO 400 and ISO 1000 film.

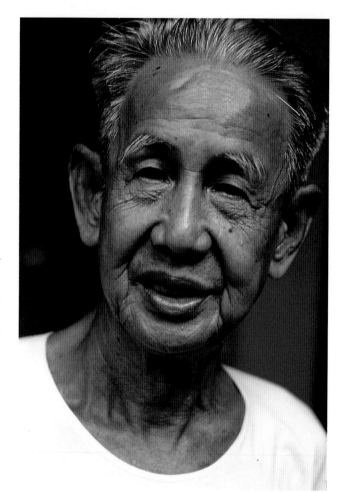

If you want to shoot portraits, either posed or candid, then you should frequent places that are accustomed to high tourist traffic. The area's vendors, shopkeepers, and residents are used to seeing tourists with their cameras and more often than not are willing subjects.
● While I ate breakfast at a busy roadside stand in Singapore's Chinatown, this cook became the focus of my attention, as well as of my camera and 80–200mm lens. While I conversed with the cook, I nonchalantly picked up my camera and began to shoot pictures of him. He was quite amazed that I could eat, talk, and take pictures at the same time. At no point did he protest.

Many amateur and even some professional photographers' portfolios lack compositions that offer unusual and/or fresh points of view. Shooting from a different perspective often breathes new life into worn-out subjects. Additionally, different points of view can create exciting compositions. ● I am a big fan of finding viewpoints that enable me to look down on the world. While visiting the town of Rotenburg, Germany, I made a point to walk the narrow path atop the high stone walls that surround this medieval city. Within a few minutes, my eyes caught sight of this woman bent over in her doorway washing the floor. ● With my camera and 80–200mm lens mounted on a tripod, I chose a focal length of 120mm. This length allowed me to compose the pattern effect of the building, and by placing the woman in the lower right of the frame, I was able to call attention to her since she doesn't fit the pattern. In this way, she becomes the focal point. Because of her stooped-over position, the image seems a bit humorous, too. ● With the aperture set to f/8, I simply adjusted the shutter speed until 1/250 sec. indicated a correct exposure for the light reflecting off the building.

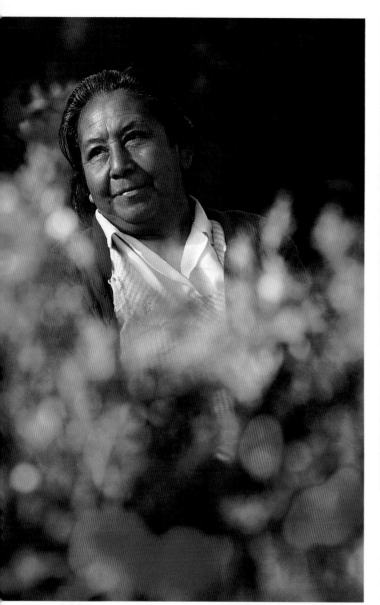

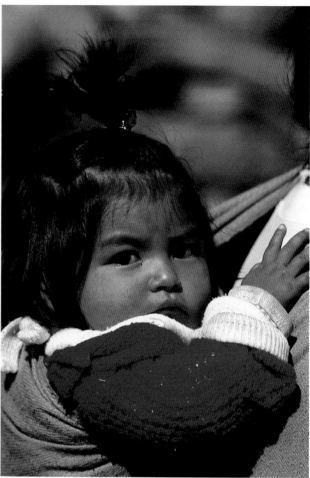

One day, the Xachimillco market was filled with women and small children. As I walked around, I saw a young mother carrying her baby in the traditional Latin American way: wrapped in a blanket and secured to her back. I took advantage of the baby's obvious fascination with the market's hectic pace. Her eyes were wide open, and her head continually darted from side to side and from front to back. Every new sound or color interested her.

● Although the baby's actions sometimes made it difficult to compose and focus, I managed to come away with several good images. I didn't want to distract her, so I used my 300mm lens in order to be able to shoot from a safe distance. With the aperture set at ƒ/8, I adjusted the shutter speed until 1/250 sec. indicated a correct exposure.

This elderly gentleman has been selling chamomile at the Xachimillco market for more than seven years. After each transaction, he grabbed the bundled flowers and handed them over to the waiting customer. As I observed him, I noticed that the bright yellow chamomile provided a great contrast to his weathered skin.

● With my camera and 300mm lens mounted on a monopod, I was able to shoot from a safe distance that wouldn't interfere with the vendor's business but, at the same time, would allow me to fill the frame. I set the aperture at ƒ/8 and then adjusted the shutter speed until 1/250 sec. indicated a correct exposure for the warm frontlight reflecting off my subject's face.

While on assignment in Mexico City, I visited many of the markets in and around the city with Louise, a Spanish-speaking assistant who made my job much easier. The Xachimillco marketplace was the most colorful and inviting, so we went there on two consecutive days to take advantage of the early-morning sunlight flooding the area.

● Despite the warmth of the early-morning sun, the woman working at this flower stand at the market was bundled up. As soon as she noticed me with my camera and large 300mm lens, which I'd mounted on a monopod, we began to play hide-and-seek. She wasn't opposed to being photographed, but she grew

shy when I pointed the camera toward her. ● When you're faced with a situation like this, patience is the key. Within 15 minutes, the vendor became accustomed to my presence. I chose a low viewpoint because I wanted to shoot through the plants and shrubs lining her space. With the aperture set at ƒ/5.6, I knew that the objects in the foreground would record on film as an out-of-focus frame. This, in turn, would palce more emphasis on the woman. As she turned her head to speak with customers or a friend who was nearby, she occasionally looked right at me. After shooting a few rolls of film of this subject, I moved on, assured that I'd taken several wonderful portraits.

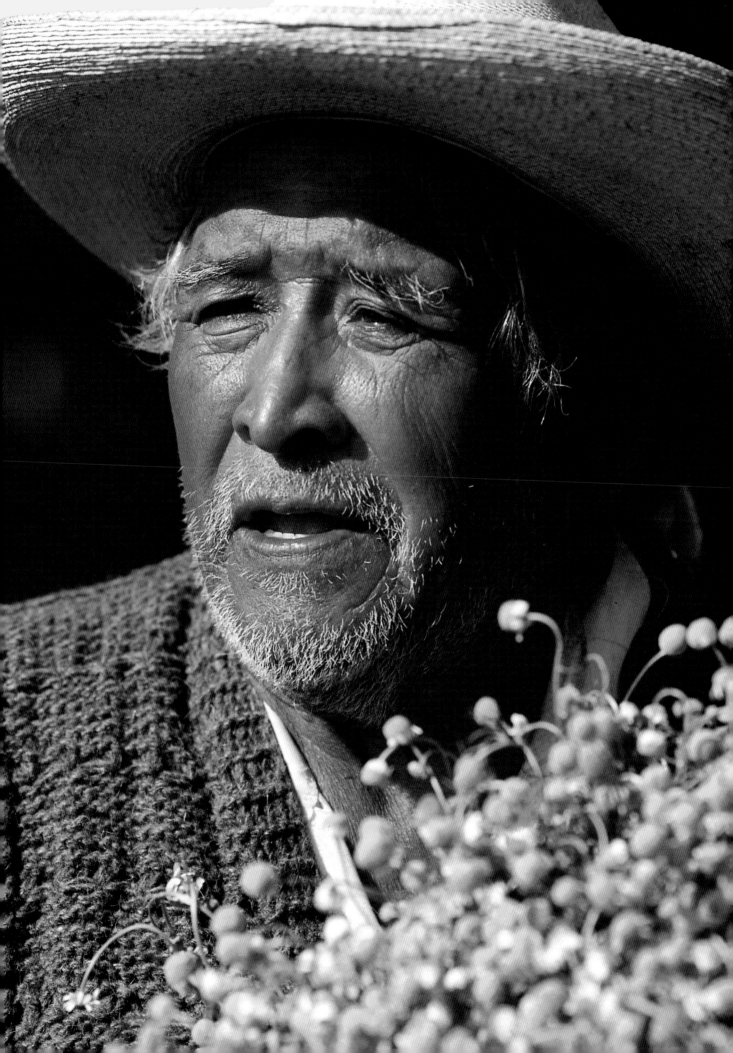

A Dutch flower exporter hired me to do a shoot in Burjumbura, Burundi, in central Africa. When I was told about this assignment initially, I had no idea where Burjumbura was. I soon learned that I was going to the area just below Rwanda, the country made famous by the film, *Gorillas in the Mist.* I looked forward to my arrival because this was my first trip to Africa. ● Although I hoped to see abundant wildlife, I was made aware that besides a colorful bird population, Burundi had little to offer. I was disappointed, but the absence of wildlife enabled me to focus on the task at hand: photographing the people who worked in the flower fields. ● This man's job was to clean out any loose stems or diseased flowers in the rows of carnations for an hour toward the end of each day. Although one hour of work might not seem like much, jobs in Burjumbura are scarce. And like many of the other people in the fields, this man took his job seriously and felt great pride in his work. For this honest portrait, I chose my 100mm lens, an aperture of *f*/5.6, and a shutter speed of 1/60 sec. ● I still feel great sadness whenever I look at this photograph. Several days after I shot it, the man was found dead next to his tipped-over wheelbarrow. I later learned that he'd had a heart attack at the age of 42, an age considered old by Burundian standards.

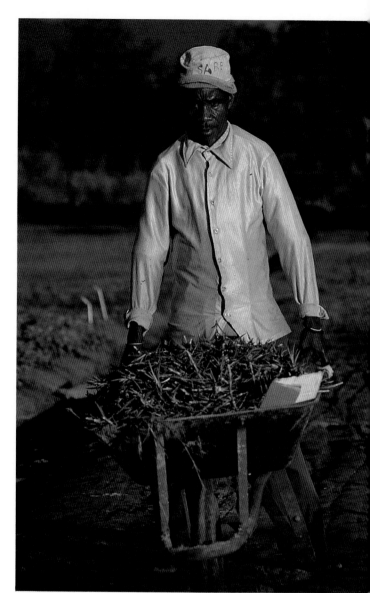

Every day around noon, a torrent of rain fell for about 20 minutes. The usually damp clay soil was transformed into a river of mud that lasted several hours. Although many of the workers chose to toil barefoot, some wore rubber boots after the daily rainstorms. At the end of the day, the workers returned the boots to their resting place, a wall with wooden pegs sticking out. ● I made this photograph of the woman in charge of the boots as the low-angled sun cast her in sidelight. Here, I used my 100mm lens and an aperture of *f*/8. Because of the extreme contrast between the woman's dark skin and the white wall, I used an 18-percent gray card to determine that a shutter speed of 1/30 sec. was required for a correct exposure.

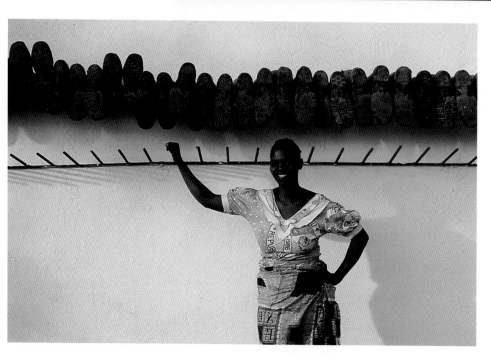

Without fail, the midday temperature out in the flower fields exceeded 100°F. In an attempt to counteract the heat, a group of workers was assigned the task of placing 8-foot tall wooden poles at 10-foot intervals among the rows of carnations. They then draped a piece of shade cloth over the poles, creating a canopy. Once the "roof" was secured, the workers stretched the cloth down the sides of the makeshift structure. ● It was at this moment that I caught sight of a young man straining as he stretched the shade cloth tight. With my camera and 300mm lens mounted on my monopod, I set the aperture at $f/8$ and adjusted the aperture until 1/250 sec. indicated a correct exposure.

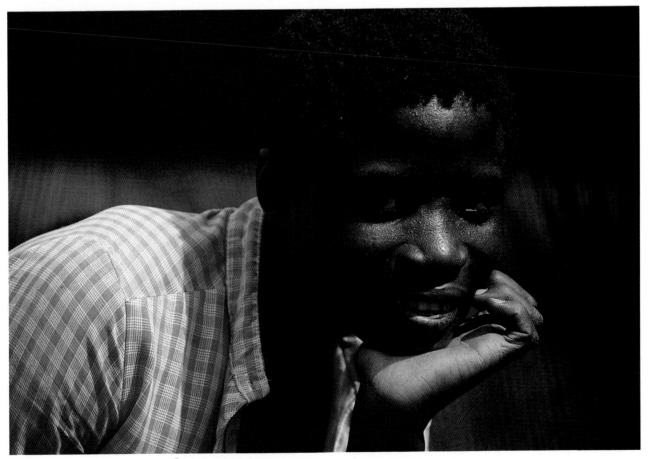

I photographed this young boy on his second day of work. He smiled from ear to ear most of the time because jobs are hard to find in Burjumbura. The French interpreter assisting told me that the boy had managed to escape when his parents were killed during a night raid on his village, and that he was now living with a French missionary family. ● For this portrait, I mounted my camera and 300mm lens on a tripod, set the aperture at $f/4$, and adjusted the shutter speed until 1/500 sec. indicated a correct exposure.

CREATING MOOD WITH LIGHT

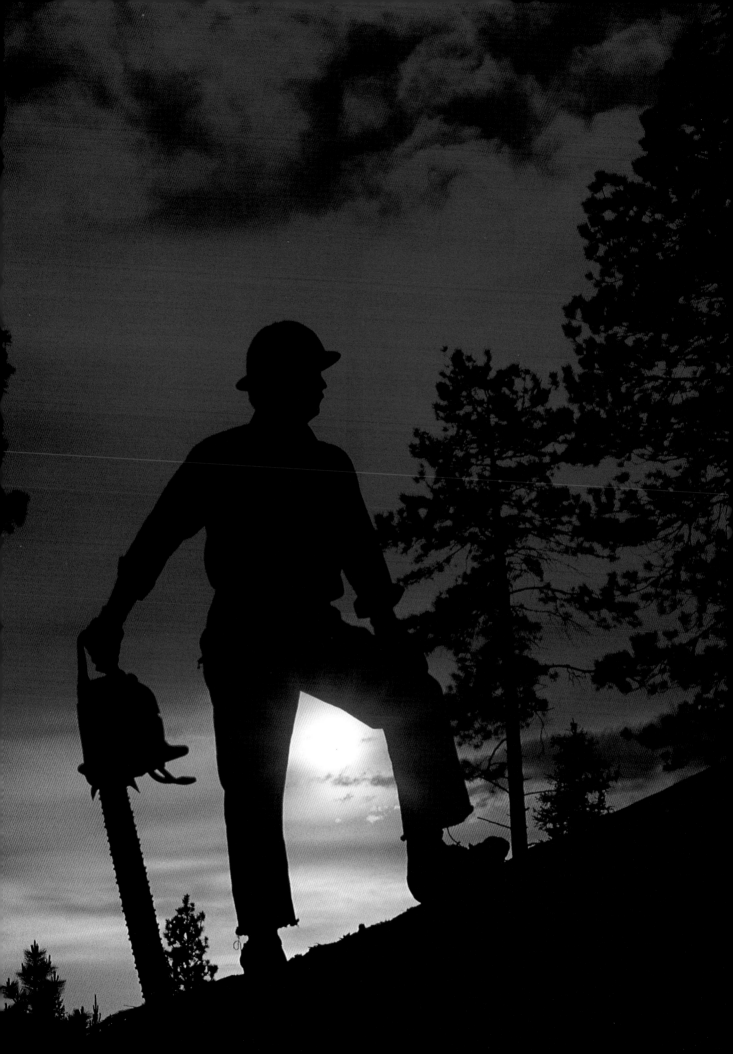

The importance of lighting can never be overstated. Without light, no one would be able to see anything. Theoretically, everyone would be blind. Also, the first light of morning assures people that a new day has begun. For most people, the proverbial light at the end of the tunnel means the end of a sorrowful or difficult period. Light also has a direct effect on people's emotions and can dictate their mood. Almost everyone has had the blues. This common type of depression occurs during the winter months when light levels are at their lowest.

Whether lighting is harsh, gentle, glaring, or diffused, or comes in straight on or from the side, behind, above, or below, it plays the greatest role in determining an image's mood. When you photograph a mean-looking woman under diffused light, you temper her appearance. Similarly, by photographing a meek, softspoken young man under harsh light, you can make him seem a bit cold and aloof. Both subjects would, of course, say, "That isn't me," upon seeing these photographs, and

for good reason. The quality of the lighting and the impression it creates on film directly contrast the way the subjects define themselves.

Another important aspect of light is its direction. To help you remember this, think back to a Halloween long ago when you visited the neighborhood haunted house. As you rounded the corner and headed up the creaky stairs, you suddenly saw someone who appeared quite ugly and frightening for the fraction of a second he held a flashlight under his chin and shined it on his face. The fear you felt was a result of the light and its angle.

People photography involves three kinds of directional light: frontlight, sidelight, and backlight. Dappled light is a modified form of frontlight. Diffused light, which is the light on an overcast day or the light from a softbox in a studio, is nondirectional. This simply means that it is equally distributed in tone throughout the scene. All four types of light take on different colors depending on the time of day, and the color of these lights greatly affects how subjects are defined.

While I was shooting at Mexico City's Xachimillco market, my assistant, Louise, explained that this man was known as the resident comedian. I couldn't understand a word he said, but everyone else within earshot was laughing. He clearly loved all the attention, so I didn't hesitate to shoot freely. ● With the aperture set at $f/8$, I adjusted the shutter speed until 1/250 sec. indicated a correct exposure for the strong sidelight on the man's face. As a result, the area of open shade, which was clearly visible, was severely underexposed and recorded on film as a dark background.

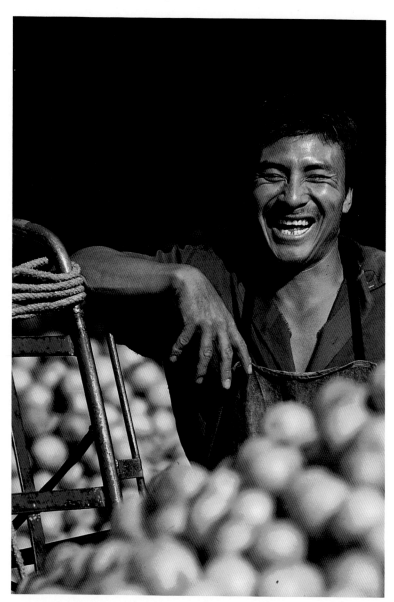

A forging company hired me for a three-day shoot in its foundry; the company wanted to produce a brochure about its services. On the first day of the shoot, I had the good fortune of being in the right place at the right time. The workers were forging some large pieces, and the steam was really kicking up. As the sun came through the large open windows near the top of the building, the light rays were visible. Amazed by this sight, I asked one of the workers to stand at the base of the rays with a fresh piece of forged material. • With my camera and 28–80mm lens secured to my tripod, I set the focal length at 35mm and the aperture at $f/8$. I then adjusted the shutter speed until 1/30 sec. indicated a correct exposure for the low-intensity light reflecting off the worker's clothing. This produced an overexposure of the light rays, but the resulting image is still effective. Had I chosen to expose for the much brighter rays of light, the worker would have been severely underexposed in the final shot.

One of the biggest mistakes amateur photographers make is thinking that silhouettes require a blazing sunrise or sunset sky. Numerous other lighting conditions render exciting silhouetted images. • While on assignment in Mexico City some time ago, I stayed at the Camino Real Hotel, which was yellow and pink. I was fascinated by the hotel's unusual color scheme. When my assistant, Monique, picked me up one morning, my eyes caught sight of the hotel reflecting in her car as I walked toward the trunk. I wasted no time asking Monique and a bellhop to pose for me. • Shooting at the 24mm focal length on my 20–35mm zoom lens, I leaned close to the trunk and set the aperture at $f/16$. Then I simply the adjusted the shutter speed until 1/60 sec. indicated a correct exposure. Since the bright yellow and pink background called for a much shorter exposure time than the subjects in the open shade of the carport, I knew that Monique and the bellhop would be rendered as silhouettes.

What is meant by frontlighting? Imagine, for a moment, that your camera lens is a giant spotlight. Thus, every time you raise the camera to your eye and look at something, the lens is capable of fully illuminating the subject in front of you. Here, the subject would be frontlit. Obviously, this isn't what happens when you shoot. But this is where the sun comes in. For most of your picture-taking efforts, the sun acts like a giant spotlight. Because of frontlighting's ability, for the most part, to evenly illuminate a subject, many experienced photographers consider it to be the easiest kind of illumination to work with.

The term "easiest" here refers to ability of the camera's meter to make the correct exposure. Since the subject is uniformly illuminated, with no excessively bright or unusually dark areas, the final slide or print will show an even exposure. With today's sophisticated automatic cameras and their respective exposure meters, frontlit subjects are now more than ever a very safe route toward foolproof exposures. However, this doesn't mean that frontlight will always flatter your subjects; you must exploit its color or intensity to help shape and define the subject's character and personality.

When experienced photographers speak enthusiastically about frontlight, most often they're referring to its color. The two frontlighting conditions that they favor most are the golden hues of early-morning light that linger for an hour after sunrise, and the orange-golden hues that are visible about an hour and a half before sunset. These colors can add warmth, passion, intensity, and even sentiment to a scene, depending on the age, gender, and clothing (or lack thereof) of the subject.

The first two days of an assignment in Black Lake, Louisiana, found me shooting the usual operations of a gas refinery: aerials, equipment, and plant managers. But on the third morning, two workers were more than eager to pose for me. The early-morning light bathing them made determining exposure easy. ● With my camera and 80–200mm lens mounted securely on a tripod, I zoomed to 135mm and set the aperture at $f/8$. Next, I adjusted the shutter speed until 1/125 sec. indicated a correct exposure.

When Marie arrived at my studio, my studio manager, Michele, and I both commented openly on her chameleon-like appearance. A local modeling agency sent Marie in response to my request to test with some of their models. She'd just arrived from Bozeman, Montana, anxious to put together a portfolio and land some modeling jobs. Over the course of the next few months, I photographed Marie in a number of locations until we had the shots she needed.

● Shooting in a park near my studio late one afternoon, I met Marie at her eye level by lying on my stomach on the grass. From a distance of about 23 feet, I raised my camera and 300mm lens to my eye, supporting them with my arms and elbows. Then I chose an aperture of $f/5.6$ to keep depth of field to a minimum, aimed the camera at Marie's pink pants, and adjusted the shutter speed until 1/500 sec. indicated a correct exposure. I deliberately avoided metering any part of Marie's white blouse because white has a tendency to read too bright, thereby producing an incorrect exposure. When I took a reading off the white blouse just for the record, 1/1000 sec. was indicated as the correct shutter speed. Obviously, that meter reading was incorrect.

DAPPLED LIGHT

This is a less intense type of frontlighting. Although photographers often use this creative and very powerful tool in the studio, they rarely take advantage of it when shooting outside. For example, in the studio a photographer might position a flat, 2 × 3-foot board that resembles Swiss cheese 2 feet in front of the main light. The shapes and sizes of the cutouts in the board disperse the illumination in varying strengths onto the subject. Although the intensities differ slightly, the photographer can move the board until the brightest part of this dappled light draws attention to the key elements of the subject, such as the person's eyes, hands, or smile.

When you're working outside, dappled light is just as readily available, but you have to know where to look. You can, for example, find an unlimited supply of dappled light at most parks. Although shadows may not be as long several hours after sunrise and before sunset, they are still present. Large maple and oak trees cast their shadows across the grass, which is where you'll see a bountiful supply of dappled light. As the bright, somewhat harsh, direct sunlight passes through the big and small spaces among the leaves, the light is transformed into a softer yet still very directional frontlight.

When you think of different types of lighting and their relationship to an image's impact, dappled light has, perhaps, the most striking effect. The more directed the light is on a subject, the more important it seems. And because dappled light is a combination of light and dark tones, the lighter areas on your subject have the greatest visual weight.

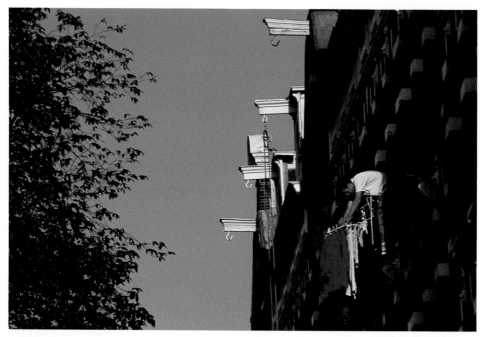

When my assistant, Monique, and I were on an assignment for *GLOBO,* a German travel magazine, she spotted this man hanging out his laundry on a side street in Amsterdam. By the time I pulled into a nearby parking spot, he disappeared, but we agreed that he would probably be back soon since his clothes hanger wasn't filled yet. Sure enough, within a few minutes the man was back on his deck hanging more laundry. ● The dappled light that illuminated the deck provided a marked contrast to the large area of shadow that covered most of the apartment building. After mounting my camera on a tripod and choosing the shortest focal length on my 80–200mm lens, I pointed the camera to the blue sky because its reflectance was equal to that of the light on the deck. With an aperture of *f*/11, I adjusted the shutter speed until 1/125 sec. indicated a correct exposure. If I'd simply aimed the camera at the apartment and then determined exposure, the shadow area would have influenced the light meter. So instead of recording perfectly exposed dappled light and dark surroundings, I would have recorded a perfectly exposed apartment building and a severely overexposed, washed-out highlight. ● After I made this image, Monique had the unenviable job of going to the man's apartment and explaining to him that because his picture might accompany a magazine article, he had to sign a model release. Fortunately, she returned to the car with the signed release within 10 minutes.

While driving through a small village in Holland several years ago, I noticed this Dutch farmer working in his field. As is my custom, I approached him "unarmed," without any camera equipment in hand. Fortunately, the man spoke English, so I had no trouble talking with him. About 15 minutes into our conversation, I expressed my desire to take his photograph. I also promised to leave behind several Polaroids and to return with a 5 × 7 print. ● I was particularly attracted to the barn door because of the dappled light on it. Although it was still midafternoon, the nearby tree filtered the harsh light falling across the tiled roof and painted green door. When I suggested that the man stand inside the doorway, he obliged and without any further direction, he placed one hand by his face and the other on the doorway. ● With my camera and 80–200mm lens mounted securely on a tripod, I zoomed out to 100mm and set the aperture at *f*/8. I then adjusted the shutter speed until 1/60 sec. indicated a correct exposure.

Sidelighting illuminates only half of a subject, leaving the other half cloaked in darkness. The combination of light and shadow creates contrast and makes this type of illumination powerful. Try this little exercise. Take an orange into a dark room, and light it from the side with a flashlight. You'll see an orange that has volume and depth. Also, only one side will be clearly recognizable; the other side will not yet be visible. If you shine the light directly on the orange from the front, you'll see a complete shape.

Sidelighting is by far the most dramatic type of illumination. For example, a sidelit portrait of a three-week-old infant with his or her parents conveys the intimate bond they share. Subjects veiled in sidelight can also suggest deception, privacy, and intrigue. A sidelit portrait of a magician can draw attention to his knowing smile, while the dark shadows in the image remind you that he has secrets.

Both painters and photographers have made sidelighting the nude a classic approach. The interaction of light and shadow reveals and defines form. When photographers choose a specific lens in order to isolate one or several aspects of the human form, they create an arresting abstract. Another classic use of sidelight is the portrait of the criminal. One side of the subject's face is illuminated while the other side is left in shadow. The foreboding image that results can cause viewers to shiver at the unspeakable horrors that might be lurking in the criminal's mind.

Sidelight is also responsible for producing appealing images on film. When experienced photographers want to render the textures of, for example, rough hands or wrinkled faces, they illuminate the subjects from the side. They also know that when they shoot outdoors, sidelighting is most pronounced and effective during the early morning and the late afternoon.

Sidelit exposures offer you a range of exposure options. For example, you might want to overexpose the highlights, thereby showing subtle details in the shadows. In another shooting situation, you might decide to underexpose the highlights so that you can turn shadow areas into seemingly infinite dark spaces in the final image. And in another case, you might want to arrive at some point in the middle. If so, you need to bracket exposures, a technique that I rarely endorse.

Bracketing simply means that after you take an initial meter reading of your subject, you shoot the indicated exposure, as well as four more at the following settings: one full stop over, two full stops over, one full stop under, and two full stops under. You can even shoot a total of eight different exposures. Simply shoot at half-stop rather than full-stop variables.

If you feel that bracketing is just a waste of film, you can try another approach. If you want to record subtle details in the shadow areas of a sidelit scene, take a meter reading of the highlighted portion of your subject and then overexpose by $1\frac{1}{2}$ stops. But if you want the shadows to be pitch black and still want to render the highlights on film, take a meter reading off the highlighted portion of your subject and then underexpose by one stop.

Sidelight created in the studio follows the same principle as sidelight found outdoors. The light source is placed to the left or right of subjects as they face the camera. As a result, light is cast on only one side of the subjects, leaving the other side in shadow. ● This recent shot of my 11-year-old son, Justin, signifies the first time that I feel I've truly captured his uniqueness. About a year earlier, he'd outgrown the little-boy stage, and he is now on the edge of adolescence. It was my fondest wish to take just one picture that would accurately reflect this passage. ● I decided that the sidelight in my studio would enable me to achieve the desired effect. After taking a flash-meter reading, I set the aperture at $f/11$; the sync speed was 1/250 sec. When I got the film back, both of us felt confident that I'd reached my goal.

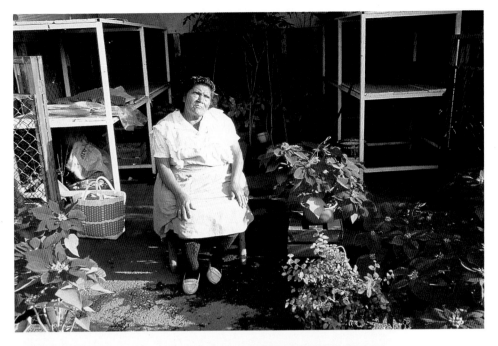

During a recent trip to Mexico City to shoot an advertising campaign for American Express's Corporate Card, I had the good fortune of traveling with Carmen, who spoke fluent Spanish and knew the city quite well. Because I'd expressed interest in photographing some of the local people, my companion suggested visiting one of the larger flower markets. When we arrived at the market in the late afternoon, many potential subjects were bathed in either frontlight or sidelight. I was in heaven. I asked Carmen to explain to this woman that I wanted to take her picture, and within a few minutes I found myself shooting several rolls of this most willing subject (top). ● With my camera and 80–200mm lens mounted on a monopod, I chose an aperture of $f/8$. Next, I filled the frame with the woman sitting in her chair and adjusted the shutter speed until 1/250 sec. indicated a correct exposure (bottom). Because the background shadows actually required a shutter speed of 1/30 sec., they're severely underexposed. As a result, the background serves as a stark contrast to the woman and her pink and white dress. ● When shooting sidelit subjects, you can easily overlook the chance to exploit the contrast between light and dark because you see light and dark simultaneously. Take a look at the photograph of the whole scene, which combines light and shadow. When I exposed for only the light, the shadows didn't record on film. In essence, whatever shadows are present in a sidelit composition, record on film as black. So unless you train your eye to visualize the world of light the way your camera's meter does, you'll walk right past dramatic lighting opportunities time and time again.

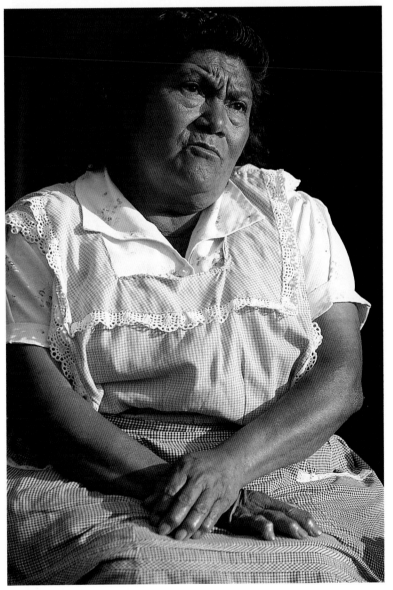

Unlike sidelighting, which conceals the subject in partial darkness, backlighting often cloaks the subject in total darkness. The resulting silhouetted shape is devoid of all details, such as age, eye and skin color, and fashionable or secondhand clothing.

This stripping of a subject's individual characteristics might explain why many experienced photographers prefer not to shoot silhouetted subjects; they think that silhouettes reveal nothing about the subjects themselves. I couldn't disagree more. Although I am the first to admit that a simple head shot silhouetted in profile doesn't offer much unless the individual's nose is prominent, you can define and call attention to the person's

uniqueness by incorporating elements directly related to the subject's activity or character.

Lens choice has the most direct impact on how you determine exposure for silhouettes. If you're shooting with a wide-angle lens against a background that includes the rising or setting sun and your subject is at some distance from the camera, simply frame, aim, expose, and shoot. On the other hand, if you're using a wide-angle lens and the subject fills up a good portion of the frame, take your meter reading off the bright sky without the subject in the frame first. In this situation, it doesn't matter if the sun's light influences the meter reading. Then simply recompose and shoot.

On a memorable day in Frankfurt, Germany, I spent more than two hours shooting this backlit fountain around midday in front of the Frankfurt Opera House. Both are located in a large square that attracts many people on foot and on bicycle. ● I recorded a variety of shapes, and because I wasn't able to see the people's hair color and clothing or to tell how old they were, I found myself making far greater assumptions about them than I otherwise would have. For example, I honestly don't know if this man actually is old, but he looks old. And the man's hat made me wonder if he was an artist. ● With my camera and 80–200mm lens mounted on a tripod, I sat on the steps of the opera house selecting subjects as they strode in front of the fountain. With the aperture set at $f/8$, I adjusted the shutter speed until 1/500 sec. indicated a correct exposure. ● One of the most important keys to composing effective silhouettes is to be aware of which objects in the frame will be silhouetted and to avoid merging them. This image would have failed if I'd pushed the shutter-release button when the man was in a direct line with the fountain's base. Because the base records as a silhouette, the combination of the man and the base would have produced an hourglass figure (the base) with an arm or two sticking out from its sides (the man).

When making a test shot of Robin in my studio, I used a backlight mainly because I'd decided to shoot the composition against a background. Without backlighting, the model's black hair might have merged with the background. For this portrait, I placed two small softboxes in front of Robin, one on her left and one on her right. This lighting configuration evenly illuminated her face. Then I added one more light behind Robin's head, the backlight.

• I used my flash meter to determine the aperture needed, $f/11$. Next, I mounted my camera and 80–200mm lens on a tripod and adjusted the focal length to 100mm. Then I made sure that the shutter speed was set at the correct speed of 1/250 sec. and shot a roll of 36-exposure slide film. • You'll notice that the intensity of the backlight resulted in some areas of overexposure. Robin's hair is obviously black, yet the edges of her hair appear white, and there is a hot white area on her left shoulder. When you backlight a portrait in the studio, these flattering effects occur quite often. With flash photography, the flash-to-subject distance determines exposure. The closer the light is to the subject, the smaller the aperture required. Because I'd set the exposure for the frontlighting produced by the two softboxes placed at a distance of about 4 feet, the backlight, which was only inches from Robin, recorded as a severe overexposure. If I'd set the aperture at $f/64$ for the backlight, I wouldn't have recorded any of her face.

After more than 20 years of making pictures, I have yet to find my level of enthusiasm diminishing when faced with backlighting conditions. In many backlit photographs, subjects are silhouetted shapes that possess an air of mystery and intrigue. ● Several years ago, I visited a friend who owns a dude ranch in Idaho.

I went there simply to make photographs for my own pleasure. ● A few days after I met these three "cowboys" over breakfast, we planned to meet toward the end of the day for a sunset shot. Arriving at the location an hour before the sun went down, we rehearsed this shot several times. Immediately following

the final rays of light, the sky lit up with yellows, oranges, and reds, and the race was on. As the men galloped straight toward me, I stood ready to shoot with my camera and 300mm lens mounted securely on a tripod. I chose an aperture of ƒ/8 and then shifted the camera toward the bright sky above the horizontal cloud.

Next, I adjusted the shutter speed until 1/500 sec. indicated a correct exposure. ● When shooting any action coming toward me, I make it a point to prefocus the camera on a predetermined spot. This enables me to fire off three or four compositions in rapid succession, assured that all of them will be in focus.

When you use a telephoto lens, which has a focal length of 100mm or greater, always take your meter reading off the bright sky to the left, to the right, or above the setting or rising sun. Then set the shutter-speed dial to the next fastest shutter speed, for a one-stop underexposure. Never take a meter reading off the sun directly with a telephoto lens; this leads to severe underexposure. In fact, the silhouetted subject doesn't even show up on film. Furthermore, your eye will need about 15 minutes to recover.

Keep in mind that backlighting doesn't always require the sun's presence. Any background that is three stops brighter than the subject in front of it renders the subject a silhouette. Additionally, in the studio photographers have the luxury of using more than one "sun"; they can use two, three, and sometimes even four lights when photographing a model or shooting a portrait.

You can accomplish this effect outside as well, but you have only one light source to work with, the sun. So you have to figure out how to illuminate the subject's face since the sun is behind the person's head. Experienced professionals and serious amateurs use reflectors. A reflector is nothing more than a white, gold, or silver disc or rectangle made of cloth or paper. When you aim a reflector toward the sun, it reflects light. Thus, as your subjects turn their backs to the sun in order to illuminate their hair, you simply aim the reflector toward the sun. This will reflect light from the sun onto the subject's face.

When you're faced with backlighting conditions, it is important that you take a meter reading of the light reflecting off the person's face or clothing. Don't allow the strong backlight coming through the subject's hair to influence the meter at all. To prevent this from happening, you may have to walk right up to the subject, point your camera at the individual's face, and set the exposure. This method always results in a correct exposure of the subject's face, and the backlit hair records as a very pleasant overexposure element. Don't be concerned if the subject appears out of focus when you do this; simply adjust focus before you shoot.

DIFFUSED LIGHT

Diffused lighting is soft with subtle shadows. This illumination makes faces look kind and enhances the calmness of an image of a sleeping child. Diffused light also casts its silken quality across hands knitting a wool sweater and noticeably minimizes wrinkles and other skin imperfections. And unlike frontlight or sidelight that restricts how you pose your subject, diffused light permits both you and the subject to move at will because it is nondirectional. As a high but thin layer of clouds block the sun, a giant umbrella of diffused light is created. And since it isn't harsh, you don't have to contend with subjects squinting or getting teary eyed.

Nothing is easier than determining exposure when you work in diffused light. Whether you're shooting a study of hands, a face, a whole body, or a subject in a particular environment, every part of the image is uniformly lit. Thus, photographing the scene is a simple matter of "compose, aim, and shoot." There are no bright highlights or dark shadows to confuse the light meter.

Diffused light isn't identical to the illumination that is present when thick rain clouds fill the sky or when bright, sunny days produce areas of shade. If you look up and see the sun, you're shooting under diffused light, even if the sun is almost completely obscured. But if you look up and you have no idea where the sun is, you're shooting under the threat of rain.

Keep in mind that whichever lighting conditions you're shooting in—very cloudy skies or bright, sunny days with shadows—you must be aware that both are contaminated with a great deal of blue light. I once had a student who was feeling a bit anxious about his first "professional" assignment. He'd been hired to shoot a friend's outdoor wedding. When he got the film back, the overall results were pleasing, but he failed miserably when he shot the family portrait. Because he photographed the group portrait around noon on that sunny day, he moved the family members to the north side of the large house in order to shoot in open shade. The final images were far from inviting because their very blue cast suggested coldness and distance, not warmth.

When you photograph anyone in the shadows of a bright, sunny day or under a sky that is threatening rain, the resulting images will record subjects with much bluer clothing and colder skin tones. To minimize these effects, many photographers rely on warming filters. The 81A, 81B, and 81C filters are amber-colored and are designed to correct for excessive blue light. Because blue light varies in intensity, the filters are available in three densities. The weakest of the filters, the 81A, is acceptable for most situations; however, you shouldn't use it when photographing subjects in the very cool shadows of a

sunny day. For this lighting condition, you need the warmest filter, the 81C. But I even find images made with an 81C filter too blue, so I simply avoid shooting in the shade on bright, sunny days. Finally, although the numerous advances in film technology promise to reduce the excessive blue light that is recorded in shade or on cloudy days, I still believe the addition of a warming filter is the safest route when you face this shooting situation.

I was headed back to Paris on a train to meet up with a model who was part of a magazine story I was shooting. I was grateful that the sky was overcast because it permitted me to shoot for the better part of the day without having the slightest concern about the light being too harsh or having to shift my subject in order to avoid shadows. With the magazine's cover in mind, I deliberately framed the model a bit lower in the image to allow for the magazine's title running across the top. One of the biggest advantages of working with models is that they expect photographers to ask them to walk, stand, or turn their head a certain way. ● With my camera and 300mm lens mounted on a monopod, I set the aperture at $f/5.6$ to limit depth of field. I then adjusted the shutter speed until 1/60 sec. indicated a correct exposure.

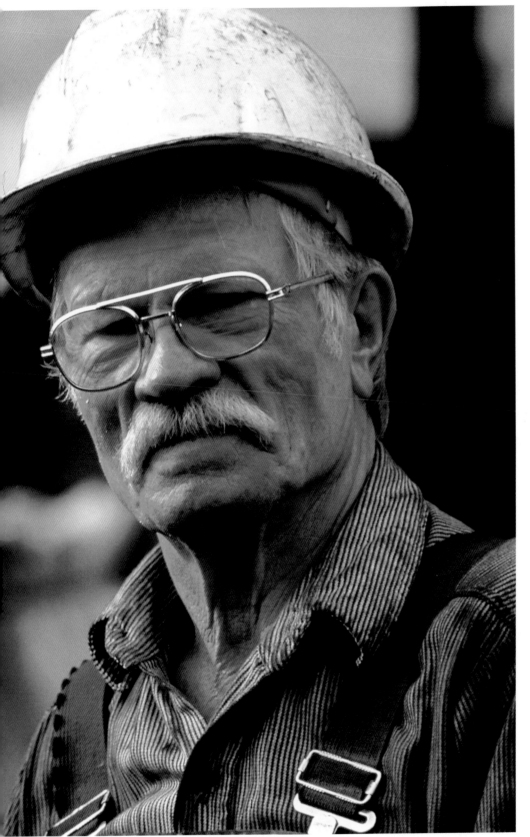

One of the more classic portraits many photographers shoot today is that of the "happy employee" for corporate brochures and annual reports. Posed portraits almost always offer direct eye contact and when successful, are pleasing to viewers. Obviously, a photograph of an employee who looks disgruntled wouldn't bode well in a corporate publication. These shots always require photographers and/or their assistants to become actively involved with the subject in order to elicit the desired warm expression. • While shooting a corporate brochure for a steel mill, I had the opportunity to photograph more than a dozen employees. Although only seven shots were needed for the brochure, I knew from experience that not every employee would appear happy on film because not all workers are pleased with their jobs. • With my camera and 80–200mm lens mounted on a tripod, I set the aperture to ƒ/5.6 to limit depth of field. I then adjusted the shutter speed until 1/250 sec. indicated a correct exposure for the diffused light reflecting off this employee's wisdom-filled, weathered face.

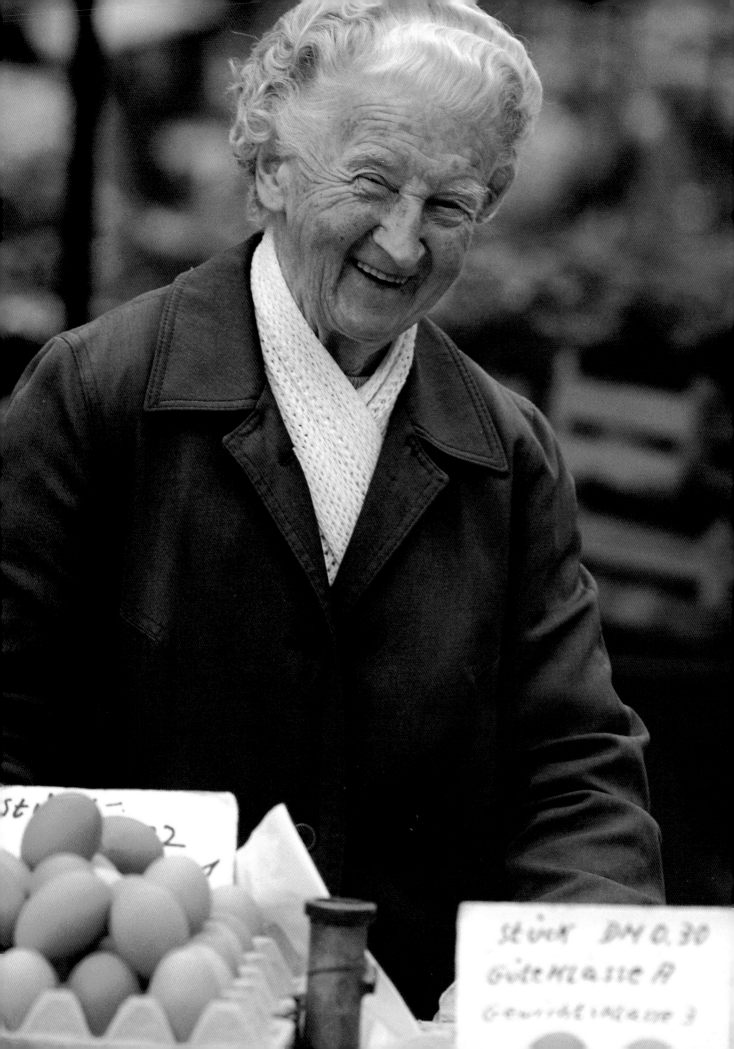

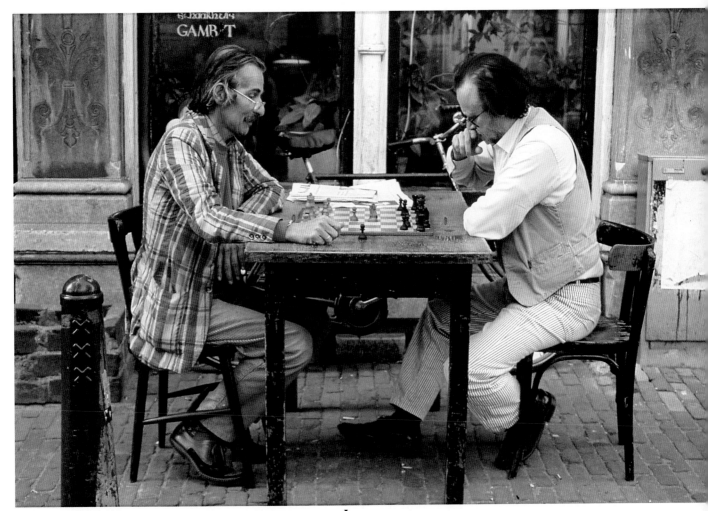

In many workshops over the years, I've often advised beginning photographers to shoot only on days of bright overcast, and only compositions that don't include the sky. This diffused light renders evenly illuminates most subjects, thereby making exposures incredibly easy. ● This French woman eagerly posed for me following several minutes of conversation. And it wasn't long before she piqued the interest of other vendors nearby, many anxious to be photographed. With all of these wonderful shooting opportunities, I was reluctant to leave. Regrettably, though, I had a train to catch. I did, however, manage to shoot six portraits that captured her youth, thanks in large measure to the diffused light. In comparison to sidelighting, which often showcases every pore and wrinkle on a subject's face, diffused light is much softer and noticeably kinder. ● With my camera and 80–200mm lens mounted on a monopod, I set the aperture to $f/5.6$ to limit the background to out-of-focus tones. Then I adjusted the shutter speed until 1/125 sec. indicated a correct exposure.

I am not completely sure who fooled who, but I believe that these two chess players were so intent on their game that they didn't notice me at all when I made this picture in Amsterdam. Half an hour later, after I'd finished a cup of coffee at a nearby outdoor cafe, I approached the men when I saw that their game was over. When I told them I'd taken their picture, they seemed astonished. But a friend said they did know that I'd photographed them as they played. ● In any event, the light of this overcast day made the exposure simple. With my 28–80mm zoom lens and an aperture of $f/8$, I adjusted the shutter speed until 1/60 sec. indicated a correct exposure. I shot an entire roll of 36-exposure slide film in about 15 minutes, patiently waiting between shots in order to record the gestures that both men often made before moving a chess piece.

COMPOSING
POWERFUL
PORTRAITS

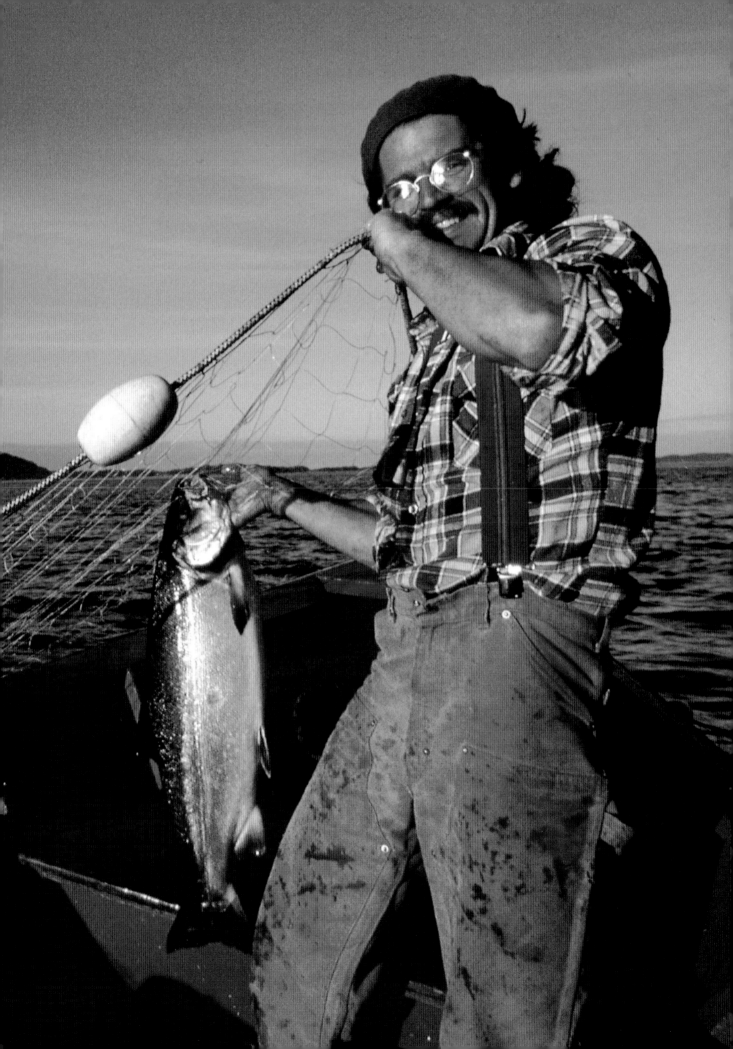

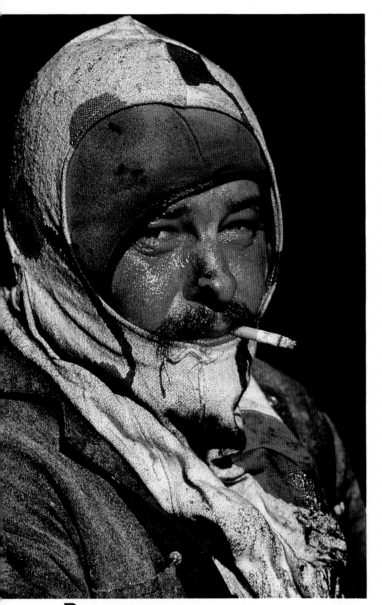

Photographic composition is based, in part, on order and structure. Every great image owes much of its success to the way it is composed, which is, in essence, the way its elements are arranged. As with any good story, song, or even salad, several variables are involved in the process of putting together a compelling composition. You can make the subject appear small and distant against the drama that might be unfolding in a panoramic landscape. You can also decide to fill the frame, edge to edge and top to bottom, with only the crowd at a football game, cropping out the players on the field below. You can compose to include a background that calls attention to the subject or, alternatively, a background that serves as a shocking contrast to the subject standing in front of it. You can also choose to emphasize a subject's weathered and worried face by moving in close, or you can step back just a bit to include the hands and face of the obstetrician whose skills and talent have brought so many "subjects" into the world.

In addition to these choices, you can utilize two specific characteristics that dominate every successful composition: tension and balance. Tension, which is the interaction among the picture's elements, affects the viewers' emotions. Balance organizes these visual elements and keeps viewers from tripping over the photograph's very obvious meaning.

As you compose, you'll also discover that finding the best spot for your subject isn't always easy. This is particularly true when you photograph subjects whose environments are supposed to call attention to their characters or professions. Here, you must be careful not to include extraneous material in the frame that detracts from the subject. For example, your '57 Chevy sitting on blocks in the driveway 30 feet behind your daughter has nothing to do with her splashing in her pool, so make sure that the car isn't visible in the frame.

Over the years many of my students have remarked on how "criminal" it is that the manufacturers of 35mm cameras offer such a "ridiculously small viewfinder" that continually challenges them to see everything going on in their compositions. Training your eye to see the world through the viewfinder of a 35mm camera is an important step toward cleaning up your compositions. To help my workshop students improve their technique, I have them do the following exercise. You should try it.

First, pull out one of your "bad" slides or negatives, and center it on a piece of 8 × 10 black poster board. If you use a slide, remove it from the mount. Then take a pencil, and draw an outline of the negative or slide on the board. With an X-acto knife or single-edge razor, make a cutout of the area you've just outlined. Now, with the board raised in front of you, begin walking around your house or yard, making certain to look only through the small window cutout. The distance from your eyes to the board determines which lens the board is simulating. At about 1 inch away from your eye, the

During a shoot at a ship-repair yard in Portland, Oregon, I was photographing a welder when Monique, my assistant, hurried over to tell me about a painter who had just taken off his mask and was having a cigarette during a break. Monique's breathless tone made it clear that I had to stop what I was doing and follow her to the location. As we came around the bow of the ship, I caught sight of the man and could easily understand why my assistant was so excited. The painter's face was covered with perspiration, and his clothes were stained with paint. I wasted no time photographing the painter. Fortunately, my camera and 80–200mm lens were already mounted on a tripod. ● My luck continued: he was fully frontlit by the low-angled sun as he stood against the ship's freshly painted black bow. I set the aperture at ƒ/8 and simply adjusted the shutter speed until 1/125 sec. indicated a correct exposure for the light reflecting off the man's clothing and face. The resulting black background created the desired contrast in the image.

view is similar to that of a 50mm standard lens; at 18 inches, it is closer to that of a 300mm telephoto lens. When you place the window cutout 1 or 2 inches from your subject's face, the view is similar to that of a macro-zoom lens.

Suppose you look at your son working on his computer through the cutout. If you want to shoot a simple portrait of him and his computer, move around until you see what you feel is your desired composition in the viewfinder. Now take one more careful look. What do you see behind him, in front of him, and to the left and right of him? Your son's unmade bed, dirty

socks, and rock-band poster on the wall behind him are both extraneous and distracting. By moving in a bit closer, shifting to the left or right, or getting down on your knees and looking up, you can eliminate the parts of the scene that have nothing to do with your son and his computer.

If you do this visual exercise for 15 minutes a day for the next several weeks and then once or twice a month for the next six months, you'll find your compositional skills increasing tenfold. You'll be training your eye to see the world through a very small window that approximates what you see through your camera's viewfinder.

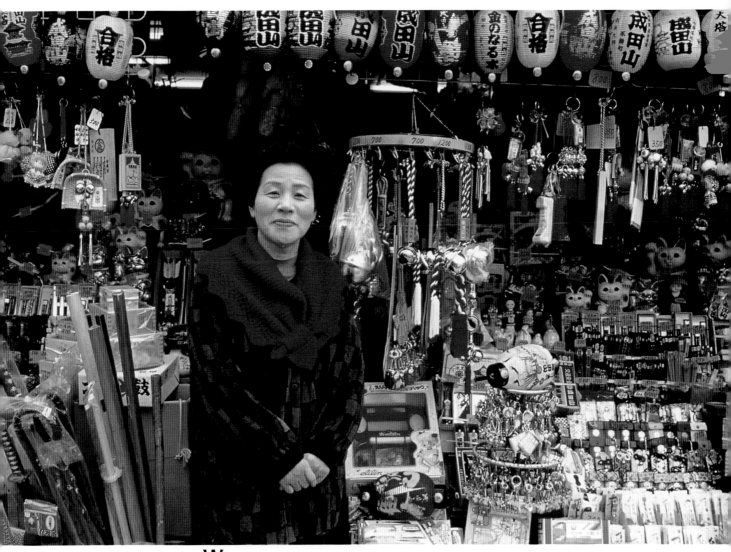

While in Tokyo, I made this photograph of a woman who was selling just about everything imaginable at an outdoor market. I could have used a 200mm or 300mm lens and caused the background to record as out-of-focus colors, but I wanted to show her and her wares in focus. So I decided to use my 50mm lens and an aperture of ƒ/16. I also composed carefully, deliberately choosing a point of view that placed her head against a background of open space rather than against the colorful products she sells. ● The bright overcast light made the exposure easy since everything in the image was equal in exposure value. I simply adjusted the shutter speed until 1/30 sec. indicated a correct exposure.

Experienced photographers use primarily two lenses when photographing people: the telephoto lens (the more obvious choice) and the wide-angle lens. The telephoto lens is popular for several reasons. Most important, it frees photographers from having to work with camera-to-subject distances that might make them uncomfortable. This benefits their subjects as well because everyone, to greater and lesser degrees, has a psychological boundary. Although this isn't clearly marked the way a parking space is, it does exist. You can quickly find out where a subject's boundary is by attempting to shoot an extreme closeup of the person's eyes. Chances are you won't get very far, especially if the individual is a complete stranger.

The telephoto lens is also popular because it renders subjects in correct proportions. When you use either a 50mm standard lens or a 35mm wide-angle lens and want to fill the same area in the frame that a telephoto lens does, you usually end up distorting the subject. For example, if you shoot a head-and-shoulders composition with a 35mm or 50mm lens, the subject's nose or chin might appear larger than it actually is. Shooting the same composition with a telephoto lens, on the other hand, would create the illusion that the eyes, ears, chin, nose, and shoulders are all the same distance from the camera.

Although there is no set rule about which telephoto length is best, many seasoned professionals swear by the 100mm. Its small size makes handholding the camera easy, which is a pivotal factor for photographers as they move about a busy street photographing vendors selling their wares. But many amateurs and some professionals use the 70–210mm, 80–200mm, and 60–300mm telephoto zoom lenses almost exclusively for their people work. These lenses are able to zoom in and out, so cropping is relatively simple. And in some situations, this lens feature frees photographers from having to walk closer to or move back from the subject.

I, however, am quite fond of my 300mm F2.8 telephoto lens. In addition to the very limited depth of field it offers, especially when used at or very near full aperture, it allows me a greater working distance from my subject than shorter telephoto lenses do. The resulting

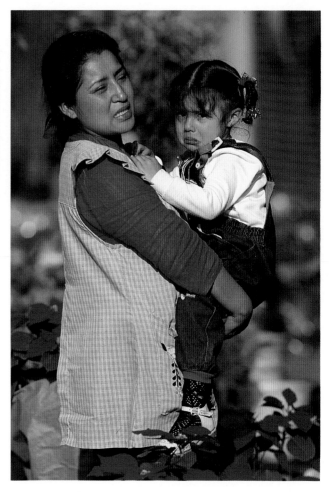

As this mother had a conversation with another person, I noticed that the child in her arms was cranky (above). In fact, the little girl was crying and often buried her head in her mother's right shoulder. But she surfaced occasionally with her lower lip stuck out. So with my camera and 300mm lens on a monopod, I patiently waited for the child to turn in the direction of the camera. Although she glanced over at me more than a dozen times, only once did she look at me long enough in order for me to shoot several frames (right). ● My 300mm lens narrowed the angle of view considerably, showcasing only the mother and child and rendering the background as out-of-focus colors. With the aperture set at $f/5.6$, I simply adjusted the shutter speed until 1/250 sec. indicated a correct exposure for the late-afternoon frontlight reflecting off the subjects' clothing.

out-of-focus backgrounds increase the visual weight of my in-focus subjects. Granted, the size of my 300mm lens makes handholding the camera next to impossible. But when I mount this camera-and-lens combination on a monopod, as I do 99 percent of the time I use it, my mobility is no less than that of a photographer who is handholding a shorter lens. (A monopod is a single metal "leg" that looks like a walking stick and can be made shorter or taller via a release lever.)

Additionally, all telephoto lenses have a much narrower angle of view than their wide-angle counterparts. For example, a 24mm wide-angle lens has an angle of view of 84 degrees, while a 100mm telephoto lens has an angle of view of approximately 27 degrees and a 300mm telephoto lens has an angle of view of only 11 degrees. The much smaller angle of view of my 300mm lens enables me to record a very select subject area for much tighter compositions. I prefer this shooting technique, especially when I'm working on the street. And I'm not restricted to photographing the face. At a county fair, for example, I can zero in on the hands that exchange money as well as a child's hands hanging on tight to cotton candy.

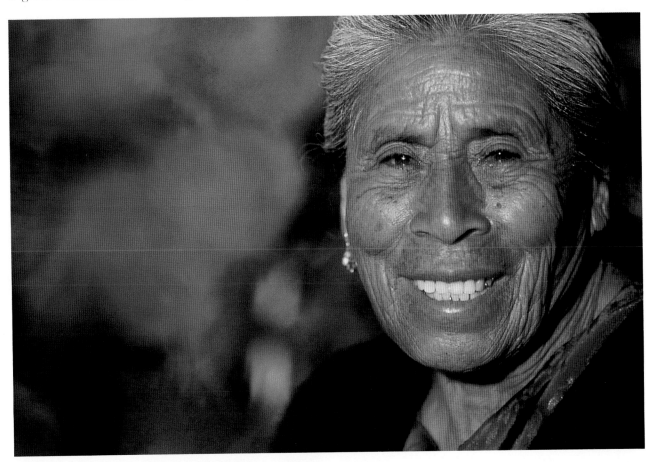

Many photographers prefer the telephoto lens for two reasons: it renders the face proportionally correct and enables them to fill the frame without violating their subjects' psychological boundary. ● While attempting to photograph the face of this Indian woman, I was reminded that some subjects want a larger protective space around them. I first approached this woman with my 80–200mm lens set at its longest focal length in an attempt to fill the frame with her face. This also required a working distance of around 6 feet. I quickly noticed that she was becoming a bit agitated and would no longer look into the camera. ● When I moved back to a distance of about 8 feet, the woman relaxed again; however, I was no longer able to fill the frame with her face (left). So I switched to my 300mm lens and moved back even farther, to a shooting distance of about 12 feet. This allowed me to fill the frame and at the same time give her the space she needed to feel comfortable (above). While composing this shot of her, I deliberately focused through a red flower and its attached green foliage in the foreground. With an aperture of $f/5.6$, the shutter speed required was 1/125 sec.

Sometime ago I was on assignment in Decker, Montana, for a coal-mining company. Arriving at the location at sunrise, I questioned the wisdom of my career choice as I stood in this open pit making photographs while the temperature hovered around –20°F. ● My first scheduled shot was of a young man standing on the platform of a large machine called a dragline. Initially, I decided to photograph him with my 35mm wide-angle lens. But as the huge bucket was moved into position at some distance from him, I soon realized that the sense of scale I wanted to record wasn't quite evident. In fact, through this wide-angle lens he looked bigger than the bucket (above). But the lens did render a sense of depth and distance. ● As I watched the activity for the next 15 minutes, I felt that in order to achieve the desired sense of scale, I needed to move back quite a bit and use my 600mm telephoto lens. About 10 minutes later, I was in position and ready to shoot. With my camera and lens mounted on a tripod, I was able to fire off 10 to 12 exposures each time the massive bucket dropped its load. The steam produced by the difference in temperature between the earth being moved and the air enhanced this dramatic composition (left). ● Because the scene was strongly backlit, I knew that it would record as a silhouette. With my lens pointed toward the bright sky and the aperture set at ƒ/8, I simply adjusted the shutter speed until 1/250 sec. indicated a correct exposure.

When photographers shoot a group portrait, they use a wide-angle lens. They probably would never use that lens for a portrait of an individual because it would distort the subject's face, hands, and body. Besides, this goes against the rules. I am the first to admit that some rules shouldn't be broken. But photography is one of the arts, and there are no hard-and-fast rules in art. A lens, just like a painter's brush, is a tool. You can use the brush to make strokes up, down, or from side to side. You can squish the brush against the canvas or reduce it to a single hair and paint ultra-fine lines. You can also throw the brush out and use a palette knife, your fingers, your nose, or even your cheeks to spread the paint around.

I believe that you can—and should—experiment with lenses much the same way. Don't reserve wide-angle lenses for group portraits. These lenses have a much greater angle of view than telephoto lenses do, so they are a natural choice for environmental portraits. They gather up those elements that call attention to the subject's character. And when shooting indoors in a small, confined area, you'll have to use at least a wide-angle lens to show the subject from head to toe. A 50mm standard lens will rarely enable you to do this in such situations, and a telephoto lens never will.

I've had a great deal of success shooting storytelling portraits of people all over the world with my 35mm wide-angle lens. These powerful compositions include the person's head and shoulders in the immediate foreground as well as information in the background that helps define the subject. Nevertheless, many photographers hesitate to use the wide-angle lens because of the image distortion that can occur. The distortion is often related to the photographer's distance from the subject. If the photographer is too close to the subject, the person's nose will be exaggerated, the ears will appear too far back, and the face will look too round.

Tilting the camera up or down also contributes to distortion. For example, if you're shooting down on a subject who is standing or seated a few feet away from you, the final image will be distorted. This is because you're tilting the camera and lens at an angle to the subject rather than keeping them parallel to the subject's face and body. To eliminate this type of distortion, simply make sure that you hold the camera straight when you shoot.

You can, however, use the distortion produced by wide-angle lenses to your advantage. Imagine a picture of a little boy begging for food with an outstretched hand that appears larger than the rest of his body. Here, the distortion emphasizes his plight. Don't be afraid to choose a wide-angle lens when you photograph individuals whose professions often call for them to use their hands in special ways, such as boxers, surgeons, pianists, and even ministers. A wide-angle portrait of the person's hands, clenched in fists, holding a scalpel, sweeping over the piano keys, or folded in prayer, and looming much larger than normal, conveys a strong sense of the subject's character.

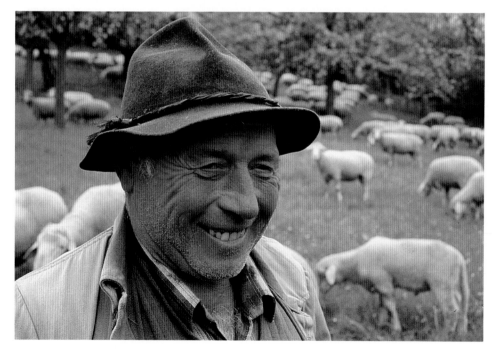

As I rounded the bend on a small country lane in Germany's Black Forest on a foggy, drizzly day, I came upon several hundred sheep grazing along the side of the road and in an apple orchard. I soon caught sight of the two sheepherders and their dogs and wasted no time making my presence known. Following a brief and hurried conversation—these sheep were on the move—I grabbed my 35mm wide-angle lens and framed this portrait of one of the men. I moved in close enough to include his weathered face and his shoulders, and by placing him off-center, I was able to include the sheep in the background. ● Not having the time to set up my tripod, I handheld my camera and wide-angle lens, and then set an aperture of ƒ/8. Next, I focused on the sheepherder and adjusted the shutter speed until 1/60 sec. indicated a correct exposure for the light reflecting off his face. The wide-angle lens rendered the sheep, grass, and trees as a sharply defined background.

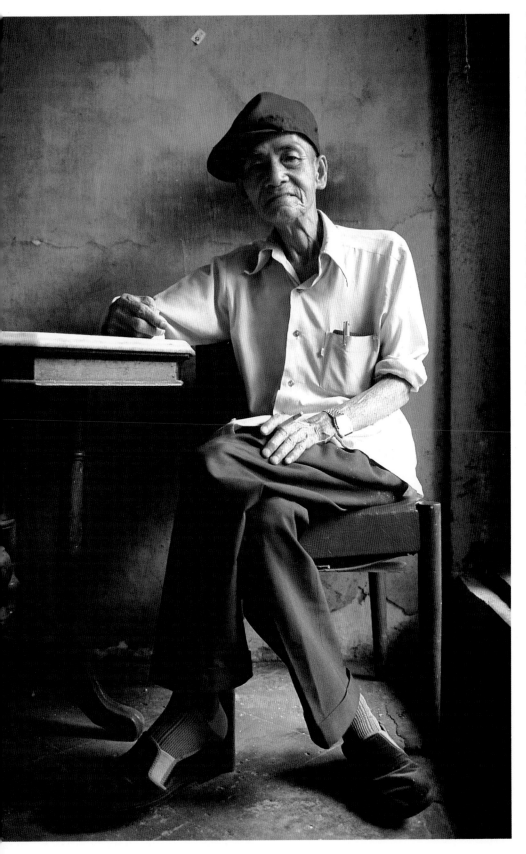

The spaces that I work in are sometimes cramped. When this occurs, I often opt for a wide-angle lens. This was exactly what happened when I entered a teahouse in China for an early-morning cup of tea. Because I wanted to shoot a full portrait of this intriguing man, I found myself in this very small room, crouching with my camera and 35mm lens in a position similar to that of a baseball catcher. ● There was no door to this teahouse, just a large entranceway that permitted bright, diffused light to enter from the man's left. This soft sidelight produced subtle shadows on his right side. With the aperture set at f/8, I adjusted the shutter speed until 1/30 sec. indicated a correct exposure for the light reflecting off the green wall. I then recomposed the scene and fired off about a dozen shots. Although my shooting position wasn't particularly comfortable, the point of view it provided resulted in a compelling portrait.

Most if not all beginning photographers tend to shoot everything from their eye level or from the spot where they first caught sight of a willing subject. But shooting from these points of view seldom leads to compelling imagery. For example, the cute picture of your daughter sitting on a swing would have more impact if you'd knelt down in order to photograph her at her eye level. Or suppose you photographed a man in a brightly colored outfit at a crowded festival in Mexico City; if you'd moved in closer, you would have eliminated the other people in the image who are distractions.

Walking around to find new shooting positions offers you a wealth of exciting possibilities. Climb some stairs, and shoot down on your subject. Lie on your back in order to shoot up at your subject. Fall to your knees, and greet children at their eye level. Getting closer to your subject enables you to better fill the frame. For example, if you move close to a picket fence and shoot it at an angle, the repeating lines in the final image will draw viewers' eyes to the woman weeding in the flower bed by the end of the fence. In another shooting situation, you might decide to lie down on your stomach and

frame cattle branding through the boots of a cowboy watching the action from 15 feet away.

Shifting your point of view is an easy way to improve your compositions. To eliminate a distracting background, simply move a bit left or right to hide it behind your subject. If you want to make someone look very important, all you have to do is get down low and shoot up as the subject looks straight ahead. If you want to make that same person look authoritative, your point of view would stay the same, but the subject would look down at you with folded arms. In order to call attention to someone's love of solitude, have the person pose in a large open space, such as a park or dry lake bed, and shoot down on the subject from a tree or rock using a wide-angle lens.

Changing your point of view about sex, politics, or religion leads to a whole new way of looking at the world. This holds true for photography, too. You can breathe new life into tired, worn-out subjects when you view them from a fresh perspective. And while changing your point of view can be scary, it also keeps life exciting and adventure-filled.

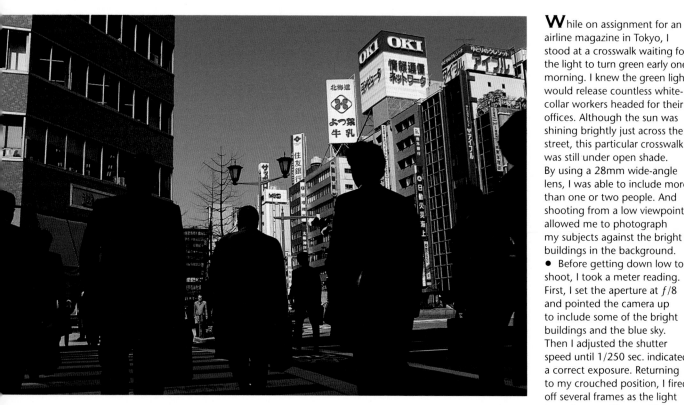

While on assignment for an airline magazine in Tokyo, I stood at a crosswalk waiting for the light to turn green early one morning. I knew the green light would release countless white-collar workers headed for their offices. Although the sun was shining brightly just across the street, this particular crosswalk was still under open shade. By using a 28mm wide-angle lens, I was able to include more than one or two people. And shooting from a low viewpoint allowed me to photograph my subjects against the bright buildings in the background.
● Before getting down low to shoot, I took a meter reading. First, I set the aperture at $f/8$ and pointed the camera up to include some of the bright buildings and the blue sky. Then I adjusted the shutter speed until 1/250 sec. indicated a correct exposure. Returning to my crouched position, I fired off several frames as the light turned green. The resulting images show the desired human silhouettes against the much brighter buildings.

Shooting for an oil company in Houston, Texas, I was hard pressed to come up with something fresh until I asked myself how this scene would look if I shot down on it from above. While an employee was doing maintenance work on a valve, I leaned over the edge of a connecting walkway between the tanks and shot straight down with my 20mm wide-angle lens. I deliberately turned my camera at an angle in order to create a strong, diagonal blue line. With the aperture set at ƒ/8, I adjusted the shutter speed until 1/60 sec. indicated a proper exposure for the late-afternoon light.
● Without the human form, this environmental portrait wouldn't have nearly as much impact as it does. The worker provides a sense of scale and enables viewers to better gauge the size relationships of the surrounding objects.

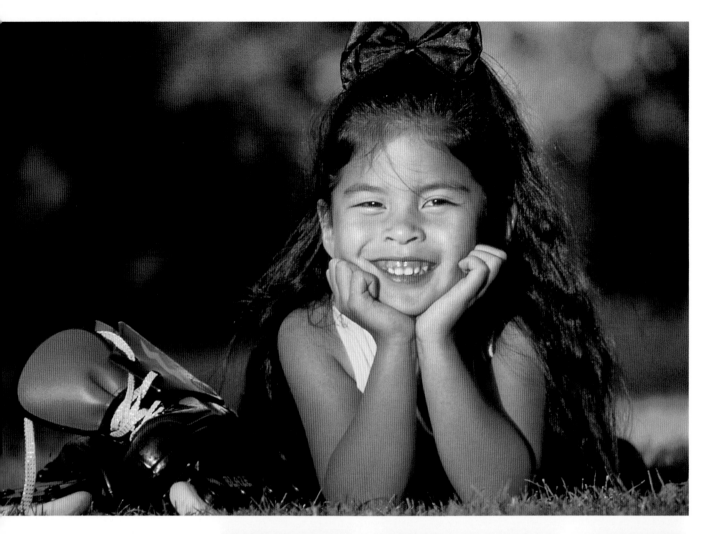

When your subjects face directly into the sun, they are frontlit. No other lighting condition is capable of bathing them as warmly as early-morning sunlight and late-afternoon illumination do. In this photograph of a young girl, the shadows are very long (right). This indicates the presence of warm light in a scene. ● By meeting the subject at her eye level, I was able to create a much greater degree of emotional participation (above). Lying on my stomach and supporting my 300mm lens with my bent arms, I set the aperture at ƒ/5.6. I made a conscious choice to include the distant trees in the background while shooting from this low viewpoint. From a working distance of 15 feet, I was able to render the trees as out-of-focus tones of green. I then adjusted the shutter speed until 1/125 sec. indicated a correct exposure.

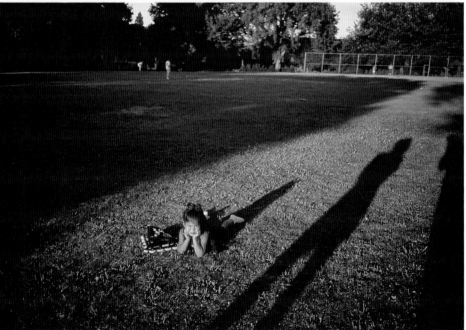

If your compositions are often predictable, you might consider looking for fresh points of view. My fascination with flying might explain why I frequently look for ways to view the world looking down from above. Even when I don't have the means to get airborne, I often ask myself the question, "How would this scene look if I could shoot down on it?" ● I was on assignment in Kauai, Hawaii, for Citizens' Utilities to produce an innovative cover shot for the company's annual report. As I looked at the last seven annual reports, I saw the usual clichéd shots of power lines at sunset, with and without men on utility poles. I suggested going to an actual site so that I could get some ideas. When I came upon several line crews doing maintenance work along Kauai's north shore, I wondered how they would look if I photographed them from above with a wide-angle lens. ● After I was given a short course in the dangers of high-voltage lines, I was put aboard a truck with a bucket and raised above this utility pole. Using my camera and 20mm lens, I shot straight down. The relationship of the man in the foreground to the much smaller man on the ground creates great depth and perspective. With the aperture set at f/16, I adjusted the shutter speed until 1/60 sec. indicated a correct exposure for the strong sidelight reflecting off the foreground subject's yellow rain slicker.

BACKGROUNDS

How critical is the background in terms of creating strong images? In my mind, 99 percent of all compelling people pictures can't survive without one, and more than 50 percent of all images owe their success to the background. The stock-photography industry has embraced the importance of backgrounds so enthusiastically that many of the larger agencies' catalogs contain as many as eight pages showcasing more than 200 backgrounds. Vivid blue skies, white cumulus clouds, orange and red sunsets, green grass, autumn leaves, and wildflower meadows are just a few of these backgrounds. And when you combine such striking backgrounds with people, they become even more important. They can make an ordinary image extraordinary.

Backgrounds can take the form of out-of-focus colors or shapes or of clearly defined elements. A successful background most often relates to the subject or enhances its importance. And on rare occasions, a background can provide a stark contrast to the subject placed in front of it.

For example, it makes perfect sense to photograph a turkey farmer from above while he stands in the midst of his 2,000 gobbling turkeys. It would make no sense at all to lie down in an empty field and shoot up at the turkey farmer against the blue sky. In much the same way, it is appropriate to photograph a little girl from her eye level against an out-of-focus background of green foliage as she hunts for Easter eggs at the local park. Green is the color of spring, and the blurred background places the emphasis on the child. It would make no sense at all to photograph her with the visibly crowded parking lot as the background. When you consider backgrounds for people pictures, ask yourself, "Where is the connection?"

Having a beautiful background but the wrong subject, or the right subject but the wrong background, serves only to magnify the question in the viewers' minds.

Lens choice and point of view play very important roles in making the connection between the subject and the background. When you shoot with a wide-angle lens, backgrounds are for the most part sharply defined. And while objects in the background can be noticeably defined when you use a telephoto lens, this lens is most often called upon to reduce backgrounds to out-of-focus shapes or colors. Even the most unflattering of environments can be turned into appealing backgrounds via the telephoto lens. The lens' ability to render muted backgrounds is one reason why it is popular among seasoned professionals. But it is up to you to find the right background that when turned into an out-of-focus color or shape connects with the subject.

A final point about backgrounds. If you are familiar with the stock agencies' catalogs, you might have noticed that many of the best-selling people photographs have a common link. The majority of the images made with a telephoto lens, whether the shots show a couple walking in the park, a child riding a bicycle, or a father and daughter sitting on a swing, have out-of-focus tones of green for backgrounds. Trees, hedges, shrubs, and, in some cases, a grassy hillside behind the subject might have provided the background colors. Green is the favored background because it appeals to everyone's desire to make a fresh start. I once heard an art-history professor say that no great painting was ever accomplished without a background. The same can be said of people pictures.

On assignment in Salt Lake City, Utah, to photograph this man for a corporate brochure, I was under strict orders not to shoot in the "sterile environment of a studio," but rather in natural light. On the day of the shoot, I thought that this was going to be a problem because the sky overhead was one continuous black cloud as far as the eye could see, and the rain showed no signs of letting up. Luck was on my side, however. As the man pulled up to the edge of the lake, the skies briefly parted, providing me with a short window of time to shoot in. ● As the man stood facing into the late-afternoon light, I chose a low viewpoint and my 35mm wide-angle lens. I did this for two reasons. First, I wanted to create a sharp contrast between the warm light on him and the passing storm clouds behind him. But even more important, I wanted to emphasize both the subject and his stature. Photographing subjects from a low point of view while looking up at them magnifies their importance. ● For this shot, I set the aperture at f/8 and then adjusted the shutter speed until 1/60 sec. indicated a correct exposure for the light reflecting off the man's shirt.

The discovery of willing subjects can often be the result of someone else's efforts. Upon his return from a vacation in Maui, my assistant, Dean, told me that he met a woman with two children who eagerly posed for him and expressed interest in doing this again. She invited him to call her when he was in the Los Angeles area and needed models. Interestingly enough, I was headed for Mexico City shortly and had a four-hour layover in Los Angeles. Since Dean knows how much I love photographing people, he called her and set up an appointment. After the woman and her two sons picked me up at the airport, I spent a few hours at the beach taking pictures of them. ● For one shot, I zoomed my 80–200mm lens to its longest focal length (left). But I was distracted by the many houses in the background along Hermosa Beach, California. Because there was no connection between this busy background and the subject, I decided to shift my point of view. ● By getting down low and moving in a bit closer, I was able to photograph the subjects against the blue sky and eliminate the houses behind them (above). The woman and the boys were so absorbed with each other that I was able to shoot several rolls of their spontaneous play and displays of affection. ● The second composition is much cleaner and focuses attention solely on the subjects. With the aperture set at $f/8$, I adjusted the shutter speed until 1/125 sec. indicated a correct exposure for the light reflecting off the subjects' clothing.

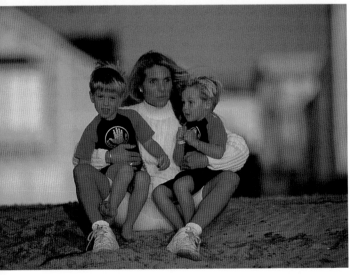

A group of students and I woke up at dawn to shoot the Portland, Oregon, skyline. One of my students had turned his attention to the strong sidelight reflecting off a nearby steel bridge. Because he was standing under an overpass, he was in open shade. With my camera and 50mm lens mounted on a tripod, I framed his profile against the skyline, which was bathed in strong early-morning frontlight. ● After setting the aperture at ƒ/16, I moved to the student's right and adjusted the shutter speed until 1/125 sec. indicated a correct exposure. I then recomposed the scene to include his profile and fired off several frames. Once again, the background is just as important as the subject.

I was on assignment for an oil-and-gas company in the Gulf of Mexico photographing everything that went on over the course of five days. While setting up to shoot a portrait of an oil-rig worker, another employee carrying a long length of chain stepped in front of my camera. Although he was a bit out of focus, this triggered an idea. As soon as I finished the portrait, I explained to the second worker that I wanted to shoot his one gloved hand and chain. ● The shot that I thought would take only a few minutes took more than 20 minutes. I just couldn't seem to come up with a compelling background. It wasn't until another worker wearing red coveralls passed by that I realized that an out-of-focus red background was exactly what I needed. ● I then had the subject move about 10 feet in front of a large, red metal hatch cover. With my camera and 300mm lens mounted on a tripod, I proceeded to record the composition I'd been trying to achieve. With the aperture set at ƒ/5.6, I adjusted the shutter speed until 1/250 sec. indicated a correct exposure.

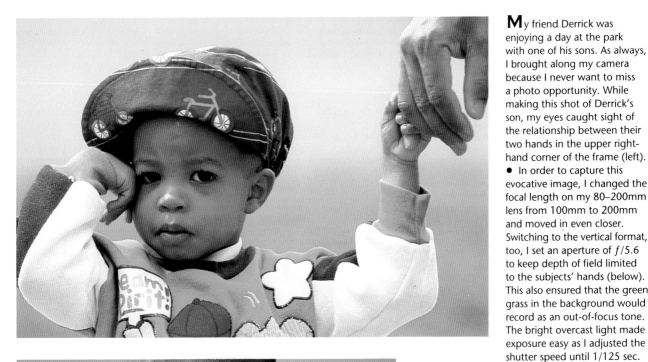

My friend Derrick was enjoying a day at the park with one of his sons. As always, I brought along my camera because I never want to miss a photo opportunity. While making this shot of Derrick's son, my eyes caught sight of the relationship between their two hands in the upper right-hand corner of the frame (left).

● In order to capture this evocative image, I changed the focal length on my 80–200mm lens from 100mm to 200mm and moved in even closer. Switching to the vertical format, too, I set an aperture of $f/5.6$ to keep depth of field limited to the subjects' hands (below). This also ensured that the green grass in the background would record as an out-of-focus tone. The bright overcast light made exposure easy as I adjusted the shutter speed until 1/125 sec. indicated a correct exposure.

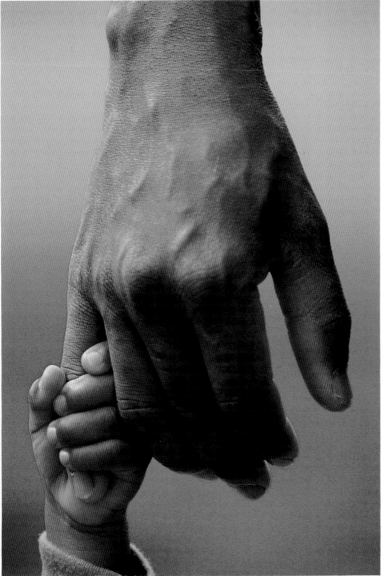

FILLING THE FRAME

When you order a glass of milk or a cup of coffee, you expect to get a full glass or cup, not so much because that is what you paid for, but because the "composition" of the glass or cup just doesn't look right unless it is full. Neither a half-full or three-quarter-full glass or cup is enough. In much the same way, effective composition almost always demands that you fill the frame, not half full, not three quarters full, not even spilling over the sides, just full.

The biggest challenge many amateur and even some professional photographers face is not getting close enough to the subject in order to fill the frame. This problem can, however, be easily solved. You can physically move closer to the subject, switch to a longer lens, or in some cases have the subject walk toward you.

Although it rarely happens, you can get too close to your subject, which is comparable to overfilling a glass. The most obvious example of this is when you eliminate information in the scene that is paramount to the story you're trying to convey. For example, if I were asked to shoot a portrait of a mechanic and the prized 440 horsepower engine he'd just overhauled, I would include the man as well as the engine in the shot. Showing only the mechanic with his arms crossed, holding a socket wrench, would leave out a critical element, the engine. Similarly, suppose that you want to shoot a portrait of a sculptor. Since the artist's hands help to define the individual's character and profession, it would be unflattering and completely inappropriate to move in so close that you leave the hands out of the composition.

When you shoot, one of the biggest challenges you face is remembering to move your feet. Don't be easily seduced by remaining in the spot where you first viewed your subject. Filling the frame effectively is critical when you shoot portraits. Make a point of moving in so close to your subject that you cut off the person's head or chin. Then and only should you back up a bit. ● From a distance of 10 feet, I made a photograph of Anita with my 80–200mm lens set at 100mm (above). Obviously, this image lacks punch because the frame isn't filled. By simply moving my feet, I got closer to Anita, thereby filling the frame with her and her alone (right). With the aperture set at $f/5.6$, I simply adjusted the shutter speed until 1/125 sec. indicated a correct exposure for the low-angled, late-afternoon light reflecting off her face.

As I drove through a small village in northeast Holland, I was keenly interested in the beautifully carved front doors on many of the houses. One door really caught my attention, so I pulled the car over to the side of the narrow road and hoped that the owner would allow me to shoot it. The elderly woman who answered my knock gladly gave me permission, and I made several exposures. ● As I was shooting, the woman's husband began relating the history of the door and the house. During our conversation, I mentioned that I wanted to take his photograph. After I told him that he could wear whatever he wanted and do whatever he wanted, this shy subject finally agreed. To my complete surprise, the man reappeared

10 minutes later, dressed in his late father's outfit, all the way to his wooden shoes. I quickly photographed him as he stood with his arms outstretched in the doorway (right). ● It took a little more coaxing and a Polaroid to convince the man that a portrait of him with the house in the background would do him even greater justice. Shooting with my camera and 35mm wide-angle lens, I set the aperture at $f/5.6$. I then composed so that he would be on the left side of the frame, and the green door, a bit of the house, and part of the thatched roof and green trim would be included in the image (above). I adjusted the shutter speed until 1/125 sec. indicated a correct exposure for the warm, low-angled frontlight of the late-afternoon sun.

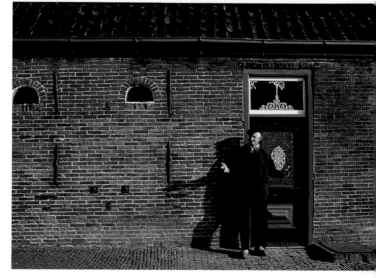

HORIZONTAL VERSUS VERTICAL

Whether you place your subject inside a vertical or horizontal frame, or both frames, is, obviously, an individual decision. Your choice will often be dictated by the mood you want to convey or by those elements that distract from or add to the subject's appearance. Landscape photography is characterized by a greater number of horizontal than vertical images, while people photography is the exact opposite. Most faces are more "vertical" than "horizontal," and most people pictures are shot while the subject is active rather than when the subject is lying down.

But the main reason many compositions fail, even when the frame is full, is because an ordinarily vertical subject has been squeezed into the shorter horizontal frame. I want to be very careful, however, not to give you the idea that every subject should be framed vertically. You'll see that an average of just 40 percent of your subjects work well in the horizontal frame. Environmental portraits are usually, but not always, shot as horizontals.

You might find it easier to identify which subjects belong in which frame once you understand the effects of both horizontal and vertical framing. The horizontal frame, like a horizontal line, generally conveys a sense of calm and tranquillity. The vertical frame, like a vertical line, suggests strength, dignity, and life. A child sleeping in her bed elicits a greater emotional response when composed inside the horizontal frame than the vertical one because the horizontal frame supports her resting form. Conversely, if you photograph the child running toward you carrying flowers from the garden, the vertical frame is the obvious choice because it parallels the child's movement.

As you begin to think about the human body from head to toe, you'll discover that your compositional choices are influenced by how close to or how far from the subject you are. If your intention is to shoot a composition of only the face, deliberately blurring the background via a shallow depth of field, the chances are good that the subject will be best suited inside the vertical frame. On the other hand, if you're shooting a head-and-shoulders composition of two people side by side, the horizontal frame will be more appropriate. Effective composition should draw attention to your subject, not away from it.

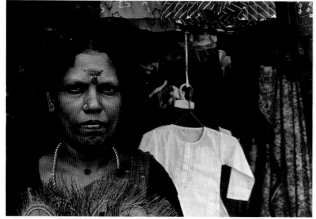

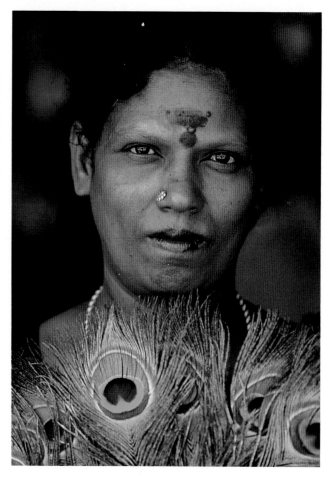

Shooting at an outdoor market in Little India, Singapore, I just didn't feel right when I placed this shopkeeper inside the horizontal frame (above). It seemed that two images were competing for attention: the woman on the left side of the frame and the clothes on the right. ● Because I wanted the woman to be the sole focal point, I turned the camera vertically to cut off the right side of the picture. I now had more space at both the top and bottom of the frame to work with. I moved in even closer and really filled up the frame with my subject (right). At the same time, the background of clothing became quite diffused and recorded on film as an out-of-focus tone. ● For this portrait, I mounted my camera and 80–200mm lens on a monopod and chose the lens' longest focal length. With the aperture set at ƒ/5.6, I adjusted the shutter speed until 1/125 sec. indicated a correct exposure for the bright diffused light reflecting off the subject's face.

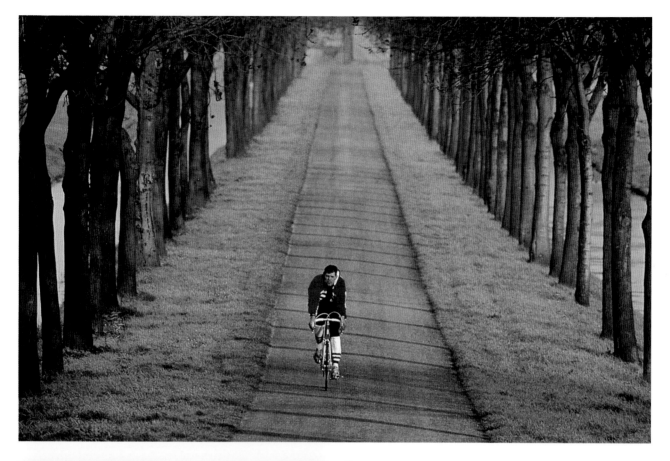

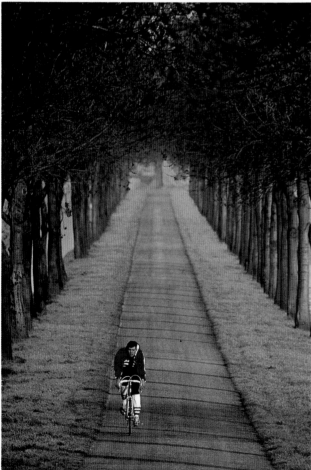

I drove down this tree-lined road in northern Holland on numerous occasions because it provided the shortest route to one of my favorite beaches on the North Sea. But it was several months before I ever considered making a picture of this road. I was so taken by the relationship between this lone cyclist and the road that I stopped the car and got him to agree to ride toward me again. This time, however, I would be ready to shoot.

● With my camera and 400mm lens mounted on a tripod, I was able to stack the trees and make the roadway seem much more compact than it is (above). Next, I set the aperture at $f/8$ and prefocused on a spot that the cyclist would pass. This ensured that when he reached that spot, I would be able to quickly fire off four or five frames, all in focus. I then adjusted the shutter speed until 1/250 sec. indicated a correct exposure. On cue, I lowered my arm and motioned to the cyclist to start riding. Once he passed through the area of focus, I asked him to repeat the ride so that I could compose this same scene inside the vertical frame (left). The primary difference between the two shots is that the horizontal image is a bit more tranquil.

RULE OF THIRDS

Much of the pleasure people have in life is based on the "sweet spot." Suppose that you get up from the couch and feel a terrible itch in the middle of your back. So you ask your partner to scratch it, saying, "Over a little bit. Now down. Just a bit more to the left. Now up. Good." That is a sweet spot. And if you are familiar with tennis, you probably know that players try to hit the ball at the sweet spot in the center of their racket.

In terms of photographic composition, there are four sweet spots. I'm referring what is commonly called the rule of thirds. According to this principle, an image should be divided by two imaginary lines that run horizontally, one at the top third and the other at the bottom third of the frame, and by two imaginary lines that run vertically, one at the left third and one at the right third of the frame. I call the intersections where these lines cross sweet spots. Carefully composing so that you place your subject on one these spots is likely to elicit a response similar to the "Aaah!" that follows finding an itch or the "Wow!" that comes after a tennis player smashes the ball.

Perhaps the easiest and often the most powerful photographic examples of finding the sweet spot are compositions that include people for scale. Although a building, ship, forest, or landscape dominates the frame, the person placed on one of the points of intersection brings a sense of size and scope to the scene. If the individual didn't appear in the photograph, viewers would see only a massive structure or a vast open space. Thus, the subject's presence is quite important to the success of the image.

To train your eye to see and use the sweet spots, make a cardboard cutout that is identical in size to a 35mm film frame. Next, place a small piece of clear, hard plastic over this opening and draw two horizontal lines that divide the plastic into three equal sections. Then draw two vertical lines on the plastic, one a third of the way in from the right and the other a third of the way in from the left. You should see nine equal boxes and four sweet spots on the plastic. Use this grid to view the world for a few weeks, paying close attention to how balance is created when you place subjects on or near a sweet spot. Look at someone's face in the vertical format, and notice how the eyes are near the top line and the mouth near the bottom line. If you do this exercise faithfully over the course of a few months, effective composition will become automatic for you.

High on my list of easily accessible destinations is Isla Majeurus, located several miles east of Cancun, Mexico. Unlike Cancun, which is much larger and far more developed, this small island is only about a mile wide and 2 miles long and has just one major hotel. Isla Majeurus's main attraction is the crystal-clear ocean surrounding it, where you can wade out for about half a mile from the shore. Standing in the water with my camera and 20mm lens, I photographed many tourists as they swam by. ● For this shot of a solitary swimmer, the horizontal frame seemed to be the natural choice. Here, the sense of calm and tranquillity this format conveys complemented the scene's relaxed atmosphere. To achieve maximum visual impact, I composed so that the swimmer appeared in the middle third of the frame. With the aperture set at ƒ/16 and the focus preset via the depth-of-field scale, I adjusted the shutter speed until 1/125 sec. indicated a correct exposure.

I went to Whistler, British Columbia, to get shots of happy couples having fun. The models weren't professionals, but they clearly enjoyed posing.
● The rule of thirds is at work in this shot. Because the most interesting parts of this image were above the horizon line, which in this case was the snow-covered ground, I placed it near the bottom third of the frame to serve as an anchor. I then composed so that the couple appeared at the point where the right-hand vertical line and the lower horizontal line intersect; this helped to balance the image. ● I mounted my camera and 300mm lens on a monopod and set the aperture at $f/5.6$. Exposing for the light reflecting off the gray card that I held out in front of the lens, I determined that a shutter speed of 1/125 sec. was needed.

Many of my students note the intimacy in some of my portrait work yet are perplexed because these images go against a rule of portraiture composition: Don't cut off any part of the subject's face. Photographically speaking, I find that when I crop in so close that part of the subject's face is omitted, the sense of intimacy increases. ● Framing the face also follows the rule of thirds, as this shot of a friend shows. Imagine a horizontal line running through Ingrid's eyes in the top third of the picture, and another line running through her mouth in the bottom third of the shot. Notice also that her face fills the right-hand two thirds of the frame. For this pleasing portrait, I mounted my camera and 200mm lens on a monopod and set the aperture at $f/8$.

During a three-day corporate assignment in Silver City, Idaho, for a gold-and-silver mining company, the weather had been fabulous, and I'd received an unusual amount of cooperation from the mine manager. Even my request to place a truck on top of the mountain was fulfilled after I assured the manager that this would result in a compelling image. Getting the truck up there wasn't a difficult task, but it took an unusually long time because the road wasn't meant for such a wide vehicle. ● My insistence on placing the truck on top of the mountain stemmed from my desire to record an image that would give a true sense of the size of these massive earth-moving machines. As the sun approached the horizon, two employees who had volunteered to help earlier in the day "walked off" into the sunset. They provide a sense of scale, and the sunset adds drama. The rule of thirds played a role in this composition: I deliberately placed the two men at the sweet spot in the lower right part of the frame. ● With my camera and 300mm lens mounted on a tripod, I set the aperture at f/8. Next, I pointed my camera toward the bright sky above the setting sun and adjusted the shutter speed until 1/500 sec. indicated a correct exposure. I then recomposed the scene and quickly shot a roll of 36-exposure film.

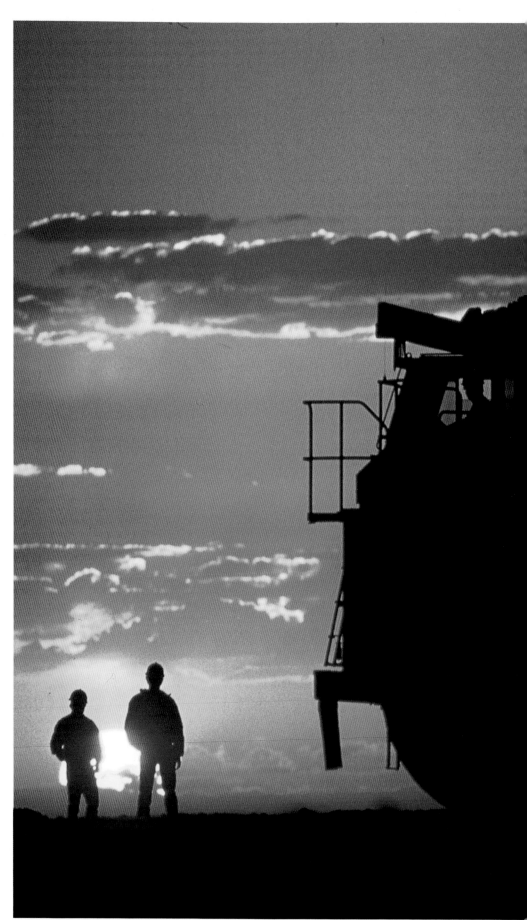

CAPTURING
MOVEMENT

America is a very sports-minded country. Not a weekend goes by that doesn't showcase two or more sporting events. Next to a baby's first few weeks of life and the family vacation, sports-related activities are probably the most often photographed subjects. Sports cater to men and women, and both young girls and boys play various sports, including soccer, basketball, and baseball. Besides shooting the action of these and other sports, such as water skiing, snow skiing, and windsurfing, many amateur and professional photographers want to capture the participants' emotions. For example, a photographer might want to record the grimaces of two soccer players as their heads collide or the frightened expression of a cowboy flying through the air only seconds after being thrown from the meanest bull at the rodeo.

Successfully shooting action-filled subjects requires not only skill and experience but also the right shutter speed. Only a fast shutter speed is capable of rendering such exacting detail and emotion on film. When action is coming toward you, such as a motorcyclist zooming over a hill, a shutter speed of 1/250 sec. freezes the subject in midair. But if you're shooting parallel to the motorcyclist flying over the hill, a shutter speed of 1/1000 sec. is a must.

When it comes to the creative use of shutter speed, 99 percent of all professional and amateur photographers still opt for only the fastest shutter speeds, such as 1/500 sec. and 1/1000 sec. But the opposite end of the shutter-speed dial offers a multitude of alternate creative effects that most photographers never discover. Action-filled subjects take on a whole new meaning when deliberately photographed at unusually slow shutter speeds. If you are a purist who still believes in the age-old standard of "razor sharp, everything in focus" pictures, I don't expect to change your way of thinking.

But if you are a photographer who is looking for some fresh approaches to photographing people, I strongly recommend that you consider "stretching" the limits of your slow shutter speeds to the fullest. Try shooting all of your people pictures handheld at slow

The north shore of the island of Maui is home to some of the best windsurfing in the world. I happened to be there when the Peter Stuyvesant World Windsurfing Championships were being held, and I had many opportunities to freeze the action of countless windsurfers doing flips during the freestyle event. ● To capture some of these amazing stunts, I mounted my camera and 600mm lens on a tripod. Next, I set the shutter speed at 1/500 sec. and adjusted the aperture until *f*/4 indicated a correct exposure for the light reflecting off the blue water. The result was an overall sharp image of a windsurfer (top). ● Quite honestly, though, I was far more interested in using much slower speeds to record these windsurfers. As the surfers returned to shore, I kept them in focus as I followed their movement (bottom). I set the shutter speed at 1/15 sec. and then adjusted the aperture until *f*/22 indicated a correct exposure. The resulting images clearly convey a sense of motion and are, I think, far superior to the photograph that shows a static windsurfer frozen in time. This image seems at odds with a sport filled with rapidly moving participants.

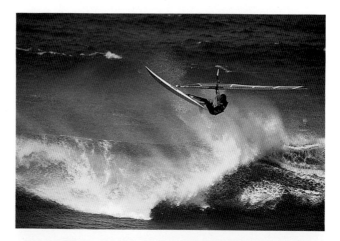

shutter speeds of 1/4 sec. or 1/2 sec. for the next week. The compelling imagery that often results becomes additional ammunition for your growing arsenal of creative approaches. Much of what you do will be experimental, but, as is often the case, new and exciting "discoveries" can be made only in the laboratory. Every photographer who is passionate about taking pictures is on a neverending journey of creative expression and strives to be inventive. Using slow shutter speeds when common sense suggests that this approach probably isn't a good idea has proven to be a successful venture for many photographers.

These compositions are filled with tremendous movement and tension. They convey strong moods and emotions and are anything but boring. You might not be able to identify the sport or activity, but in the midst of the blurred motion you recognize the human form. Fast-action shots made with slow shutter speeds are "alive." They can resurrect memories of an earlier exciting time or confirm the current excitement in your life. Everyone, by nature, feels invigorated when there is movement in life, and everyone at one time or another has experienced boredom, life without movement.

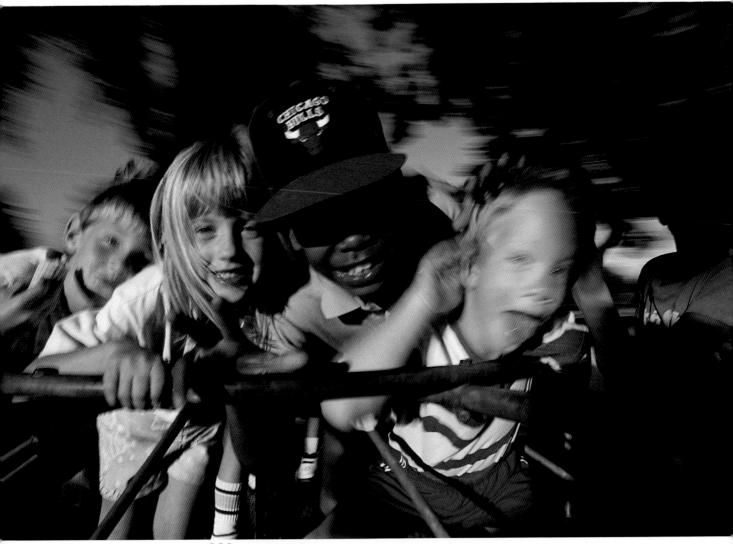

When I arrived at a local park, more than 15 children were crowded onto the merry-go-round. Encouraged, perhaps, by their laughter, I didn't hesitate to hop on; in any event, I wasn't going to let this moment go by without recording it on film. ● With my camera and 20–35mm lens, I zoomed to the lens' shortest focal length and set the shutter speed at 1/4 sec. Then I adjusted the aperture until ƒ/22 indicated a correct exposure for the low-angled frontlight reflecting off the children who were visible in the viewfinder. As the merry-go-round revolved, I continued shooting until I finished a roll of 36-exposure slide film.

Motion-filled opportunities are present at every action-oriented event, and when slow shutter speeds of 1/4 sec. or 1/8 sec. are used to record them, dramatic effects often result. Handholding your camera at such slow shutter speeds might seem almost ridiculous, but it is necessary if you're going to successfully pan the action of your subject. Panning a subject simply means that whether your subject enters the frame from the left or right, you move the camera in the subject's direction while depressing the shutter-release button. This ensures that your subject remains relatively stationary on a particular spot on the film, while all of the stationary objects that surround the subject record as horizontal streaks on the film. As such, the main subject in the image appears crisp and sharp, and the rest of the frame is blurry. You can almost always effectively pan a subject when you use shutter speeds of 1/30 sec. or 1/60 sec. The combination of panning and the slow shutter speed intensifies the sense of motion and the activity that your subject is involved in.

You may find that shutter speeds of 1/4 sec. or 1/8 sec. are too slow: you notice that the subject as well as the background often record as streaked blurs. If you encounter this, try the following alternative approach. Setting your shutter speed to 1/60 sec. and then panning your subject often renders the subject very sharp while keeping the stationary background a horizontal blur.

When you pan a subject, keep in mind that you must have appropriate backgrounds in order to be successful. Backgrounds are rendered as blurred, horizontal streaks of color. If you were to paint colored horizontal streaks onto a canvas, a single color would look like nothing more than a solid color with no evidence of streaking. But if you were to use several colors, you would be able to distinguish the streaks.

In much the same way, panning a jogger against a solid-colored blue wall will show little if any evidence of this technique because of the lack of tonal shift or contrast. But if that wall is covered with handbills, it will provide an electrifying background when panned. Simply put, the greater the color and contrast in the background, the more exciting the resulting panned image will be. So rather than concentrating on choosing the right shutter speed when you pan a subject, you should make seeking out an appropriate background a priority. This will greatly improve your panned images.

While living in Europe, I came to regard the bicycle as a wonderful alternative to the car. Additionally, I saw countless bicycle races all across the countryside and in many small towns and villages. At one race in a small town in Holland, I stationed myself on a street corner where the cyclists would make one of several turns. With my camera and 20–35mm zoom lens, I set the focal length at 20mm and the shutter speed at 1/8 sec. Next, I adjusted the aperture until f/22 indicated a correct exposure for the light reflecting off the gray road.
• Ready to shoot as the cyclists entered the turn, I would simply move the camera in a flowing direction from left to right when they came into the viewfinder. When you pan a scene this way, you want only the subject to appear sharp. Here, the cyclists are crisp, and the background is a blur.

If you want to create excitement in your compositions, consider panning subjects that are filled with movement. You might want to try this technique when photographing, for example, rickshaw drivers in Bangkok.

• At the famous Alkmaar cheese market in Holland, runners haul auctioned cheese from weight scales to awaiting trucks from April to October. In order to successfully pan the runners, I set the shutter speed at 1/30 sec. and adjusted the aperture until ƒ/22 indicated a correct exposure. As the runners passed in front of me, I focused on them, moved the camera in the direction they were going, and fired off several frames. Panning the scene enabled me to record the sense of motion and excitement that I experienced at the market.

CHOOSING THE
RIGHT APERTURE

As you'll notice throughout this book, I've listed which aperture I used for every photograph. Perhaps you're wondering why I used $f/5.6$ for some, $f/8$ for others, and $f/16$ for still others. After all, as many of my students say, "An aperture is an aperture, and apertures simply are there to help you make the exposure." This is true—up to a point. If all you're concerned about is getting the right needles to line up or the right light-emitting diodes (LEDs) or colored diodes to light up, you can use any aperture you want. But your images will always be a hit-and-miss proposition.

Apertures have many functions. The most obvious role they play is to control the volume of light that passes through the lens and onto the film. An aperture is merely a hole in your lens where light enters. When you release the shutter, light comes down this hole and exposes the film. Thus, an image is formed on the film. Every lens, with the exception of the mirror lens, has an aperture ring that is usually located on the lens itself (one manufacturer puts the aperture ring on the back of its camera bodies). Turning this ring enables you to change the size of the aperture. You can make the hole smaller when shooting subjects in bright light, such as snow and sandy beaches, and larger when shooting subjects in low light levels, such as church interiors.

Apertures also determine just how much of the scene behind and in front of what you focused on appears sharp on the film. Simply put, the wrong aperture can spoil a picture just as quickly as the right aperture can be responsible for a picture's success. Obviously, then, you should make choosing the right aperture a priority.

What do I mean by the "right" aperture? To understand this concept, simply think about the creative use of aperture in one of three ways: the right aperture can tell a story, isolate a subject, or fall into the "not important" category. Photographs in which you isolate a particular subject are also called singular-theme compositions.

Of these three aperture options, only the storytelling and isolation apertures really have an impact on your images. Storytelling apertures, $f/16$, $f/22$, and, on some cameras, $f/32$, render an area of sharpness well beyond the subject you focus on. And using a wide-angle lens at these settings is ideal for environmental compositions. For example, storytelling apertures allow you to record detail and sharpness in the background when your main subject is in the foreground. The reverse is also true. When the main subject in the background, a storytelling aperture lets you render both the distant subject and the foreground sharp on film. Thus, storytelling apertures provide extensive depth of field.

When I use my 80–200mm and 300mm lenses at the isolation apertures of $f/4$, $f/5.6$, and, occasionally, $f/8$, and focus on subjects that are 10 to 15 feet from the camera, I know that the backgrounds will record as out-of-focus shapes or colors. ● To make a compelling photograph of this little girl, I decided to shoot at her eye level and to use my 300mm lens. Next, I set the aperture at $f/5.6$ to ensure that the background would appear as out-of-focus tones of green. Finally, I adjusted the shutter speed until 1/250 sec. indicated a correct exposure for the low-angled frontlight reflecting off her face.

When wide-angle lenses are used at the storytelling apertures of ƒ/16 and ƒ/22, they offer a great deal of sharpness from front to back. As such, a storytelling aperture is the perfect choice when you shoot an environmental composition. ● On a recent trip to Maui, my assistant, Ingrid, and I found Makenna Beach to be quite a wonderful place for fun and relaxation as well as photography. For this dramatic shot of the incoming surf, I needed a human form to provide a sense of scale. Ingrid graciously agreed to serve as my model. After a wave crashed down on the shore, it rolled up the incline, rose over the top, and finally spilled onto the raised beach. Another wave soon followed, and, almost unbelievably, it was at this moment that Ingrid just happened to turn around and smile. ● Shooting with my camera and 20mm wide-angle lens, I set the aperture at ƒ/16 and adjusted the shutter speed until 1/125 sec. indicated a correct exposure for the frontlight. Here, the shutter speed froze the motion of the wave because I shot the wave at its peak. To use a faster shutter speed, I would have had to shoot the wave while it was crashing down onto the sand or rising up over the incline.

But when you want only the main subject to appear sharp on film and your working distance is between 10 and 30 feet, you should choose an isolation or singular-theme aperture, ƒ/2.8, ƒ/4, or ƒ/5.6. When you use these apertures on either a 100mm, 200mm, or 300mm telephoto lens, they always render any background or foreground colors or objects as out-of-focus tones and shapes. Because of this, you need to deliberately seek out foregrounds and backgrounds that when recorded out of focus on film will call attention to your subject.

Telephoto lenses, by their very design, limit the angle of view. And when they're used at singular-theme settings, they reduce depth of field. As such, they give the isolated subject more visual weight. Simply put, when you look at a photograph, you quickly scan the image and assume that whatever is in focus is the most important element. Clearly, you should use an isolation-aperture/telephoto-lens combination when you want to focus all of the viewer's attention on the subject, not on the surroundings.

The third aperture option comes into play when aperture choice isn't critical to an image's success. For example, when you photograph your subject against a brick wall, does it really matter what aperture you use? No. The same principle holds true when you shoot your subject from a low position against a background of blue sky, as well as when you shoot straight down on your subject from above. In all three situations, and in countless others, the aperture doesn't play a very important role.

Although you can select any aperture you want in such shooting situations, your best choices are ƒ/8 and ƒ/11. They often render the most sharpness and optical clarity possible. These lens openings are called critical apertures; if a lens isn't critically sharp at these settings, it won't be tack sharp at any of the others. Of the two "Does it really matter?" apertures, I automatically choose ƒ/8 more often when I shoot compositions where depth of field isn't important.

Start paying close attention to your aperture selection. Think of an aperture's powerful ability to determine visual weight when you shoot people pictures.

Whenever I shoot, I automatically choose an aperture of ƒ/8 when I find myself saying, "It doesn't matter what aperture I use since depth of field isn't important." This is exactly what happened when I met this German woman quite by accident. While driving around the countryside, I ran out of gas in front of her farm, and she generously offered a gallon of gas to get me going again. Before I knew it, I'd spent more than five hours with the woman and her daughter talking about life on the farm. ● Of the many photographs I made that day, this is one of my favorites. Because the woman was positioned against the brick wall and nothing was between us, depth of field was of no real concern. So I didn't hesitate to set the aperture at ƒ/8. I then zoomed my 80–200mm lens to the 100mm focal length and adjusted the shutter speed until 1/125 sec. indicated a correct exposure for the bright diffused light reflecting off the brick wall.

PEOPLE AS
THEMES

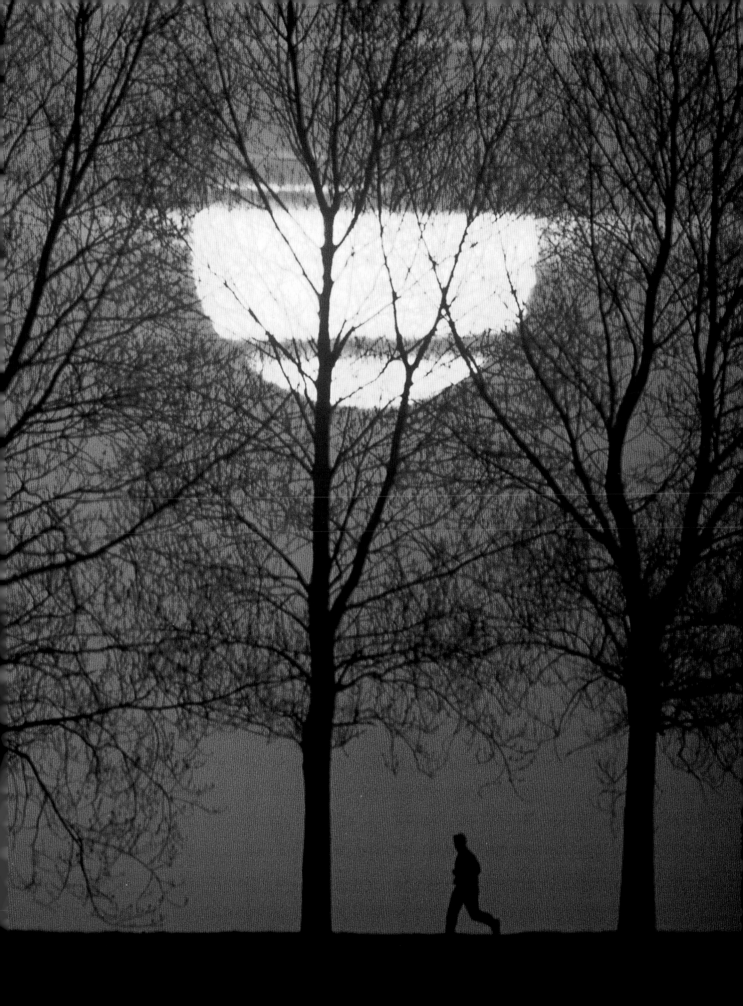

Most, if not all, people experience periods in their life, which can last for several days, weeks, and sometimes even months, when they search their storehouse of creativity only to find that the shelves are empty. For some photographers, this discovery can be downright frightening, especially when it coincides with an important event or assignment. This is a serious problem for professional photographers who are expected to deliver the goods and seldom have the luxury of taking off for an extended length of time in order to restock the shelves of creativity.

When I think about my own dry spells, I find that they usually happen when I'm shooting without a purpose or theme. Although themes might come relatively easily to nature photographers, people photographers might find it harder to define themes for their work. For example, a nature photographer may shoot only waterfalls, under only rainy or overcast skies, and only at shutter speeds of 1/4 sec. or longer. When I suggest to students whose primary interest is photographing people that they consider a theme, they often look confused. Some students respond with ambivalence, making such comments as, "I hardly think that a series of simple headshots would be a compelling theme." Although this statement might be partially true, I tell my students to further explore the idea of shooting with a theme.

The first step, of course, is to select a theme. Suppose that you decide to photograph only those individuals who have a deep love of gardening. You might begin by driving around your neighborhood, taking note of the yards that look as if they should be featured in *Better Homes and Gardens*. Stop your car in front of these houses, knock on the door, and introduce yourself to the owner. Compliment the person on his or her yard, and then briefly explain your current project, shooting portraits of gardeners. Because you're proposing to photograph the homeowner in an environment that calls attention to a favorite pastime, the person will probably agree to pose for you.

As you develop this theme over time, you'll discover surprises in your pictures that you might not have even thought of when first planning these shots. For example, you might find that most of the gardeners have a weathered complexion and rough hands, wear loose-fitting cotton clothes, and seem rather tranquil in nature. Obviously, these pictures would be vastly different from a series of shots for which coal miners are the theme. Their world is usually dark, their faces are seldom clean when they work, and their eyes often seem scarred with fear.

Children provide an opportunity to shoot a theme that is often overlooked because it is so obvious. Beginning with your child's first birthday, have the child sit on a kitchen chair and hold the birthday cake. Repeat this exact composition for the next 17 years. The resulting images will be fun to look at—and cherished for a long time.

Other potential themes that you might consider photographing include people who: wear hats, have blue eyes, have red hair, drive Saabs, wear uniforms, own horses, drink beer, make homemade jam, or work at country stores. Clearly, this list of themes is endless. Add your own, and then go out and shoot them.

Although I spent most of the day photographing a key employee at the Bonneville Power Administration in the Pacific Northwest, I didn't feel that I had the one shot that summed up the man's importance. As we walked along one side of a dam, the spill gates unleashed a powerful surge of water. When I commented that this would make a good background, he suggested an alternative. By taking an elevator down into the dam and going through a maze of tunnels, he could stand out on one of the walkways that ran the length of the dam, just above the spill gates. When he came out onto the platform, I was amazed to see him wearing an orange-red rain slicker. What a bonus! ● With my 80–200mm zoom lens set at 100mm, I composed a scene that was limited to the spill gates. With the aperture set at ƒ/16, I simply adjusted the shutter speed until 1/125 sec. indicated a correct exposure.

I met this model, Eric, when a local agency sent him over to my studio for some test shots. After several sessions, which enabled him to fill some voids in his portfolio, I explained to him that I'd wanted to make a visual statement about racial inequality for a long time. Eric graciously agreed to pose for this concept shot. ● I asked Eric to disrobe from the waist up and to rub petroleum jelly over his skin; I then sprayed him with a little water to create some perspiration. The final touch was placing a 7-foot-long steel chain around his neck and wrists. Moving on to the lighting setup, I placed a light inside a 2 × 3-foot softbox, which I then positioned directly over Eric's head. To heighten the sense of drama in the image, I used a black background.
● Just about ready to shoot, I took a flash-meter reading. This indicated that I needed an aperture of f/11. Then I adjusted the shutter speed until 1/250 sec. indicated a proper exposure. Using my 50mm lens, I began to frame various compositions of Eric as he manifested a slave's pain. I shot just one roll of film, but as this compelling portrait shows, that was enough.

PEOPLE AT WORK

Most people spend a third of their life at work! Think about that for a moment. Now think about the number of times your friends have made you sit through slide shows of them at work. What slide shows?! Exactly!

Most people don't have a visual record of how or where they spend a third of their life. Although your supervisor or boss would eventually fire you if you spent the entire day photographing your co-workers on company time, you can shoot during your lunch hour or coffee breaks. And because you know the other employees as well as what goes on during the day, you have the chance to shoot both great candids and posed pictures. Thinking of the people you work with as potential subjects rather than just co-workers you see day in and day out will inspire you as you shoot.

If ever there was fertile ground for photo opportunities, the workplace is it. Consider the wealth of subject matter found in the following professions outside the white-collar industry: carpenters, loggers, welders, shipyard workers, farmers, cowboys, firefighters, police officers, taxi drivers, truck drivers, commercial fisherman, steel workers, oil-rig workers, garbage haulers, window washers, commercial painters, railroad workers, landscapers, and power-line workers. The environments that these people work in and around are some of the most colorful and picturesque. Additionally, you'll find an unlimited supply of props that go hand in hand with the subject right there on location. Blue-collar professions are an untapped gold mine not only for portraiture but also for stock photography. Furthermore, you might even be asked to shoot a corporate brochure or an annual report for a company whose employee portraits you're taking.

When you photograph people at work, you meet them on their "turf," where they feel comfortable and often freely express their opinions and reveal their emotions. Workplaces can be high-pressured environments, and they're always distracting. As such, most employees are so busy that they won't pay much if any attention to you and your camera—unless you direct them to. This is why photographers find the work environment to be a breeding ground for great candids. And people on the job are also willing subjects, grateful for the opportunity to be photographed at work so that they can finally show their spouse, friends, and family just what it is they do. After all, most people define themselves in large measure by their work.

You might be wondering how to approach people at work. Hang out at a truck stop, and you'll not only find willing subjects but you'll probably also be offered a chance to go on the road. The next time the garbage truck wakes you up with the loud clanking of your cans, greet the haulers at the door and tell them what you have in mind. Go to a small sawmill, and ask for the whereabouts of the independent loggers working in the nearby woods. Head down to the local harbor, and make inquiries at the fish-processing plant. Visit a nursery, and ask if you can follow the gardeners to their next job.

You should photograph people at work because, if for no other reason, it gives you an opportunity to see, experience, and record how the "real world" lives. In addition, you'll be a bit more versed on the subject of work, and of why people do what they do.

Some of my favorite places to photograph people at work are the countless open-air markets located throughout Europe and Asia. I migrate to them with a great deal of enthusiasm because the vendors and customers alike are such colorful subjects. While living in Germany for the better part of a year, I shot some of my best images at markets in Freiberg, a beautiful town in the southwestern part of the country. The markets are in full swing from 7 A.M. to 3 P.M. every day except Sunday and Thursday, so I had plenty of time to shoot.

This experience reminded me once again just how much pride people take in their work. The vendors at the Freiberg markets treated their jobs seriously but at the same time never lost their sense of humor. Although for some people work is just something they do for a set number of hours each day, for many others it is a passion. Seek out those individuals when you shoot in the workplace, and you'll end up with great pictures of vibrant people.

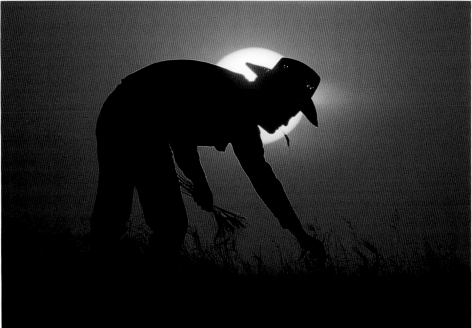

Upon arriving at an open-air market in Freiberg, Germany, at 9 A.M., I was glad to see that it was still somewhat overcast even though the weather forecast called for a clearing sky. Not only would this umbrella of overcast light make determining exposure easy, but all of my potential subjects wouldn't be under the harsh sunlight that is typical of this time of day. ● When I heard a very loud female voice coming from around the corner, I followed the voice to its source: an elderly German woman who was clearly enjoying selling her many vegetables. In fact, she was having so much fun during a spirited shouting match, comparing her produce to that of other vendors, that she paid no attention to me. ● I chose my 35mm lens because its moderately wide angle of view enabled me to include the woman, her vegetables, and the market in the background. With the aperture set at $f/16$, I simply adjusted the shutter speed for the balanced light reflecting off the entire scene until 1/30 sec. indicated a correct exposure.

Looking for stock-photography opportunities on a trip to Oregon's wheat country, I came upon this farmer who had just finished combining a large field. The sun was approaching the horizon when he agreed to pose for me. ● I rushed into the field, chose a shooting position that was some distance from him, and mounted my camera and 600mm lens on a tripod. I framed the farmer against the setting sun as he bent over to pick up a shock of wheat. My first attempt wasn't quite the composition I'd hoped for, so I asked him to repeat this action. Like a perfect model, the farmer held his position long enough for me to fire off several rolls of film. ● With the aperture set at $f/11$, I adjusted the shutter speed until 1/250 sec. indicated a correct exposure for the light in the sky to the left of the setting sun.

While working on a project that featured women in industry at a ship-repair firm in Portland, Oregon, I caught sight of this female welder. She was taking a break from making countless welds in the anchor chain of a ship that was in dry dock. The low-angled lighting fell on the side of the welder's face and body and the huge interlocking chain. As she looked out over the river, I set up my camera and 80–200mm lens on my tripod. I chose a focal length of 100mm and decided on a low viewpoint in order to photograph the woman at her eye level. • Next, I set an aperture of ƒ/22 to achieve extensive depth of field. I wanted both the welder in the background and the chains in the foreground in sharp focus. I placed the back of my hand in front of the lens, making sure that it was illuminated by the low-angled light. Then I adjusted the shutter speed until 1/60 sec. indicated a correct exposure. The much desired highlights and shadows in the final image combine to create great depth and perspective. Such is the drama of low-angled sidelighting.

I met Claire during a four-day assignment for a company in Sheridan, Wyoming, photographing employees for its annual report. He was quite a character and really loved his job. After I made several exposures, I felt that he would be a contender for the cover. When the company executives saw the shots I'd taken of Claire, they agreed and, to my delight, his portrait appeared on the cover of the annual report. • With my camera and 80–200mm lens mounted on a monopod, I zoomed the lens to its longest focal length. I focused as close as I could in order to fill the frame. Next, I set the aperture at ƒ/8 and adjusted the shutter speed until 1/125 sec. indicated a correct exposure for the frontlight reflecting off his face.

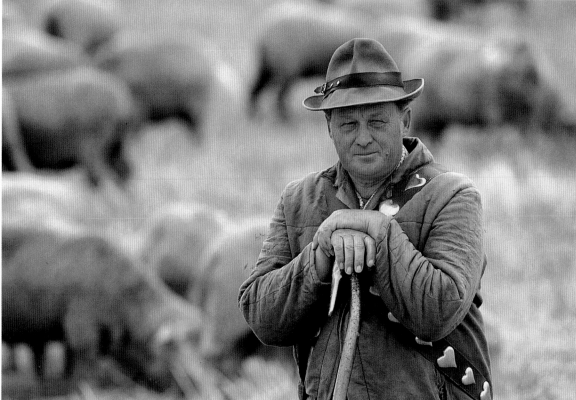

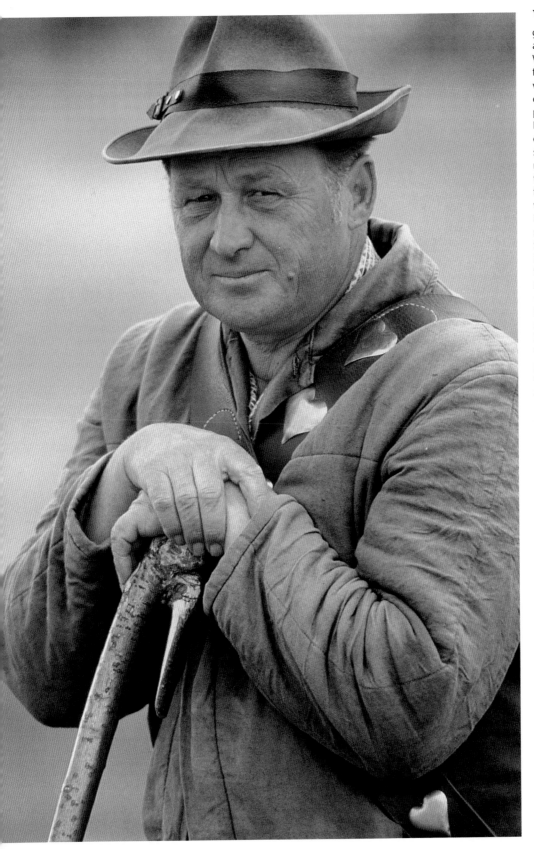

Venturing into this field of grazing sheep proved to be almost hazardous to my health. When I first walked into the field, the two sheep dogs were running free. Their very quick, sharp nips on my legs promptly reminded me that I had to watch my step. After calm was restored, I spent several minutes expressing my interest in photographing this sheepherder and his flock. ● I made the first shot with the textbook market in mind (far left, top). This storytelling picture clearly shows the sheepherder, his very important dogs that keep the flock under control, and the sheep grazing in the field.
● While shooting the second image, I had the magazine market in mind (far left, bottom). This composition would fulfill the need for a portrait of a sheepherder, complete with out-of-focus sheep in the background. ●
I shot the third image for the advertising/corporate market (left). Although you might not be able to readily tell that the man is a sheepherder, the copy on the advertisement or the caption under the picture in a wool-industry publication would easily solve this problem.
● For all three shots, I mounted my camera and 80–200mm lens on a tripod and zoomed the lens to its longest focal length. I also used the same aperture, f/8, and shutter speed, 1/125 sec. The bright overcast light made determining the exposure quite easy because everything in the scene was evenly illuminated. The only difference is that I walked closer to the main subject for each successive photograph.

PEOPLE AT PLAY

What is leisure time? Although this concept signifies different things to different people, it always involves pleasurable activities, such as playing in a company softball game, having a backyard barbecue, throwing a frisbee, searching for seashells, pitching horseshoes, reading a book, fishing from a boat on a still lake, listening to music, camping in the wild, mountain biking, flying a kite, and going cross-country skiing. These are just a very few of the many activities people participate in, if only to relax and get their minds off work.

Unfortunately, the ability to effectively photograph people at play seems to elude many photographers. How many of you have had the unpleasant experience of sitting through your neighbors' neverending slide show of their trip to Maine or listening to co-workers provide running commentary as they show you each 4 × 6 print of their family vacation? These situations are a nuisance because, at best, very few of the pictures are compelling.

Spare me the photograph of your son holding up his prized 17-ounce trout with your distracting Jeep in the background. Show me a shot where he is standing in front of the lake, so that there is a clear connection between him and the background. You can also be inventive, and take a picture of your son and father's hands as they place a worm on a hook.

And spare me the shot of you and a friend leaning on your mountain bikes in a deep green forest. Don't describe the rush the two of you felt when you came down a 40-degree incline. Show it to me! With your camera set at a shutter speed of 1/60 sec., pan as your friend zooms by. This electrifying image won't require commentary. Show me the grandeur of the rugged terrain by photographing your friend from a distance against the large, looming mountains, and I'll have no trouble understanding your thrilling adventure.

Show me the intensity on your daughter's face as she pitches a horseshoe. After you mount your telephoto lens on your camera, walk up to her and fill the frame with her face and the perspiration that has formed on her brow. Still using your telephoto lens, focus tight on the rod that ringers land on. Set an action-stopping shutter speed of 1/500 sec. in order to freeze the dirt that will surely fly when the horseshoe makes impact.

And when you're shooting at the beach, get down low with your wide-angle lens and set the aperture at f/16 to tell the story about your friend in the distance who is about to gather seashells. Then show me the collection she has at the end of her stroll; compose the picture so that only your friend's hands filled with seashells are visible.

These are the kinds of memories everyone wants to capture on film. Of course, you can argue that this is your leisure time, too, and that the extra effort such shots require is just too much. This is where you're mistaken. It doesn't take any more effort to shoot a compelling image than to shoot a merely acceptable one. Although you'll have to think a little bit more, this isn't devising a way to end world hunger. The rewards of your creative thought process will last much longer than the "toll" it takes on your mind and emotions.

I'd invited my friend Dorothy and her husband to the beach one morning to photograph them walking along the beach flying a kite (left). I deliberately chose my 600mm lens because it would allow me both to shoot from quite a distance so that I didn't interfere with the couple and to fill the frame with their play. Because I hadn't planned any shots, my subjects were free to move at will—and move they did, especially when a small wave caught them off guard (right).
● With my camera and lens on a tripod, I set the aperture at f/8. Then I adjusted the shutter speed until 1/250 sec. indicated a correct exposure for the frontlight. Next, I put the camera's motor drive on high-speed mode; I wanted to be ready for anything. When the wave came, I was able to record the couple's candid expressions.

Just like people hard at work, subjects hard at play provide you with many opportunities to shoot candids. Outside Atlanta, Georgia, these three boys were having a great time riding in inner tubes. I watched as they launched themselves down a shallow river at the base of a waterfall near an old cotton mill. As the boys stood under the falls discussing their course, I fired off several quick frames with my 80–200mm lens set at its longest focal length.

● This is an unusual photograph because I don't usually shoot when the light is almost directly overhead. With the aperture set at $f/8$, I took a meter reading of a nearby gray rock that was in shadow and adjusted the shutter speed until 1/125 sec. indicated a correct exposure. I metered off the rock because the boys were also in shadow; I knew that the resulting exposure would be correct.

On a trip to Oregon's coast, I met a mother walking along the beach with her twins. After a few minutes of conversation, I managed to make an appointment to photograph them several weeks later at a local park. When a shoot involves children, taking them to a park is always a safe bet because they can always find something to do; they can, for example, enjoy the rides or play ball. In addition to being fun, these activities prevent the children from focusing their attention on you and provide you with some great picture possibilities. ● As the early-morning light cast its glow on the ladder leading to the top of the slide, I was able to capture the twins making their ascent. Most 2-year-olds are next to impossible to direct, and these twins were no exception. But this lack of control is what makes photographing children in this age group both challenging and rewarding. When you get even one compelling image, you feel that you really worked for it.

● Fortunately, the twins made more than 10 trips up the ladder, so when they wouldn't look toward the camera, I would simply wait for them to start climbing again. With my camera and 300mm lens secured to a tripod, I zeroed in on the portion of the ladder illuminated by the sun. I set the aperture at $f/8$ and adjusted the shutter speed until 1/250 sec. indicated a correct exposure for the light reflecting off the children's clothing.

● I never managed to get both children to look my way with wide-eyed smiles, but this picture was a winner. The mother ordered a number of 8×10 enlargements, and the image has done quite well as a stock shot.

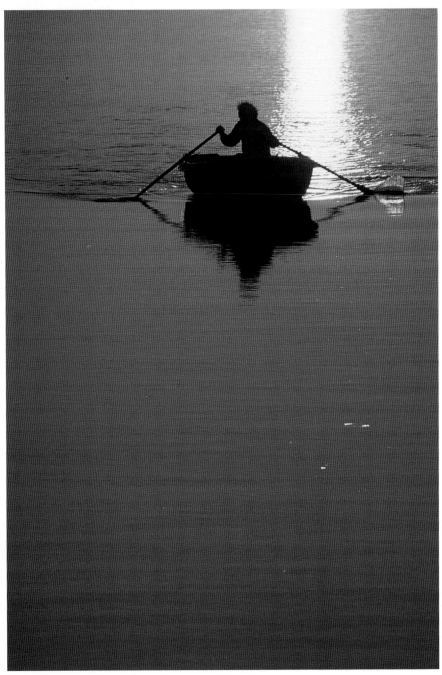

During my numerous trips to Rustenburg, a small village in North Friesland, Holland, I'd shot many photographs of these three windmills from a bridge that crosses a dike. Although I photographed this particular scene in different seasons and in various types of light, this was the first and only time that I had the good fortune of arriving at sunset and finding a lone rower in the water. ● With my camera and 80–200mm lens on a tripod, I set the focal length at 80mm; I then composed so that the sun was setting to the right of the windmills and the rower. After adding an orange filter to increase the color saturation, I set the aperture at ƒ/16 and adjusted the shutter speed until 1/125 sec. indicated a correct exposure for the light in the sky to the left of the sun (top left). I then fired off quite a few frames. ● Over the next several minutes, the rower came closer to me. I quickly zoomed the lens to 200mm and shot both a vertical and a horizontal composition that included only the man and the strong ray of sunlight on the water (left and top right). By framing the scene this way, I was able to increase the stock value of the images. Without the windmills, they are simply pictures of a man rowing a boat. ● For the shots of the rower alone, I set the aperture at ƒ/8 and adjusted the shutter speed until 1/500 sec. indicated a correct exposure for the light reflecting off the water to the right of the strong ray of light.

I have yet to meet a photographer who didn't agree that children are the easiest subjects to photograph. They seldom refuse to pose, they aren't likely to stiffen up, and they never ask for payment in the form of pictures. Children are a source of boundless energy, creativity, and imagination.

It wasn't until my son, Justin, was born that I learned many valuable lessons about children, not the least of which is that they don't remain children for very long. And what is true for me is true for every parent: Time flies when you have children. So make the extra effort to record, at the very least, the truly big events in your children's lives.

Babies are, perhaps, photographed most the first few days following birth. A few weeks later, babies begin to smile. If possible, dress your baby and anyone holding the infant in color-coordinated outfits when you shoot. Move in close, and with your telephoto lens, fill the frame with the baby and the arms of the person cradling him or her. Start cooing, and fire at will the instant the baby smiles. Six months later, however, you'll probably be taking pictures of the baby with a teething ring and tears flowing from his or her eyes. Keep in mind that at this point in their development, some babies can sit up independently, but most infants will have to be propped up.

The next important event is a baby's first step. Keep your camera out, loaded with film and fresh batteries, and be ready to shoot when you notice that your baby is attempting to walk. Use your telephoto lens; its narrow angle of view will eliminate any clutter in the room and call attention to this once-in-a-lifetime moment. However, if you miss your baby's actual first step, don't be too upset. I can assure you that your baby will be glad to take another step for you when you have your camera handy. As the baby lets go of the hand of the person lending support, be ready to capture the baby's wide-eyed grin.

And don't forget to shoot on the day when you present your child with a puppy or kitten. Once again, make sure that the background isn't filled with extraneous objects, and let your child have center stage. With your telephoto lens on your camera and the exposure and focus set, cue a friend to lift the pet out of a cardboard box. Your child's expressions will range from surprise to delight to fear to joy as you fire away.

If I could make only one recommendation about photographing children, I would tell you that from the time your child is born, you should have your camera ready at all times. As the months and years go by, you'll record some truly memorable and touching photographs, and your child will become very used to seeing you with your equipment. As a result, your child will feel very comfortable in front of the camera and won't freeze up when being photographed.

If there is any frustration involved when you're photographing children, it comes from their inability to take direction. This problem arises because they are often too self-absorbed to listen to you. Ironically, however, because you have to move around while shooting, your fresh perspectives can lead to some wonderful images. But if you still feel that you want some degree of cooperation from your subjects, try giving the children a toy or some other prop. Then ask the children to tell you the story behind it. Trust me, most children speak volumes when asked to. If you don't have a prop handy, ask the children where worms come from, how high they can jump, or what shapes they see when they look at the clouds.

When my son was between the ages of three and five, I had numerous conversations with him, during which I kept my camera to my eye, shooting his various expressions at will. This routine actually began as a poor man's substitute for a camcorder: I recorded our talks, too. These sessions proved to be wonderful experiences. I have a wealth of images that show Justin's ever-changing face and expressions during a period of rapid growth. Children are children for just a very short time. So take the time and make the extra effort to photograph your children on special occasions as well as in ordinary, everyday situations.

Taking a shortcut to a grocery store in Hoorn, Holland, I discovered this little girl sitting in the basket on her mother's bicycle. This photo opportunity reaffirmed my belief in carrying at least one camera and my 28–80mm lens at all times. ● With the lens set at a focal length of 70mm and an aperture of ƒ/8, I adjusted the shutter speed until 1/125 sec. indicated a correct exposure for the sidelight reflecting off the brick wall. I shot more than two rolls of various compositions, but this picture is my favorite. I deliberately positioned my subject in the upper right sweet spot to balance the image and to make her prominent. ● I realizing that the girl's mother was probably in a nearby shop, so I waited for her to return. When she arrived a few minutes later, I asked her to sign a model release, as well as to give me her name and address because I wanted to send her a print.

Fountains, by their very design, attract people, and the crowds around them really swell when the temperature is above 80°F. And unlike timid, self-conscious adults, children waste no time jumping into fountains. ● When I came across this fountain, I sat on a nearby bench for about 30 minutes and watched the action through the eyes of my camera and 300mm lens. I observed many shocked expressions as the children came into contact with the cold water. Within seconds, however, the children were completely drenched and were used to the water temperature. ● As I shot the scene, a 15-month-old child caught my attention. She hesitated briefly, glancing back toward her mother before taking each careful step into the shallow water. Finally, feeling that she'd gone far enough, the toddler bent down and seemed to plant a kiss on the surface of the water. To capture this charming moment, I set the aperture at f/8 and adjusted the shutter speed until 1/250 sec. indicated the proper exposure.

Children at play provide photographers with abundant photo opportunities. Because they're often consumed by the game or activity at hand, you can move around freely to create memorable images. Don't put your equipment away if the children spot you; chances are good that they'll show off for you. • One day, I noticed my son, Justin, and his friend, Joshua, seeking relief from the near 100°F temperature under the lawn sprinkler in the backyard. As they played in the water, they occasionally hugged one another. During one of their hugs, I managed to fire off several frames and record what will someday be a special memory. With my camera and 300mm lens mounted on a tripod, I set the aperture at $f/8$ and adjusted the shutter speed until 1/125 sec. indicated a correct exposure.

I often photograph the children of friends and neighbors. On a hazy day a few years ago, I found myself in a local park watching Kayla play. At one point, I gave her a large ball and started firing away as she focused all of her attention on it. • Kayla huffed and puffed as she tried in vain to lift the ball in order to throw it. I knew that a shot of her determined struggle would make a great portrait. With my camera and 300mm lens mounted on a monopod, I set the aperture at $f/5.6$. Then I adjusted the shutter speed until 1/250 sec. indicated a correct exposure.

While shooting at a local park, I saw this little girl and her mother get out of their car and walk across the grass toward the swings. I made a mental note to head over there as soon as I was finished photographing some children playing frisbee with their dog. A few minutes later, I noticed the mother and daughter coming toward me as I lay on the ground shooting. I immediately realized that I had a new subject. ● Although I appeared to be photographing the frisbee players, I was actually focusing on the toddler holding her mother's hand. With my bent arms supporting my camera and 300mm lens, I was able to make only four images in quick succession before the girl and her mother moved too close. Then I told the woman that I'd just taken a nice picture of her daughter, chatted with her a little while, had her sign a model release, and promised to give her a print.

WORKING WITH MODELS

When amateur and even some professional photographers hear the word "model," they immediately assume the discussion centers around a gorgeous woman in her late teens or early twenties, who is 5'9" and has a slender build. Experienced location and studio photographers, however, know that the term "model" refers to anyone, from a baby to a senior citizen, who fits an assigned role and is capable of expressing the desired emotion in front of the camera.

Under the heading "Model Agencies" in the *Yellow Pages* of all major cities and many smaller ones, you'll find such a vast array of talent listed that you may begin to wonder why you don't use models all the time. Many photographers are surprised to learn that the cost of hiring models is often quite low. I've never paid a model more than $100 for an all-day stock-photography session. And in many cases, hiring a model costs nothing more than a few 8 × 10 color prints. (I usually limit the selection to three different shots; if models want more prints, they pay the price the film lab charges me.)

Along with the availability of models and the small expense hiring them incurs, you might find working with a model appealing because both a photographer and a model can gain something from their "marriage." This new approach will make the photographer's images look fresh and may even renew the photographer's enthusiasm for his or her work. The model will get new portfolio shots and may even find a photographer who can bring out his or her best in front of the camera.

Suppose that you want to get assignment work from advertising agencies whose clients sell products geared to healthy lifestyles. These clients might include, bicycle and running-gear manufacturers, as well as companies that make breakfast cereals and vitamins. As such, these companies want to show healthy-looking people wearing trendy exercise clothes and enjoying the good life because of the benefits they gain from bicycling, eating nutritious cereal, and taking the right vitamins. Unfortunately, your portfolio shows your expertise in photographing agricultural and travel subjects but includes nothing that demonstrates an ability to photograph health-conscious people having fun. Although you know you can do this, you won't get an opportunity to shoot such an assignment until you can prove that you can because advertising assignments tend to be very literal.

Aware of this hole in your portfolio, you decide to go to a modeling agency and explain your dilemma. Chances are good that an agency staff member will come up with a list of models, male and female, who, like you, want to be hired for advertising jobs but have nothing to show that they can do this type of work. After carefully looking through the many headshots the agency offers, you find five or six models who would work perfectly. The agency then calls the models to find out if they want to do a test, which simply means that they hire out for free in exchange for some usable prints. You might agree on one head shot in return for several hours of posing, or an entire portfolio of shots for several days of modeling. (Needless to say, testing models isn't meant as an opportunity for new photographers to try to hone their skills regarding *f*-stops and shutter speeds, but as a serious shooting session for experienced photographers who have a particular aim in mind.)

Finally, a primary benefit of using models is the degree of control that it gives you. Directing models can be an enjoyable process because these individuals want to be photographed and are usually more than willing to cooperate with you. But you should keep in mind that the extent of their cooperation rests in large measure on the tone and sincerity of your intent.

I received a call from an advertising agency requesting a shot of "a child in a red shirt who looks really surprised." Most children are capable of looking surprised, but only a few can do so on cue. Although hiring a child model through an agency was an option, I called a student of mine and asked him to bring his young son over the following morning. The boy isn't a professional model, but I knew that he was capable of "acting." When Dean and his son arrived at my studio, I asked the boy if he would like to have a bunny rabbit that laid gold eggs. You can see his response to my question. ● I placed a strobe inside a 2 × 3-foot softbox and positioned the unit on the boy's right side, and repeated the process for his left side. I then test-fired the strobes. According to my flash meter, an aperture of *f*/16 was needed. With my camera and 80–200mm lens mounted on a tripod, I set the shutter speed at 1/250 sec. Aware that children can tire easily when asked to make the same face over and over, I felt fortunate to get eight wonderful shots from the one roll of film I shot.

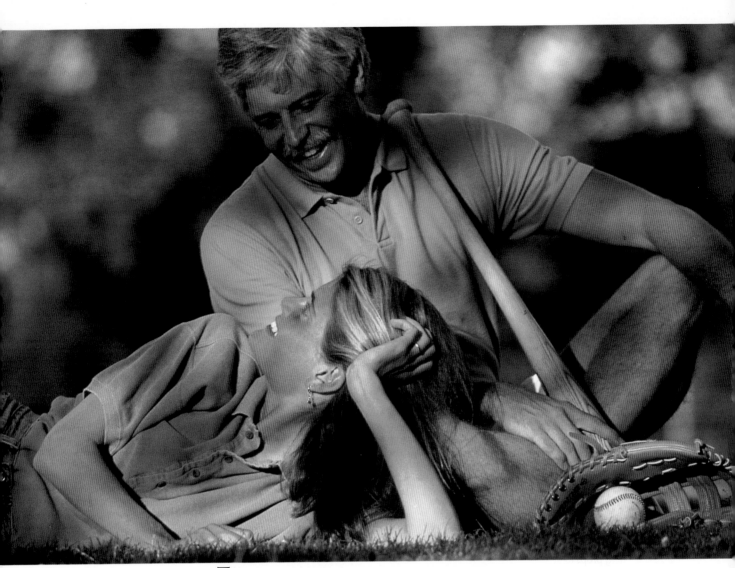

The two subjects in this composition are both friends of mine. I met Henry at one of the workshops I teach, and Diana is a neighbor. Although Henry had never modeled before, he took to it quite easily. Diana, on the other hand, is used to being in front of the camera; a former New York model, she still takes jobs occasionally. ● Wanting to use as few props as possible, I placed a bat, glove, and softball inside a large area of dappled light. As Henry and Diana engaged in friendly conversation, I got down to their eye level and supported my camera and 300mm lens on my arms and elbows. This shooting position enabled me to include a background that would record on film as out-of-focus tones of green. With the aperture set at f/5.6, I adjusted the shutter speed until 1/250 sec. indicated a correct exposure for the light reflecting off the subjects.

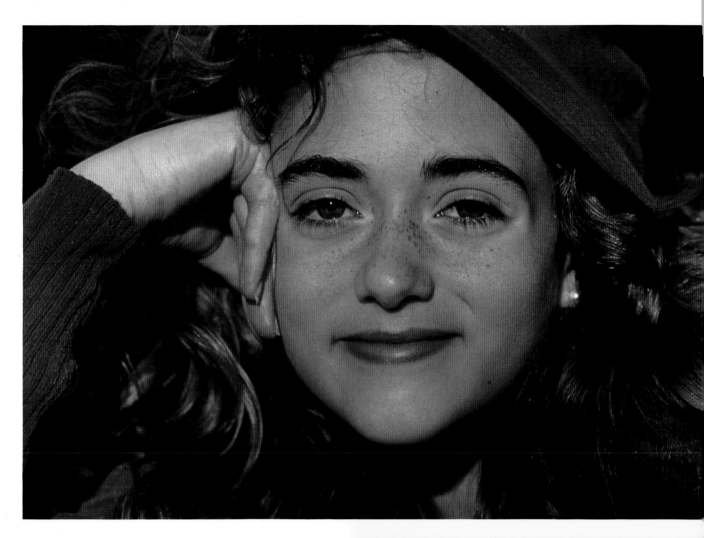

Although I am a strong believer in using props for stock images or assignment work, I also believe that you should always shoot a straightforward portrait of your subjects as well. I'd met Rene when she attended one of my workshops with her mother. Afterward, I asked Rene to pose with some schoolbooks at a park for a simple stock shot. ● Toward the end of the year, the weather in Oregon is seldom conducive to shooting stock. So I took full advanatge of the next "good-weather" day. Rene and her mother met me at the park, and I managed to fire off four rolls of 36-exposure slide film. Shooting with my 300mm lens, I got down on the ground to photograph Rene at her eye level (right).

I supported my camera and lens on my arms and elbows. Placing Rene in dappled light, I set the aperture at $f/5.6$ and then adjusted the shutter speed until 1/250 sec. indicated a correct exposure for the diffused but strong light reflecting off the girl's face and clothing.
● Having shot the schoolgirl composition I wanted, I moved in even closer but exposed the same way to shoot this simple, clean portrait (above). The books in the first photograph limit its marketability as stock. The second image, on the other hand, has much greater sales potential because it contains no props. This shot can be used, for example, to sell facial and health-oriented products and to illustrate stories about teen sex or religious values.

SELLING YOUR
PHOTOGRAPHS
AS STOCK

The term "stock photography" is used to describe the pictures that photographers sell to publishers of calendars, greeting cards, and textbooks, as well as to graphic-design firms and advertising agencies for use in corporate brochures, annual reports, and even advertising campaigns.

The chief advantage to buying stock shots is that this is generally cheaper than hiring a photographer directly. For example, if I work at an advertising agency and need a shot of the Eiffel Tower, I can call either a stock-photography agency or those photographers whose mailings have made me aware of their inventory of stock images. Most stock agencies have about 2 million pictures on file and represent anywhere from 30 to 200 photographers.

I decide to go with a particular agency and call in my request. Within several days, a courier delivers two dozen or so images of the Eiffel Tower. After choosing the one image that meets my expectations and needs, I call the agency to negotiate a price and arrange to return the other shots. The fee depends on several factors: how I intend to use the image, such as repeatedly for six months in a travel campaign or just once in a magazine advertisement; where the picture will appear, such as inside the magazine or on its cover; what size the image will be, such as a full page or a half page; and the circulation of the magazine, which refers to the number of people expected to see the image.

Suppose that I need the Eiffel Tower shot for the cover of American Airlines's in-flight magazine. Because the image will appear on the full cover for one month and will be circulated to more than 50,000 people, I might be charged between $500 and $700. If I were to hire a photographer to shoot a picture of the Eiffel Tower, I would have to pay a minimum of $350 per day plus expenses (film, processing, food, transportation). Of course, I would have no guarantee that the photographer will make the shot in one day. The weather might be bad, or the sky might not be colorful enough at dusk. Before I know it, I've spent more than $700 and still might not have the image that I could easily find through a stock agency. This is why there is such a big market for stock.

When I'm not busy working on assignments, I try to spend as much time as possible shooting stock images. This doesn't mean, however, that I can't generate stock while I am on assignment. Many of my outtakes from a photo assignment do become stock shots, and depending on the client, I might use stock as a bargaining chip when bidding on the job. For example, several years ago, I was hired to photograph Germany's largest precious-metals plant. I knew that I would be afforded the opportunity to shoot plenty of gold bars of varying weights, so I reduced my assignment fee slightly in exchange for permission to keep numerous outtakes for my stock files. This was the right move because these pictures have generated more than $8,000 in stock income over the last two years. And when you do assignment work for magazines, keep in mind that all of your pictures are returned once the article runs in the magazine. You are then free to use these images as stock.

To be really successful in the stock-photography field, however, you need to approach it the way you would a full-time job, and you should make photographing people your primary focus. Stock shots of people, from infants less than a year old to individuals older than 85, at work or at play, account for more than 80 percent of stock sales worldwide. And much to the surprise of many newcomers in the marketplace, the greatest producers of stock income are pictures of people involved in very simple activities. Popular shots include the following subjects:

- A mother holding a sleeping baby
- A father and daughter fixing a bicycle
- A grandmother with her hot-from-the-oven cupcakes
- A grandfather and grandson fishing
- A young family posing in front of their yet-to-be-completed home
- A teenage boy washing and waxing his new car
- A girl giving her dog a bath
- A boy playing the piano
- A father and mother in their business clothes leaving the ball park with their two sons in their Little League baseball uniforms
- A family picnic
- A family building a treehouse
- A grandmother surrounded by roses in her garden
- A grandfather asleep in a hammock
- A couple strolling on the beach
- A couple horseback riding
- A group of children riding a merry-go-round.

Although these subjects seem ridiculously mundane, they can be very profitable if you execute them well. That is the trick to successful stock photography. You can apply everything you've learned in this book to shooting stock images, such as framing a closeup study of a subject's face or hands, creating mood with different types of light, or changing your point of view. Most if not all of these principles are at work in almost every image shown here.

In terms of profitability, stock shots of people at work are second only to shots of people involved in leisure-time activities. Banks, insurance companies, and health-care firms are just a few of the potential clients continually looking for innovative images.

• While shooting an annual report for an international grower of flowers and cut bulbs, I had many opportunities to photograph people involved in day-to-day operations. I found the flurry of activity surrounding the loading of packaged bulbs onto trucks to be particularly appealing. To record this employee as he went about his work, I mounted my camera and 50mm lens on a monopod. I set the shutter speed at 1/30 sec. in order to pan my subject and then adjusted the aperture until f/11 indicated a proper exposure. This typical workplace image has been used three times as a stock shot.

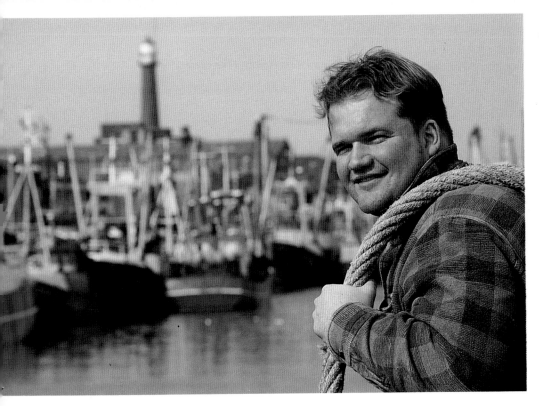

I sat across from this tugboat operator in a cafe near Rotterdam, Holland. After my assistant and I spoke with him for about 15 minutes, he agreed to pose at the edge of a dock with a nearby port in the background. I zoomed my 80–200mm lens to its 100mm focal length and set the aperture at f/8. Then I adjusted the shutter speed until 1/125 sec. indicated a correct exposure for the light reflecting off the blue sky. • This picture has been used as a stock shot twice. Somewhat surprisingly, an insurance company in Oregon once chose this photograph because the young man fit the mold of the typical fisherman along Oregon's coast. Of course, the red lighthouse was removed via computer manipulation before the image was printed.

Finally, there is one very important aspect of photographing people that you must never forget: getting signed model releases for every person you photograph. Used in this context, the word "model" doesn't necessarily mean that the person is a professional model; it is simply a generic term that covers anyone featured in a photograph. Even if you don't currently have one iota of interest in selling your pictures for publication, get model releases! Suppose that two years from now you decide that you do want to try your hand at marketing. What are you going to do with your wonderful collection of people pictures that you have no releases for? Any reputable publisher, design firm, or stock agency won't even consider your work without model releases.

In a nutshell, a release simply states that the model or models featured in the photograph have given you a blanket permission to use the image in any way that you and a prospective client might deem necessary. Some model-release forms are long, and others are short. My model releases fall somewhere in the middle (see below). I used this model-release form for each and every person in this book, and I've had the release printed in Chinese, French, German, Italian, Japanese, and Spanish. Contrary to popular belief, model releases are becoming the norm rather than the exception with publishers worldwide.

When you ask someone to sign a release, your explanation should be short and to the point. You might want to say something like, "I don't know if the photographs I am about to take of you will ever be published (a true statement, by the way, whether you are on assignment or you're shooting stock), but in the event that they are, the publishing world requires that I have you sign this permission slip." Shift the blame off you and onto publishing.

Whenever possible, I try to get my subjects to sign releases before I take the first picture for a few reasons. The models might "get away" before I'm finished shooting, or they might feel that they acted foolishly in front of the camera and are reluctant to sign anything before seeing the processed film. This can be a big problem when you must leave immediately for a new location 500 miles away.

Whether you get the signatures before or after the shoot, be sure to get signed releases from everyone you feature in a photograph. Some photographers don't have friends or family members sign releases, but this can lead to disaster. Imagine this scenario. Three years after photographing your husband, you get divorced. He then sues you for selling pictures of him for stock without a model release. Similarly, your former in-laws sue you for selling shots of them on the local golf course because they never signed releases. Friend or foe, relative or stranger, get that model release signed right then and there. And every time you photograph friends and relatives, have them sign a new release that covers that specific shoot. Don't assume that 5 or 10 different shots made over the course of several months or years are all covered by the same model release. They aren't.

Wherever your travels take you, whether just down the street or halfway around the world, you won't be lacking subject matter when your goal is to photograph people. As your experience grows with this seemingly inexhaustible supply of material, you'll learn to observe these subjects from a variety of perspectives. A simple portrait of a person's face will no longer be your only option. You'll discover that you can shoot just your subject's hands, or you can opt to shoot an entire profile. In some cases, you might suggest different attire or different hairstyles, or you might want to add props.

You'll also want to try shooting from a variety of points of view, changing your lenses, and using a whole host of backgrounds. At other times, you'll want to experiment with illumination, photographing the subject under frontlighting, backlighting, or sidelighting conditions, or in bright overcast. Finally, you might want to direct your subjects in a number of ways, asking them to move left or right, or closer or farther away; you'll also have the option of having them look directly at the camera or turn their heads away. Obviously, you have many choices—and subjects.

BRYAN F. PETERSON, PHOTOGRAPHER
MODEL RELEASE

I hereby give to Bryan F. Peterson, hereby referred to as the photographer, his legal representatives and assigns, those for whom the photographer is acting, and those acting with his permission, or his employees, the right and permission to copyright and/or use, reuse and/or publish, and republish photographic pictures or portraits of me, in color, or black and white made by the photographer at his studio or elsewhere.

I hereby warrant that I am over twenty-one years of age, and competent to contract in my own name insofar as the above is concerned.

I am to be compensated as follows:

I have read the foregoing release, authorization and agreement, before affixing my signature below, and warrant that I fully understand the contents thereof.

DATED _____ NAME _____

WITNESS _____ ADDRESS _____

ADDRESS _____ SIGNATURE _____

I hereby certify that I am the parent and/or guardian of _____ an infant under the age of twenty-one years, and in consideration of value received, the receipt of which is hereby acknowledged, I hereby consent that any photographs which have been or are about to be taken by the photographer may be used by him for the purposes set forth in original release hereinabove, signed by the infant model, with the same force and effect as if executed by me.

PARENT OR GUARDIAN _____

ADDRESS _____

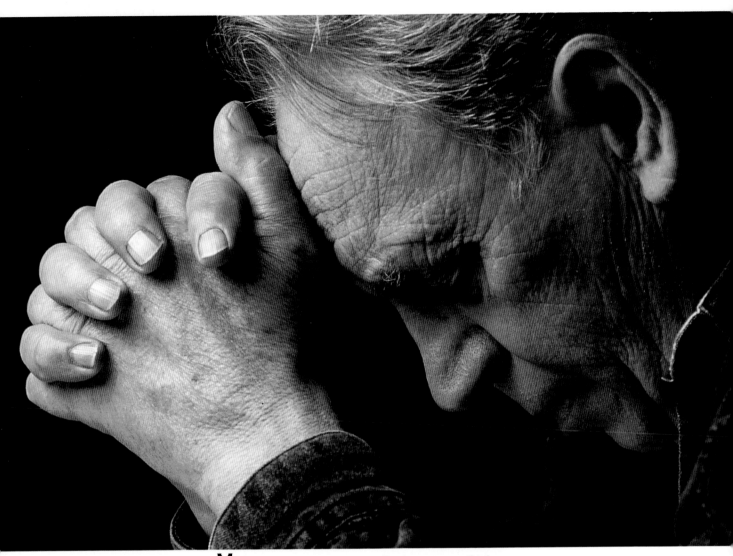

My father, a retired Lutheran minister, always bowed his head in prayer before every meal. As my family sat down to have lunch during a recent visit, I suddenly realized that this pose reveals all there is to say about my father. He gladly obliged my request to shoot this timeless portrait in my studio. I decided to photograph him against a background of black seamless paper because black creates a sense of mystery, intrigue, and infinite space. In addition, I thought that the background would provide an effective contrast to his face.

● Since I prefer to shoot in available light, I use just one light in the studio whenever possible. For this shot, I placed a single-head strobe inside a 2 × 3-foot softbox and then positioned the unit at a 45-degree angle to my father's left side. Next, I fired a test flash, and the flash meter indicated that an aperture of $f/11$ was required. After setting the shutter speed to 1/250 sec., I composed this scene with my 80–200mm lens set at its 135mm focal length, and made several exposures.

Whether I'm working on an assignment or simply shooting for myself, I always have the stock-photography market in mind. And I make sure that I include people in my images for two main reasons. Clients usually prefer people pictures, and these photographs are the biggest producers of stock income. ● While on assignment in Holland for Northwest Airlines, I decided to include two bicyclists in the cover shot for the airline's *Compass Readings* magazine (right). The out-of-focus windmill establishes a sense of place, but the young woman's smile makes the image warm and inviting. The elderly woman looking out her window on the cover of my *Germany* book has the same effect (below left).

And the man in the rowboat is the exclamation point, not an intruder, in the shot of the tranquil landscape on the *Holland* book cover (below right). ● Liberty Northwest Insurance hired me to shoot original pictures as well as to supply stock shots for six brochures describing the company's services. In the end, the company used two of my stock shots. The picture of employees with friendly attitudes was chosen because it captures the workplace image that every company wants to promote (far right, top). The dramatic shot of the foundry worker was selected because it shows the type of employee Liberty Northwest insures (far right, bottom).

Perspectives on Business and Leisure

December 1989

Compass *readings*™

Business is Sweet at Tootsie Roll	32
Honoring the Land in Holland	52
Vikings' Anthony Carter	112

GERMANY

PHOTOGRAPHY BY
BRYAN F. PETERSON
TEXT BY
KLAUS KLEBER

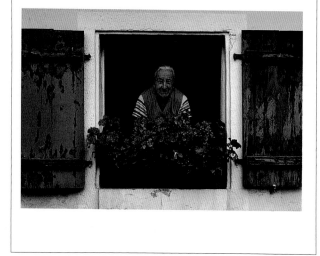

Holland

Photography
BRYAN
PETERSON

Essay
HELEN
COLIJN

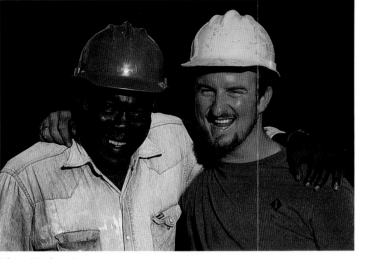

HELMSMAN NORTHWEST

Self-Insurance Services

For those employers who choose to self-insure their workers' compensation liability, Liberty Northwest provides a full line of self-insurance services through its wholly owned subsidiary Helmsman Northwest.

Helmsman Northwest tailors personnel and services to meet the unique needs of self-insured employers. We offer self-insured Oregon employers what no other service company can provide: a full range of state-of-the-art services *plus* maximum containment of medical costs through a statewide Managed Care Network.

The self-insurance services package includes:

· Service teams that manage all aspects of cost control

 Claims Administration and Management

 Field Investigations

 Medical Care Utilization Review

 Managed Care Network

 Rehabilitation Services

 In-house Legal Consultation

 Management Information Reports

Other **Helmsman** services include:

 Excess and Aggregate Insurance

 Loss Prevention Services

 Vocational Rehabilitation Eligibility Evaluations

Liberty Northwest's commitment to service excellence and demonstrated ability to contain costs make Liberty Northwest Oregon's premier workers' compensation insurance service provider.

Your Helmsman Northwest claims team provides experienced service personnel who get results. They manage all aspects of workers' compensation issues facing self-insured employers.

Liberty Northwest's commitment to service excellence and demonstrated ability to contain costs make Liberty Northwest Oregon's premier workers' compensation insurance service provider. Helmsman Northwest proudly offers these services to self-insured employers.

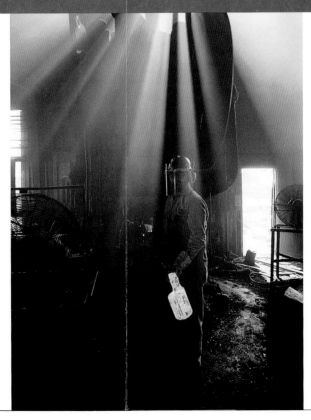

LOSS PREVENTION

We Give You More

Loss Prevention services you may have come to expect from your business insurer generally include traditional safety programs, surveys and loss analysis consultation. Liberty Northwest's loss prevention specialists *offer those traditional services—and much more:*

· Research lab facilities
· Manual materials handling evaluations
· Certified industrial hygiene staff
· Economic equation/payback period on engineering controls
· Slip meter evaluation capabilities
· National safety training institutes
· Multiple-location risk service
· Extensive safety poster distribution capabilities
· Safety publications
· Result-oriented supervisory safety training

Liberty Northwest's loss prevention specialists and the services provided are the best in the industry. These services are available from any one of our 12 Northwest branch offices.

When you need loss prevention services which go beyond the traditional, you can rely on Liberty Northwest.

We help you prevent claims costs at the source. Our loss prevention specialists actively reduce on-the-job injuries by locating work hazards and minimizing your potential risks.

When you need loss prevention services which go beyond the traditional, you can rely on Liberty Northwest.

INDEX